SEVEN SUMMITS
ART WOLFE

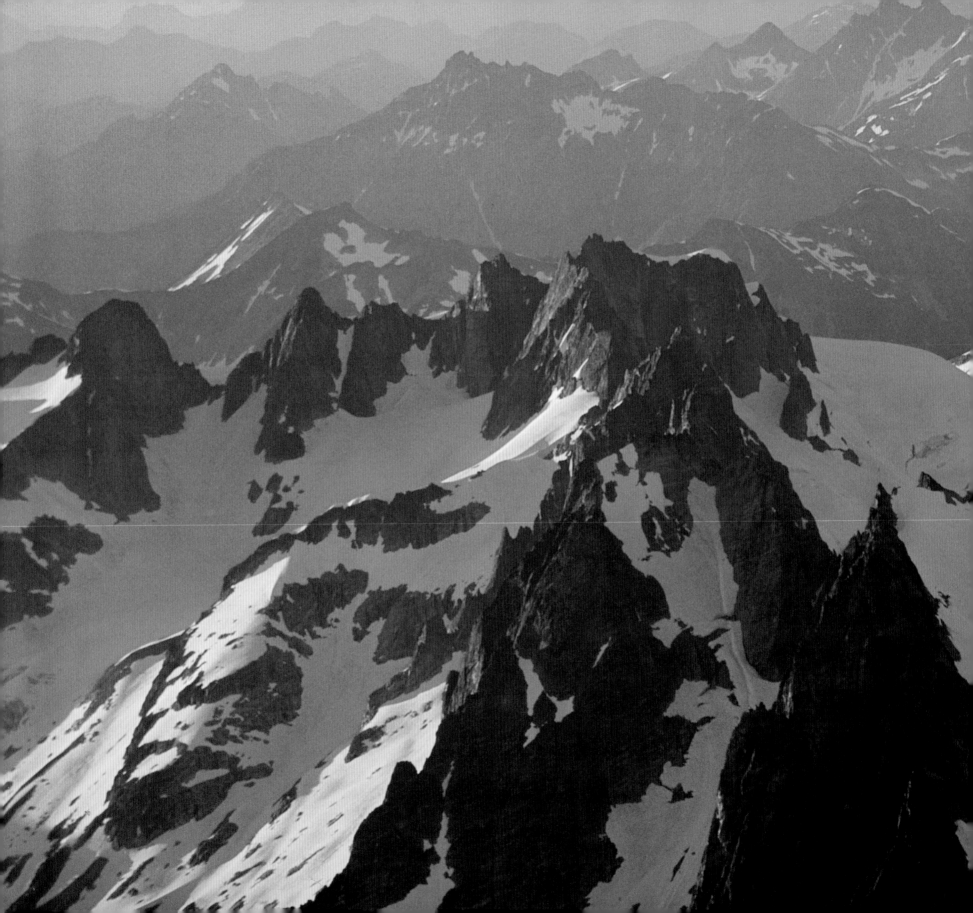

SEVEN SUMMITS

The High Peaks of the
Pacific Northwest

ART WOLFE

text by MICHAEL LANZA

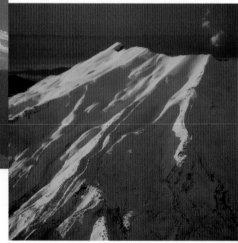

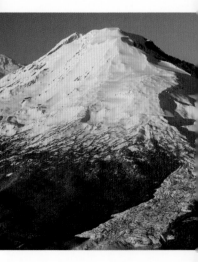

CONTENTS

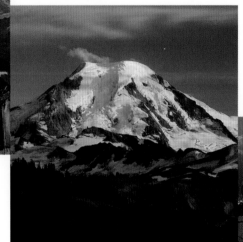
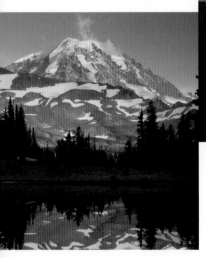
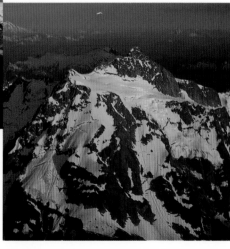

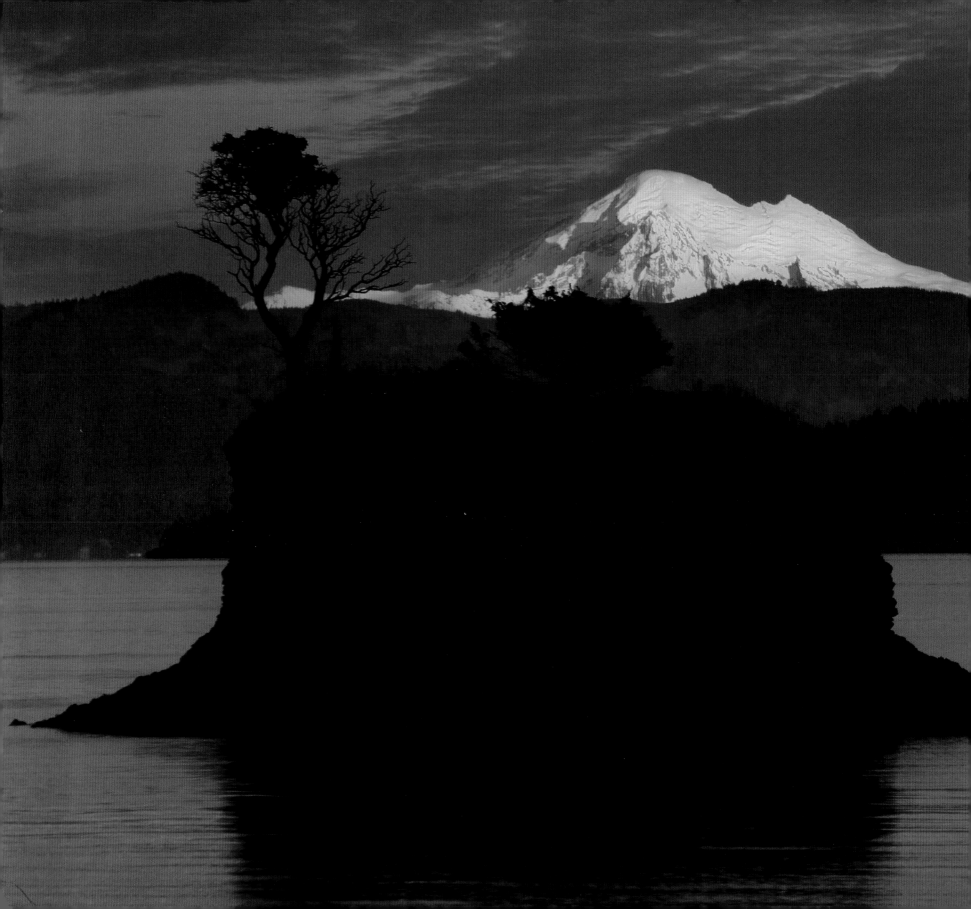

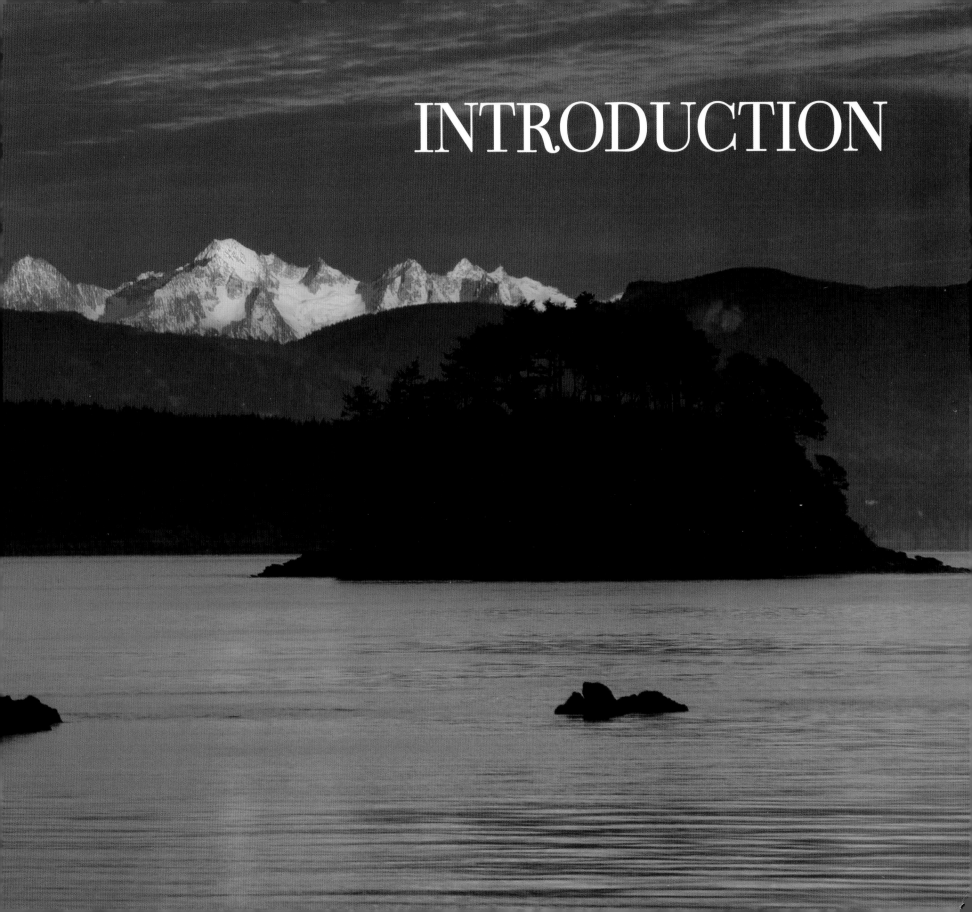

INTRODUCTION

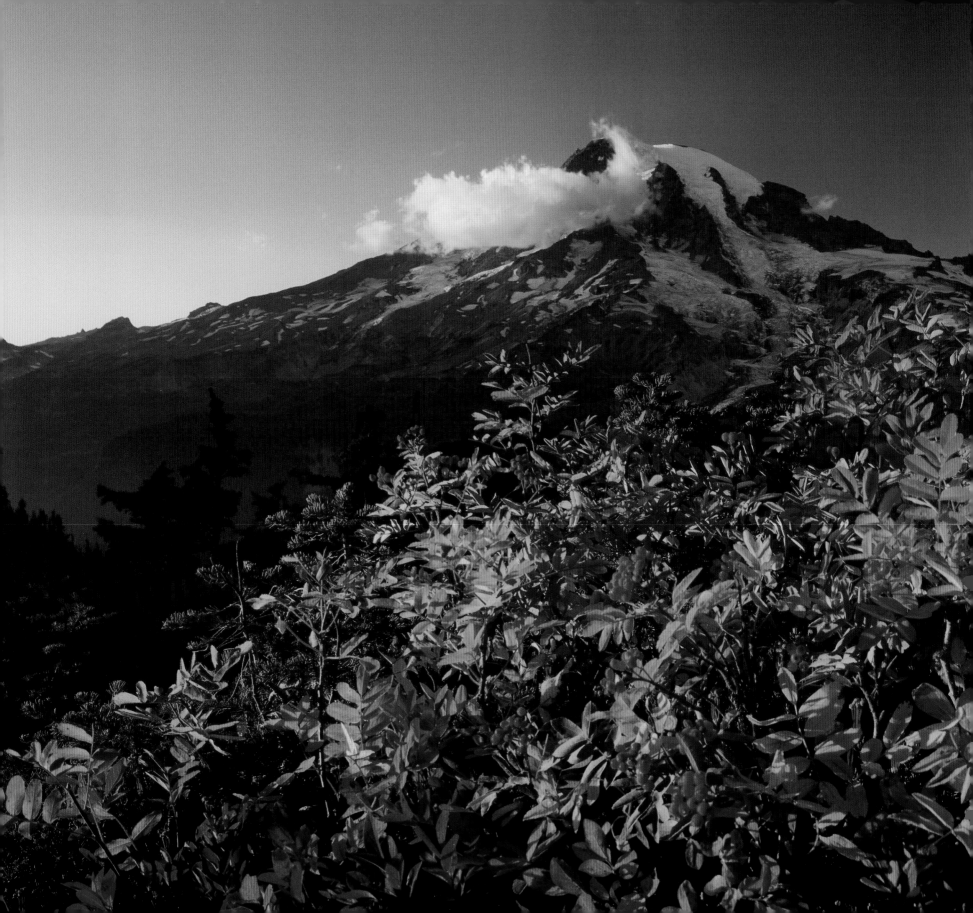

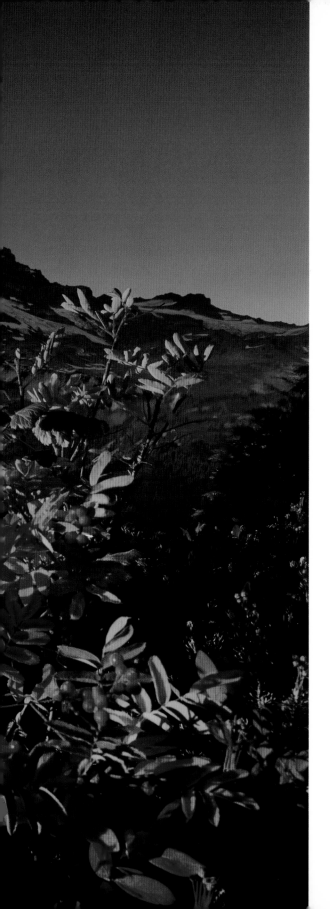

W e started moving upward well before dawn. The stark light of our headlamps offered an identical view for a short distance in every direction of a mono-colored landscape: white. The air was calm, the only sound the soft sliding of the rope connecting us over the snow, a sound like sand pouring into a wooden bowl. As predawn light dripped in around us, we saw that the visibility wasn't improving. Fog seemed to engulf all of Mount Baker as we marched up the Coleman Glacier under heavy packs, intent on camping high on the mountain—perhaps even, conditions permitting, on the summit.

The cloud danced silently around us, sidling up close and then spinning away, giving us occasional glimpses of a ridgeline of rock pinnacles above, or a sucker hole of blue sky, before swallowing everything again. Other climbers coming down the mountain stepped out of the dense air as if through a doorway, passed by, and then quickly disappeared into it. Periodically, dark gray strips that barely contrasted against the milky gray-white of ground and atmosphere slowly came into focus,

Previous page: Mount Baker from Cypress Island, San Juan Islands, Washington

Left: Mount Rainier from Plummer Peak

only revealing themselves as gaping crevasses once we were virtually upon them. Carefully skirting their lip, we'd peer nervously down into the beautifully frightening blue emptiness.

At a saddle 1,500 feet below Baker's summit, the fog gave no inclination of lifting and the frigid wind began a violent assault. We pitched tents and fled inside, resigned to the idea that we might not move again until morning.

Then the unexpected happened: sunshine lit up our tent walls. We stepped outside to discover that the cloud ceiling had dropped below us and the wind had calmed. Quickly gearing up, we dashed for the summit as the long, red light of a summer evening brought out every wrinkle and cotton-candy swirl in the sea of clouds reaching to every horizon far below us, pierced only by the distant white crowns of other big Cascade volcanoes: Glacier Peak and, much farther off, Adams and Rainier. It being a Sunday evening, with the weather poor for so much of the day, every other climber on this popular peak had already descended. We had Baker's broad plain of snowy summit to ourselves. The details of scenery, the cold wind and blinding sun on snow, are etched vividly in my memory, as if it were last weekend and not 10 years ago.

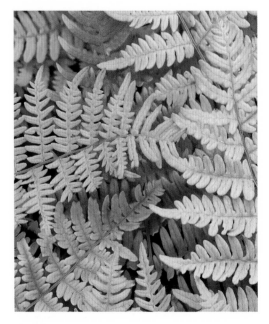

That was my first climb on one of the Northwest's Seven Summits—but not my first enchantment by one of these geologic goliaths. That experience came, as it does for many, on the first visit to Seattle. A native of New England, where the mountains are rugged in their own way but do not nearly approach the scale of those in the Northwest, I arrived lacking the mental calibration necessary for viewing mountains here. So on a bluebird late-summer day in the city, when I happened to swing my gaze to the southeast for my first sighting of Mount Rainier, floating above the urban horizon like an oversized image projected onto a wall of sky, I stopped and stared with that blend of awe and disbelief known by anyone who's enjoyed that sight. In an

age of cynicism, when so much of our daily lives are divorced from any interaction with the outdoors, the scene looks too fantastic to immediately trust that it's real. Even for locals who've seen it more times than they could calculate, the unexpected glimpse of Rainier on the horizon can still cause a physical reaction: it induces a catch in the throat, quickens the pulse, and snaps you out of the trance of mundane concerns. Even on the worst of days, it places things in perspective—it reminds us of one of the most important reasons we live in the Northwest.

Just days after standing atop Mount Baker, I stood at the shattered rim of Mount St. Helens, listening to the perpetual clatter of rocks tumbling into the crater beyond my toes. I stared, dumbstruck, hundreds of feet down into the steaming maw that 15 years before had been the foundation of another 1,300 feet of mountaintop, now gone. The smallest and technically easiest to climb of the Northwest's Seven Summits—a walk-up via the popular Monitor Ridge, though a tedious hike for all the loose, beach sand–like pumice—St. Helens stands alone for its moonscape born of the historic May 1980 eruption. It's also arguably the most spectacular day hike in America. Shortly after departing the trailhead, one emerges above timberline into an ashen landscape of

broken rock and dust that continues right to the "summit," really just a high point in the crater rim. From the rim, a climber enjoys a spectacular view: white-capped volcanoes piercing the blue sky in three directions. It's a view unique to the Pacific Northwest, the only part of the country where such massive peaks, wearing a year-round cloak of white, rise so high above their surroundings—Rainier to the north, Adams to the east, Hood to the south.

I've since skied up and down Mounts Shuksan and Adams on perfect days of bulletproof blue skies. I've backpacked, skied, and snowshoed on the flanks of Mounts Rainier and Hood. As I write this, I'm crafting plans to hike around and climb Glacier this coming summer.

What's so special about these mountains? The answer is both instinctively knowable and impossible to communicate fully in a

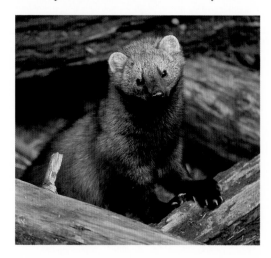

vocabulary that does the subject real justice. Whether we climb them, hike or ski or snowshoe in their long shadows, or simply admire them from a distance, these biggest peaks of the Cascade Range are totems for this place we call the Northwest. Our region would be immeasurably diminished without them (though that argument doesn't apply to losing just *part* of one, as evidenced by how the 1980 eruption of St. Helens has only amplified our fascination with it).

They mesmerize us on many levels, foremost in their size and grandeur. They physically dominate the landscape, rising many thousands of feet above surrounding valleys and mountains. Mount Rainier, for instance, clears its neighbor peaklets by a lofty 7,000 to 8,000 feet—a vertical mile and a half of troposphere separating its summit at Columbia Crest from the tops of the nearest mountains—and stands nearly 11,000 feet above the river valley that begins at the toe of its own Carbon Glacier, a vertical distance equivalent to that between Mount Everest's base camp and summit. Theodore Winthrop, an early proponent of naming Rainier Mount Tacoma, a name closer to the various Native

Far left: Bracken fern
Left: Fisher
Right: Black-tailed deer fawn

American names for the mountain (though he was motivated in part by a rivalry between the cities of Tacoma and Seattle), wrote, ". . . of all the peaks from California to Frazer's River, this one before me was the royalest."

When Lewis and Clark descended the Columbia River in 1805, they thought St. Helens the highest peak in America, it so dominates the horizon when viewed from the river. Mount Shuksan, the only nonvolcanic member of the Seven Summits, is not even the tallest among the nine or ten nonvolcanic peaks over 9,000 feet in the Cascades. But it is iconic (and often photographed) for its highly visible position towering above the Mount Baker Highway, for its jagged profile from any aspect, its hanging glaciers and icefalls, and its distinction as the only nonvolcanic Cascades peak with 3,000 feet of relief above timberline. Of Glacier Peak—Washington's sole remaining wilderness volcano, residing many miles from the nearest road— Professor William D. Lyman once wrote: "It can be seen in all its snowy vastness . . . bearing upon its broad shoulders miles and miles of rivers of ice, the most beautiful and significant of all the poems of nature."

A single perspective on any one of them doesn't begin to convey its immensity. Hike or drive around one and you see

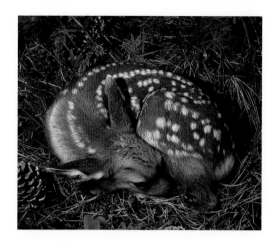

how its face transforms—how, as the photos in these pages illustrate, it looks like a completely different mountain from different aspects, in different seasons or light. Get closer to one and it appears to swell ever larger. For the most persuasive measure of its size, get on it and see the mountain expand like a gas cloud before you; it taxes the intellect to comprehend that this vast expanse of rock, ice, and snow sprawling over most of your field of vision is but a tiny fraction of the whole.

These mountains impress on an intimate scale as well—and to fully appreciate a big volcano, you have to get up close and personal. With the notable exception of the blast-denuded slopes of St. Helens, dense forests drape the lower elevations, lush, cool, and rain-soaked, the extravagant feast of vegetation a shock to eyes accustomed to drier climates or forests that have felt the saws of loggers. The profusion of water

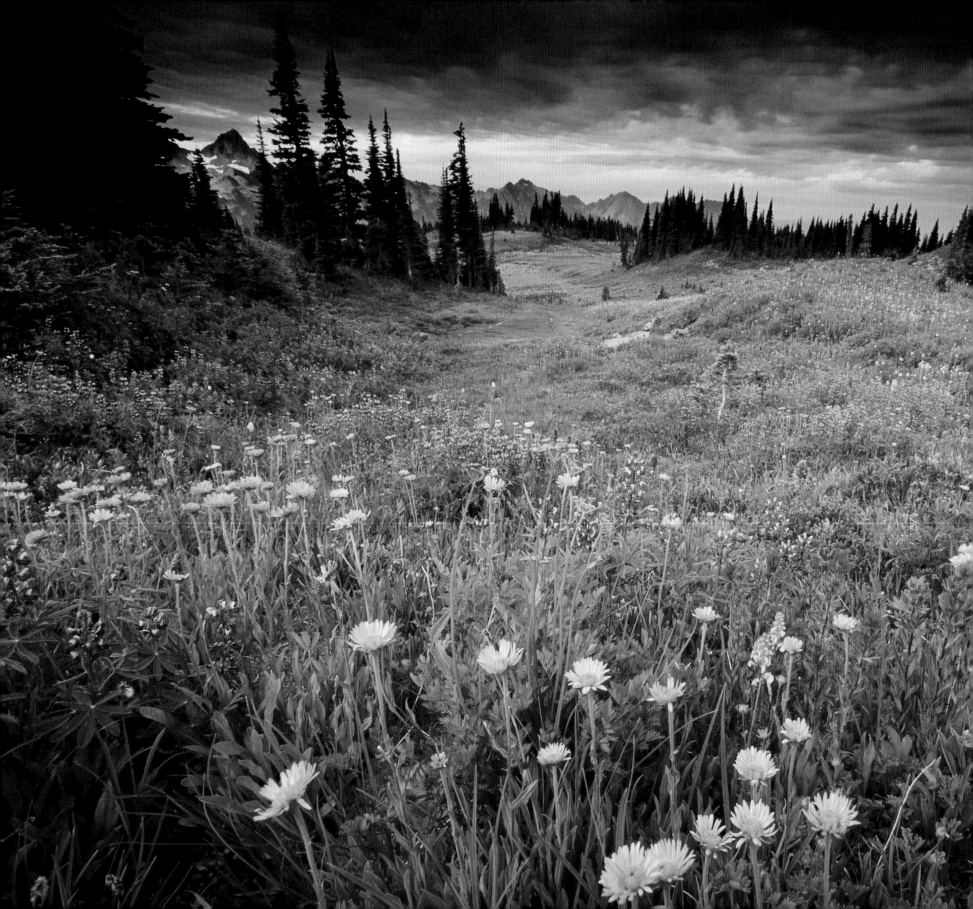

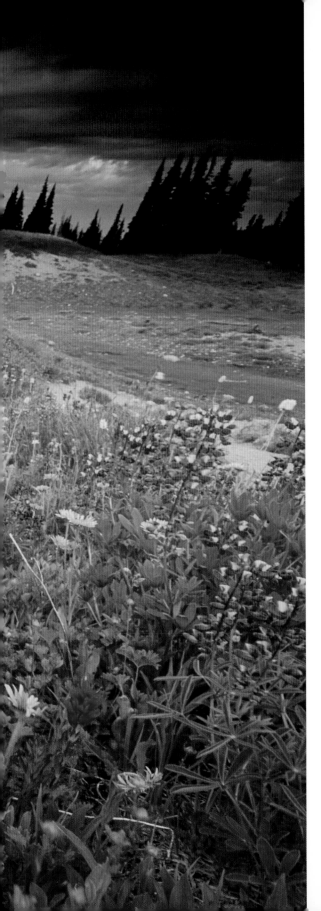

boggles the mind. Creeks explode down virtually every gully, and rivulets seeping from carpets of green appear every few steps along some trails; the hiker on the forest trails of Mount Rainier National Park, home to 382 lakes and 470 miles of rivers and tributaries, almost doesn't need to carry a water bottle. Higher, the forests open up to meadows erupting with wildflowers during the brief alpine summer. The snouts of glaciers mark the dynamic boundary between frozen and melted, where great chunks of ice periodically calve off, meltwater thunders over waterfalls and out of the gaping mouths of ice caves, and foaming rivers run gray with the glacial flour ground over centuries of shifting ice crushing rock and dirt. In the protected wildlands around these mountains, you may well encounter bear, mountain lion, elk, marmot, and mountain goat; these places are the last refuges of many of these species.

And finally, these greatest of Northwest mountains imprint themselves upon us in ways deeply personal. We tend to visit them with people who are special to us, and the sights and sensations of place and

Left: Alpine meadow, Paradise Valley, Mount Rainier National Park

Right: Buttercups, Mount Rainier National Park

shared experience swirl and blend into the waters of memory until the associations between people and place become inseparable. I made those first climbs of Baker and St. Helens with the girlfriend who has since become my wife; the few days we spent together on those two peaks have assumed a place in the narrative of our lives, among the times we cherish and the stories we tell, disproportionate to the fleeting hours we actually passed there. These mountains cast memories as long as their late-afternoon shadows.

VIEWPOINTS

11,239: Elevation, in feet

45° 22′ N; 121° 42′ W: Latitude/longitude of summit

50: Miles from Portland, Oregon

12: Number of named glaciers

October 29, 1792: Lieutenant William Broughton, under the command of Captain George Vancouver, identified and named the peak after British Royal Navy Admiral Lord Samuel Hood

1845: Year that Oregon Trail pioneers Samuel K. Barlow, Joel Palmer, and their parties opened the first wagon trail over the Cascades on the south side of Hood; while still very difficult, the Barlow Trail was preferred over the treacherous Columbia River rafting route to Oregon City

July 11, 1857: First ascent, by Lyman Chittenden, Wilbur Cornell, Henry L. Pittock, and T. A. Wood

More than 10,000: Number of climbers who annually attempt Hood, sometimes described as the most-climbed snow-covered peak in America, or "America's Mount Fuji"

500: Alleged number of ascents of Hood by a dog named Ranger, the last in 1938; he was buried on the summit after his death in 1939

1907: Year of Hood's last minor eruption

July 1915: First wedding held on Hood's summit, of Blanche Pechette and Frank Pearce

Wy'East: Native American name for Mount Hood

9: Number of students who died when caught by a storm high on the mountain in 1986

8,500: Elevation, in feet, of the top of the Palmer Ski Lift, located on the South Side climbing route

2: Number of weeks, in September, that the Timberline Ski Area on Hood closes each year

200: Approximate number of years since the last major eruption of Hood (just before Lewis and Clark reached the region)

Quicksand River: Name Lewis and Clark gave the river now known as the Sandy, which at the time of their arrival was still choked with a huge volume of volcanic rock and sand from a 1790s eruption of Hood

1,067,043: Area, in acres, of the Mount Hood National Forest

47,160: Area, in acres, of the Mount Hood Wilderness within the national forest

Right: East face of Mount Hood from Grass Valley, Oregon

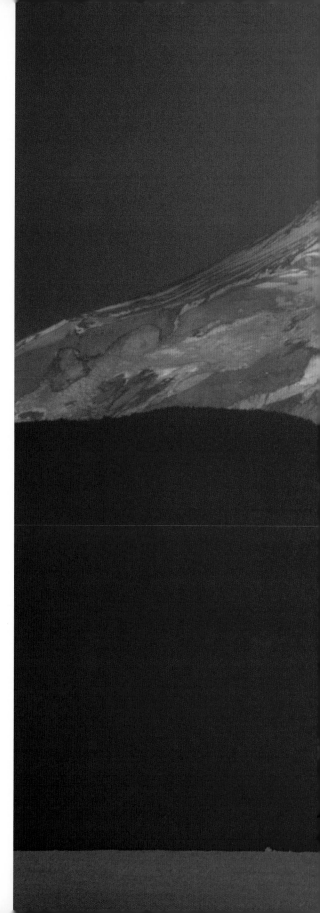

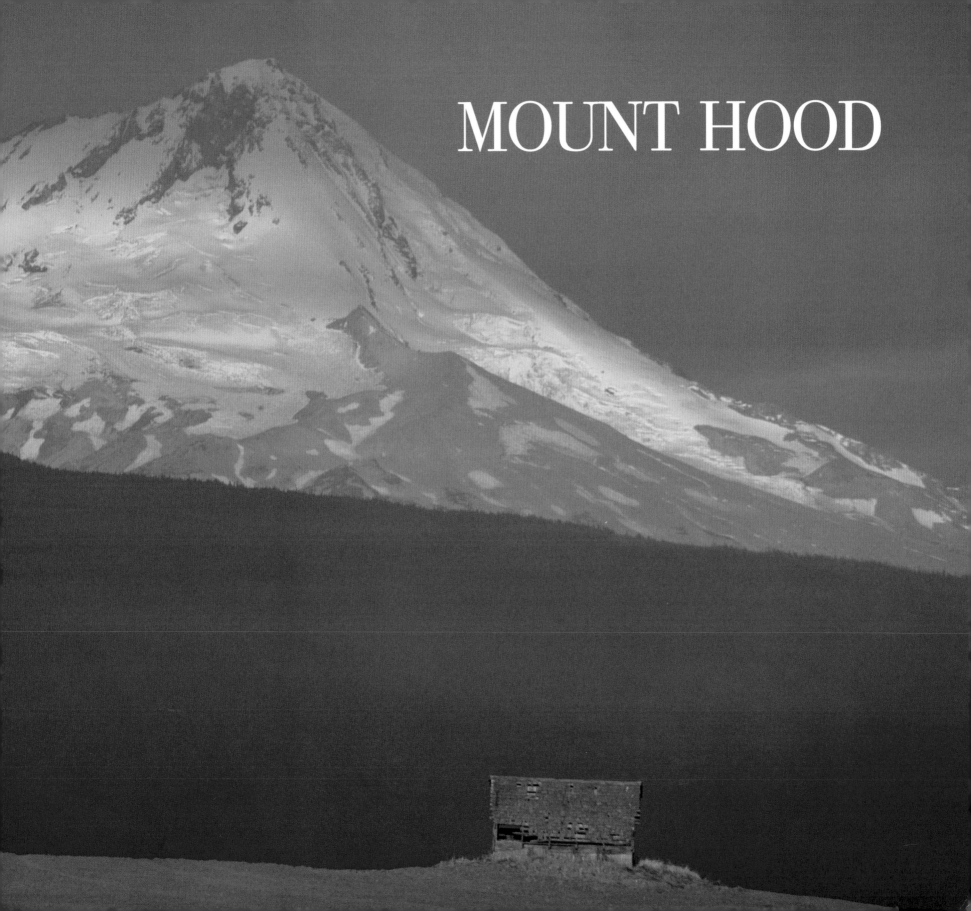

MOUNT HOOD

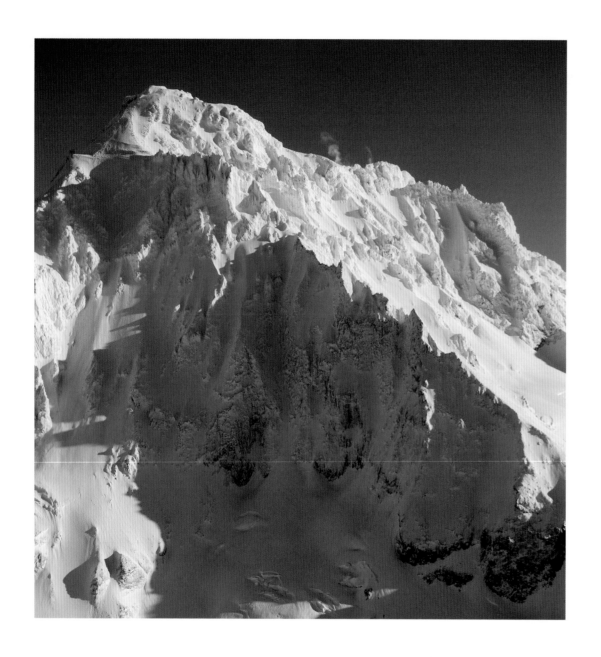

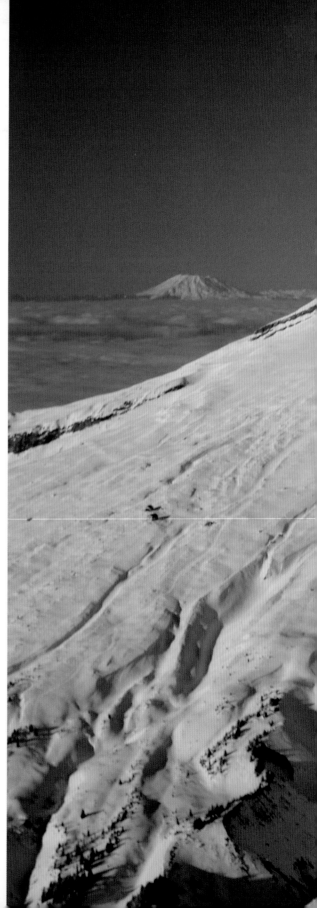

Above: North face of Mount Hood

Right: Southern slopes of Mount Hood;
visible in the distance are Mount St. Helens
(left) and Mount Adams (right)

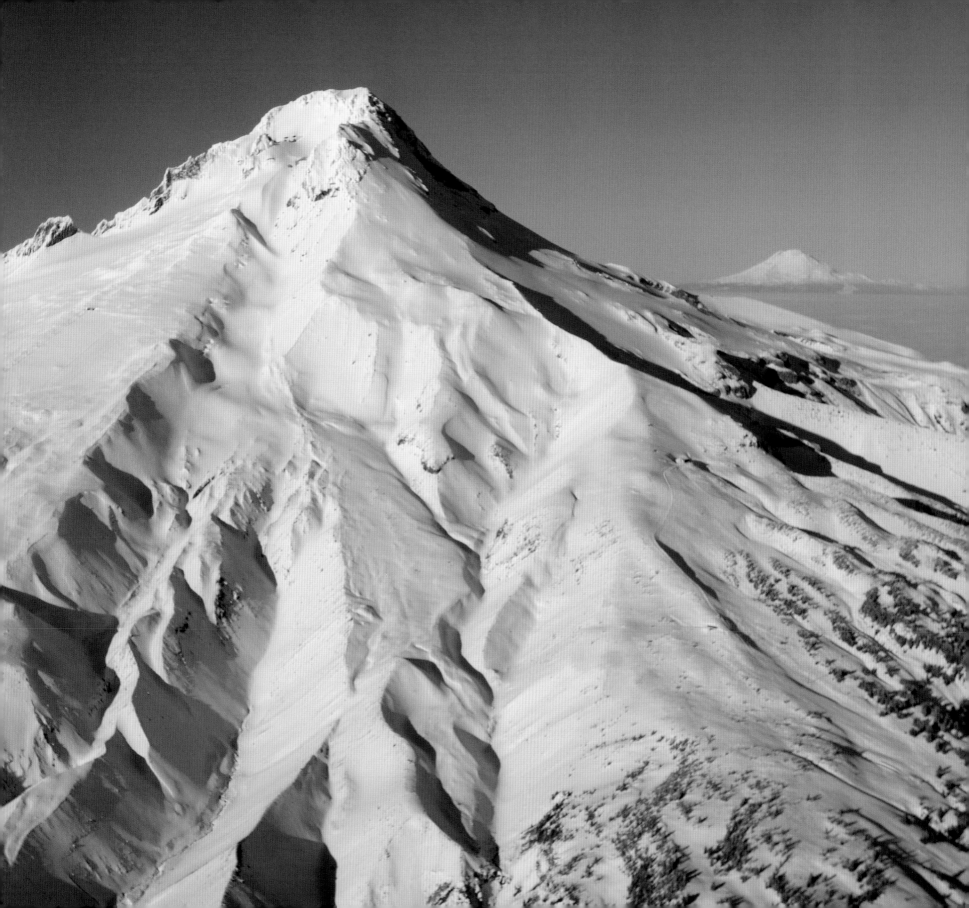

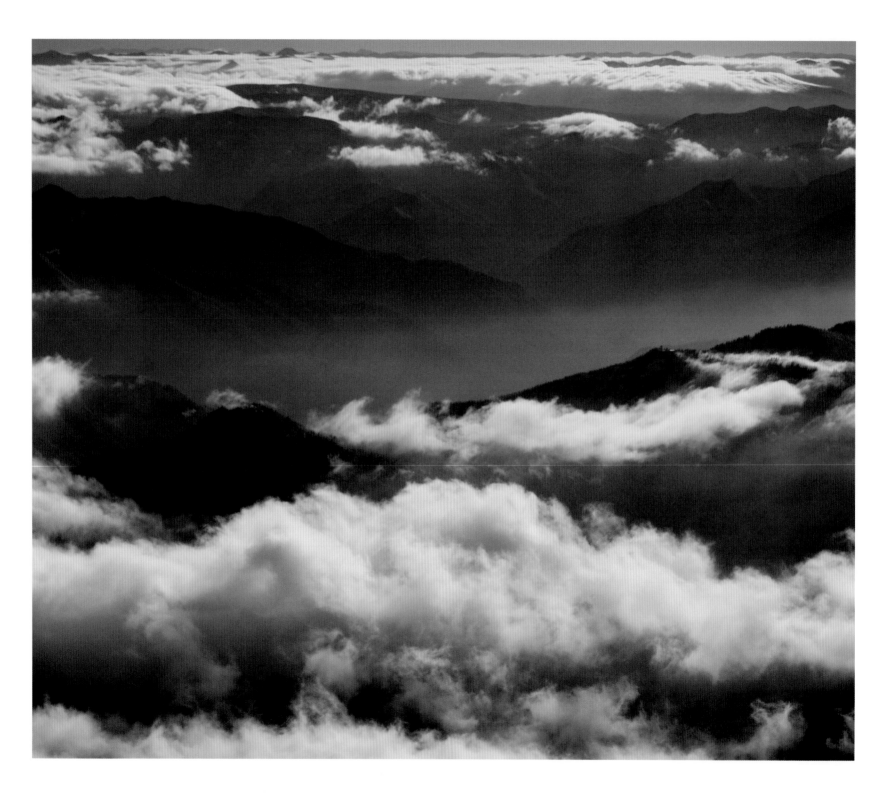

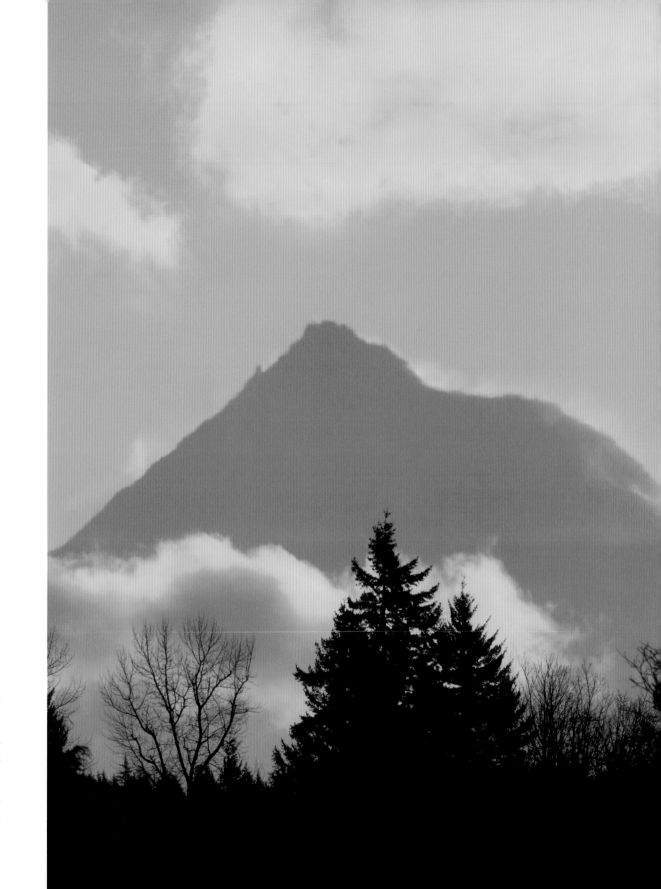

Left: Aerial view of Mount
Hood National Forest

Right: Northwest face of Mount Hood
from Larch Mountain Road

Page 6: Climbers on the summit

Page 7: Mount Hood's venerable
Timberline Lodge

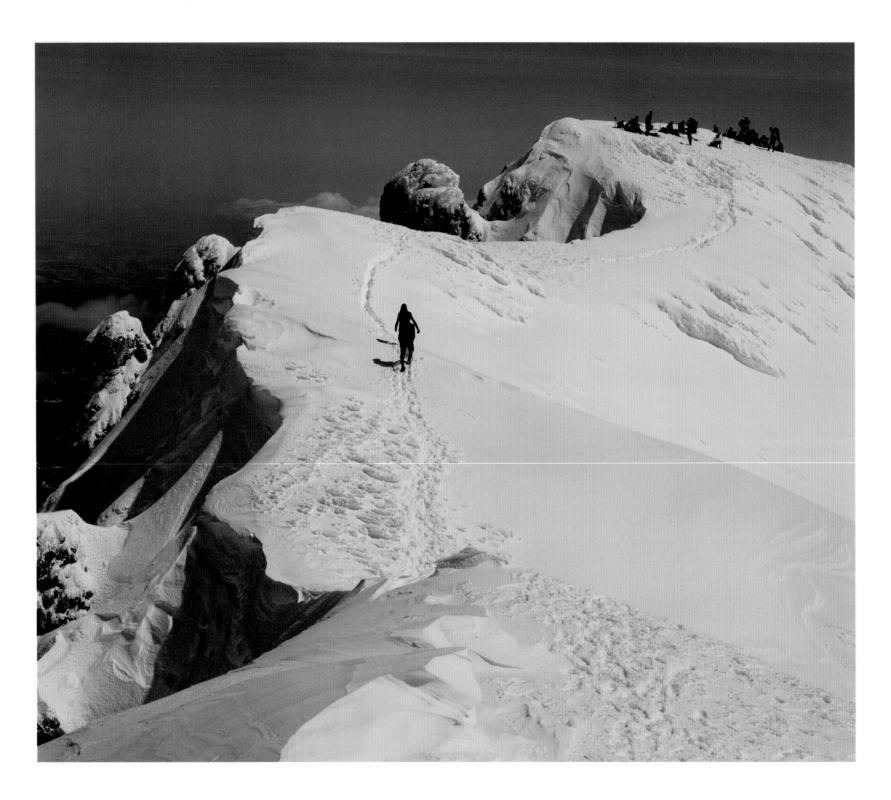

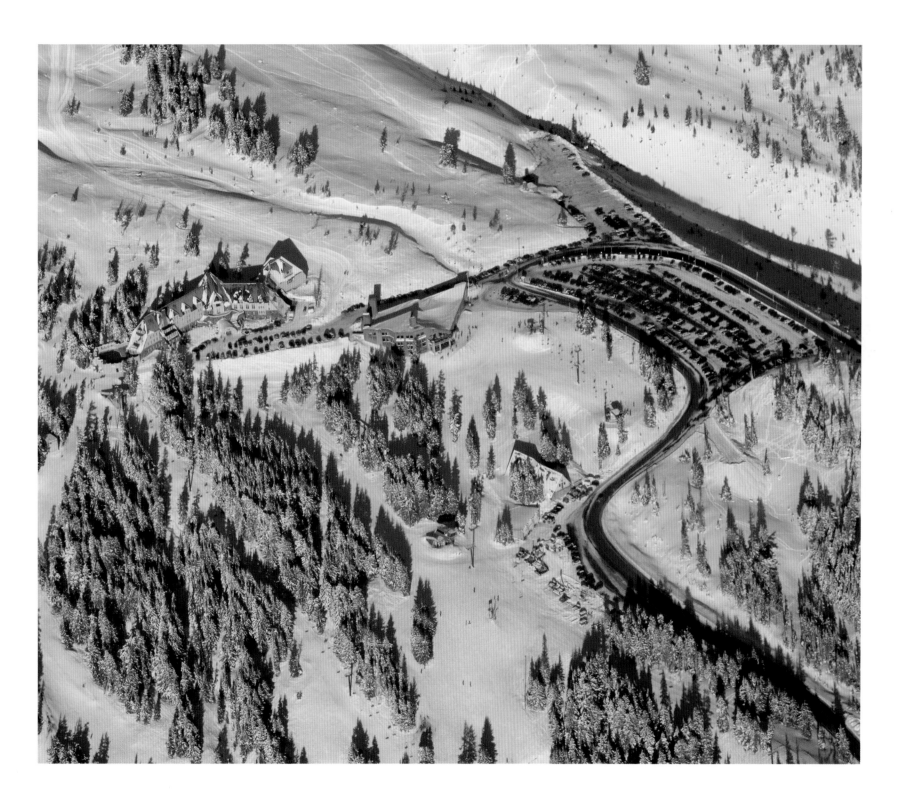

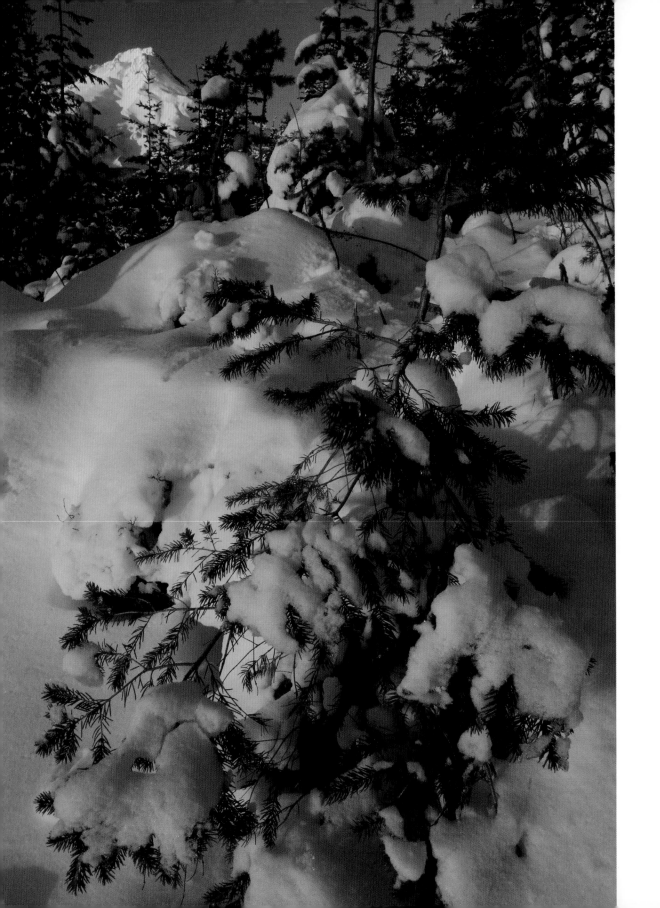

Left: Mount Hood viewed from the Barlow Pass region, Oregon

Right: Snowscape in Mount Hood National Forest

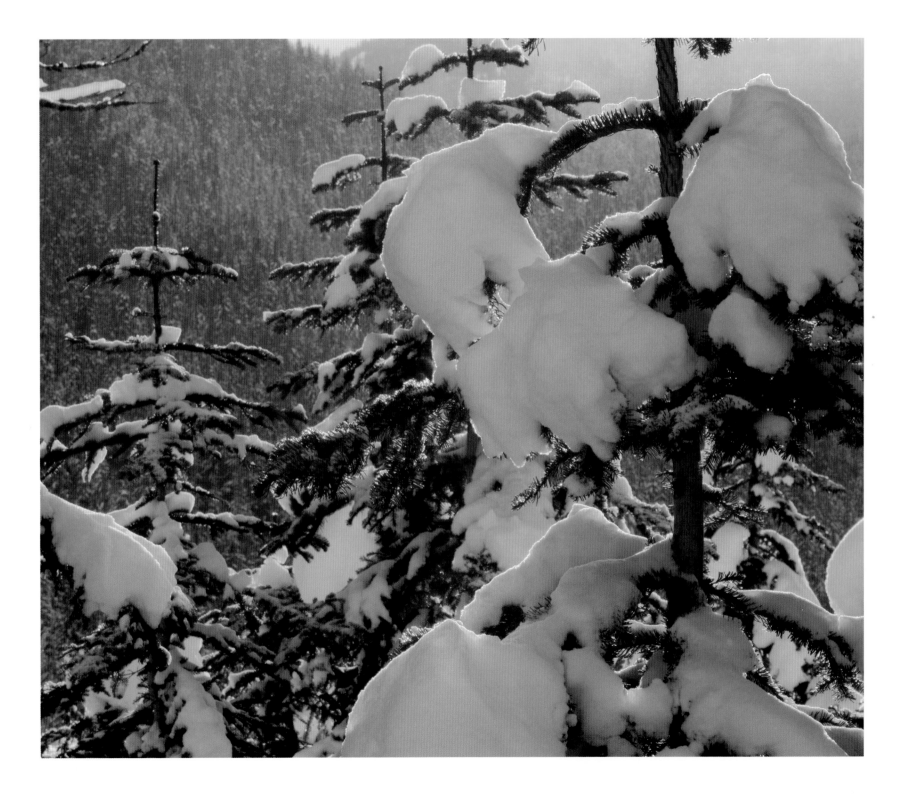

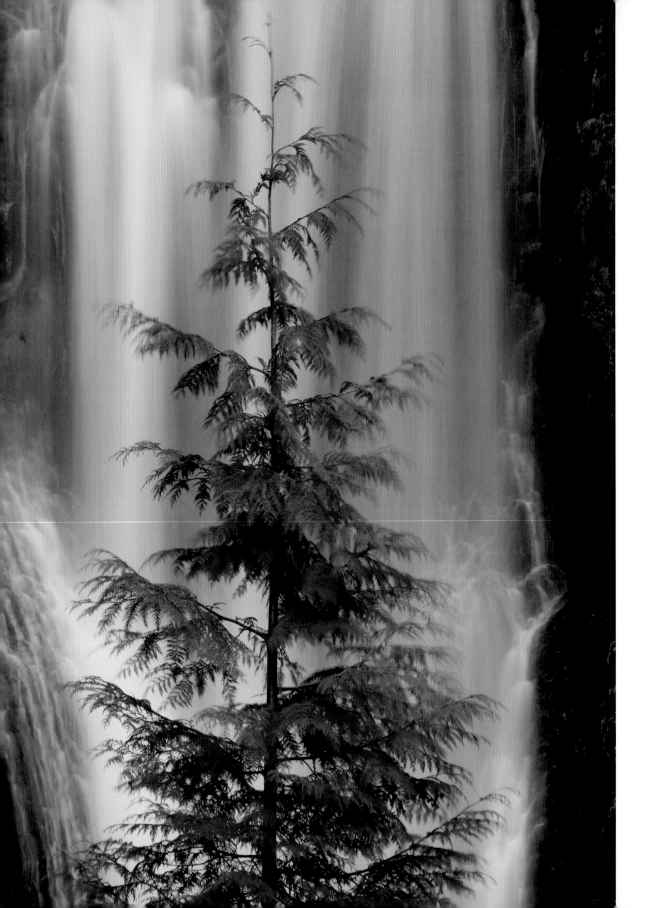

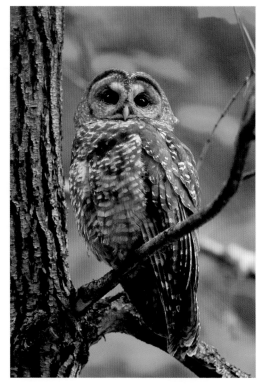

Left: Multnomah Falls, Columbia River
Gorge National Scenic Area, Oregon

Above: Spotted owl, Mount
Hood National Forest

Right: Lower slopes of Mount Hood's north side

Next page: Subalpine fir, Mount Hood
National Forest

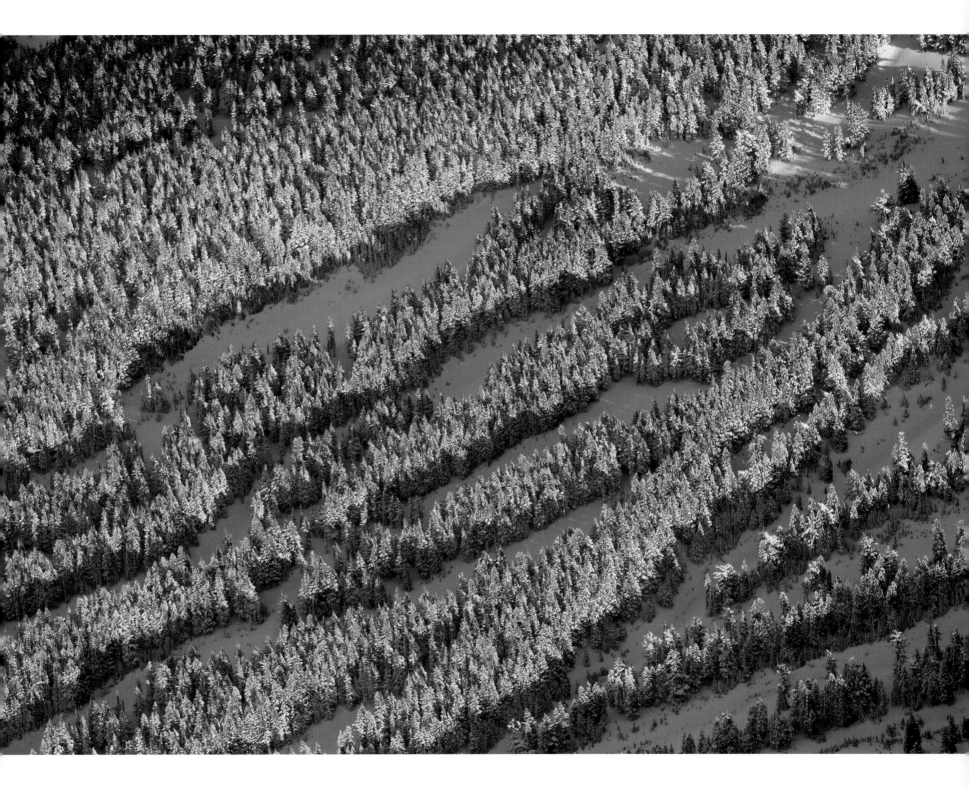

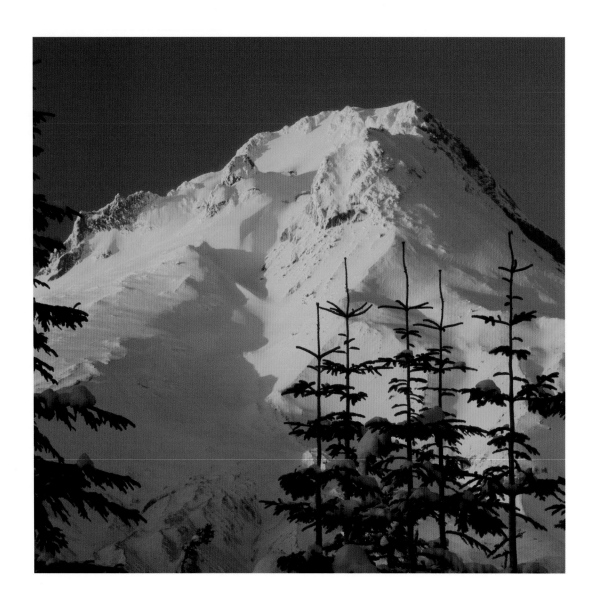

Above: Alpenglow on Mount Hood's western face

Right: Sunrise silhouette of Mount Hood, as seen from Portland's Rose Garden

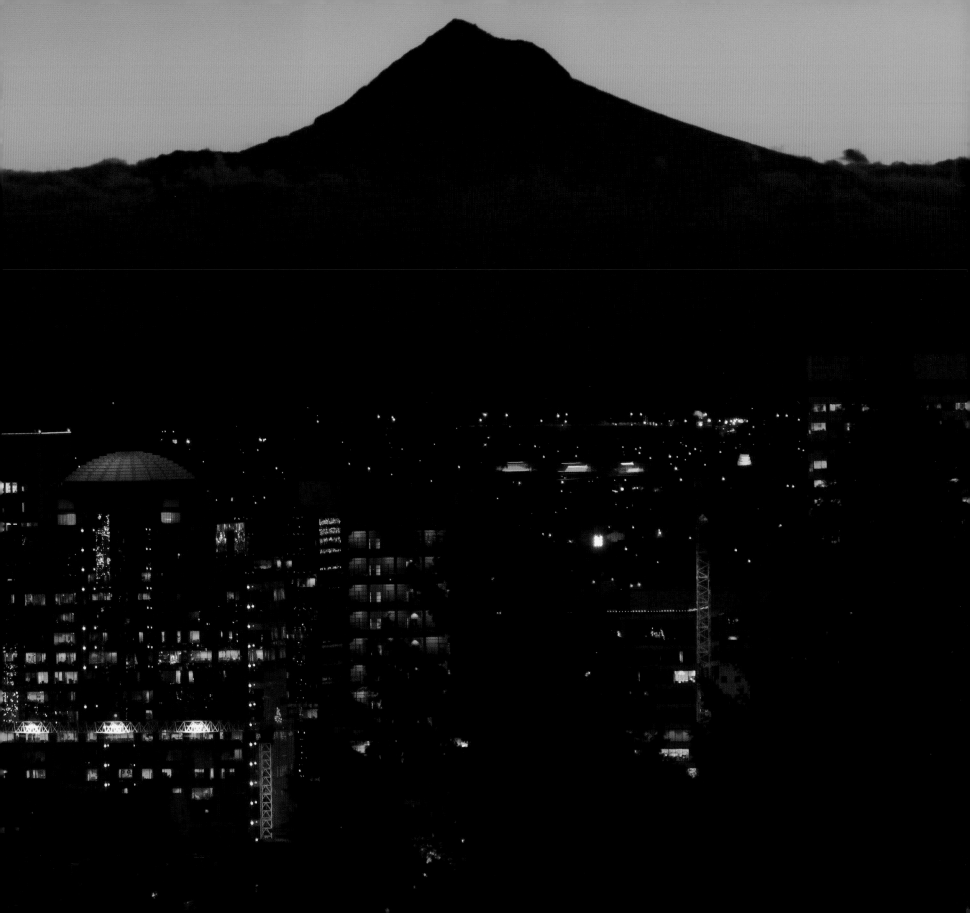

VIEWPOINTS

8,364: Elevation, in feet

46° 11' N; 122° 12' W: Latitude/longitude of summit

50: Approximate distance, in miles, from Portland, Oregon

9,677: Elevation, in feet, prior to the May 18, 1980, eruption

August 27, 1853: First recorded ascent, by a party including Thomas J. Dryer, whose reports about the climb were published in The Oregonian newspaper. It was the first known ascent of a major snow peak near the coast.

Loo-wit-lat-Kla: Name the Klickitat tribe gave the mountain

5.1: Force of the earthquake, measured on the Richter scale, that triggered the 1980 eruption, causing the mountain's entire north face to collapse in the largest landslide in recorded history

230: Square miles of forest blown over, or left standing but dead, within minutes after the 1980 eruption began

1,300: Temperature, in degrees Fahrenheit, of the fiery pyroclastic flows (composed of rock and volcanic gases) that traveled at 50 to 80 miles per hour from the erupting volcano, toppling old-growth Pacific silver fir and mountain hemlock trees—or ripping them from the ground—and stripping them of their branches

70: Percent of the mountain's glacial ice volume that was obliterated by the 1980 eruption

57: Number of people killed directly by the eruption

4,000 to 4,400: Elevation, in feet, of timberline, unusually low among the region's peaks because of recent eruptions and the thick pumice covering the ground

100 to 200: Estimated number of years it will take for a mature coniferous forest to reappear on the devastated slopes around St. Helens

1900 B.C.: Approximate date of an eruption estimated to have been four times the size of the 1980 eruption

1982: Year that President Ronald Reagan and Congress created the 110,000-acre Mount St. Helens National Volcanic Monument

Right: Mount St. Helens's southwestern slopes
catch the last light of a winter's eve

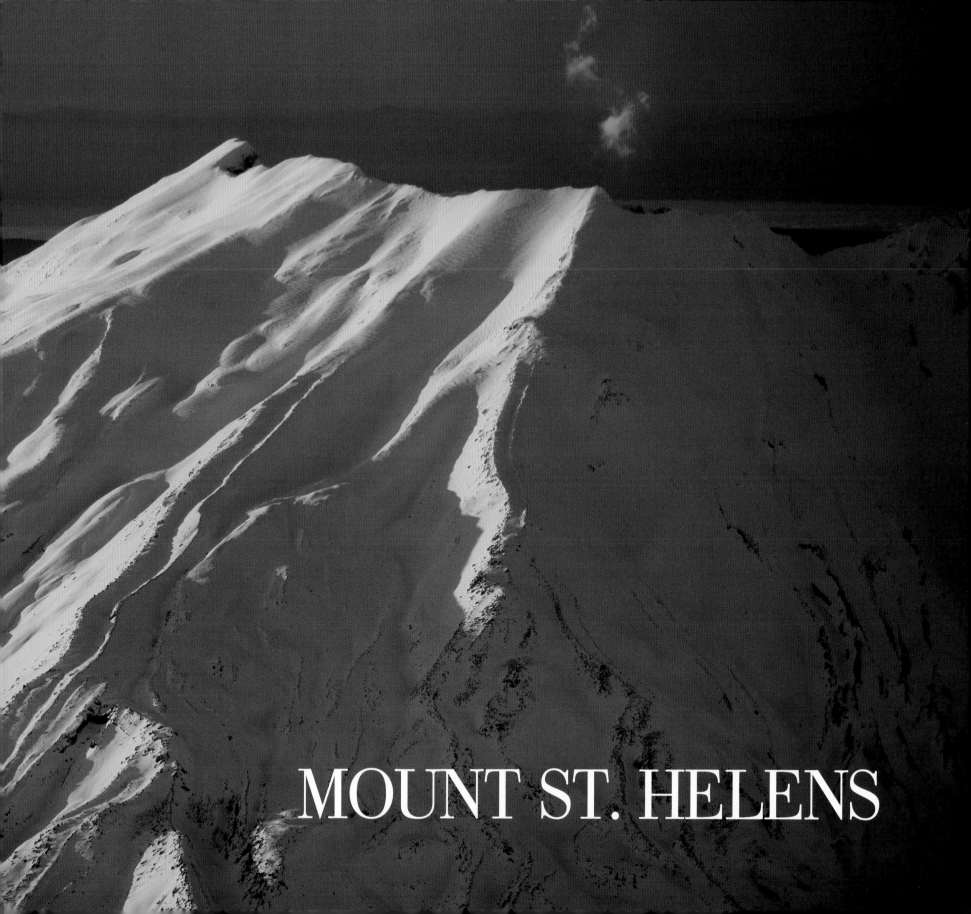

MOUNT ST. HELENS

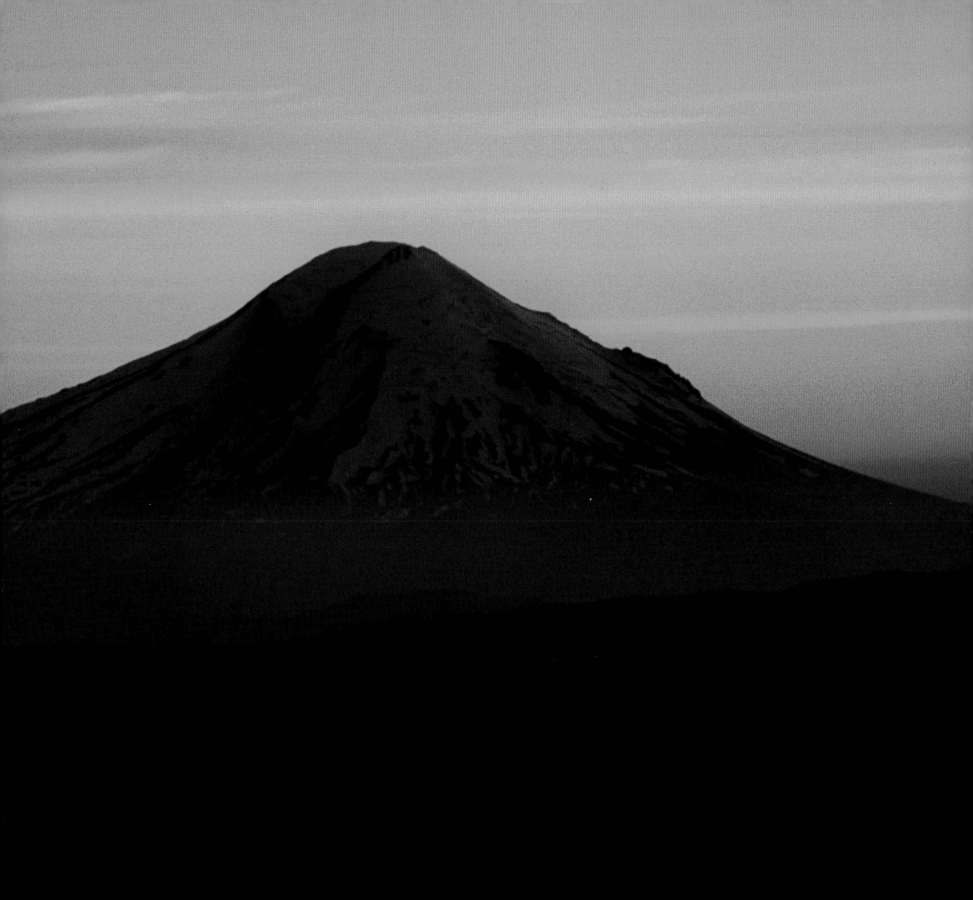

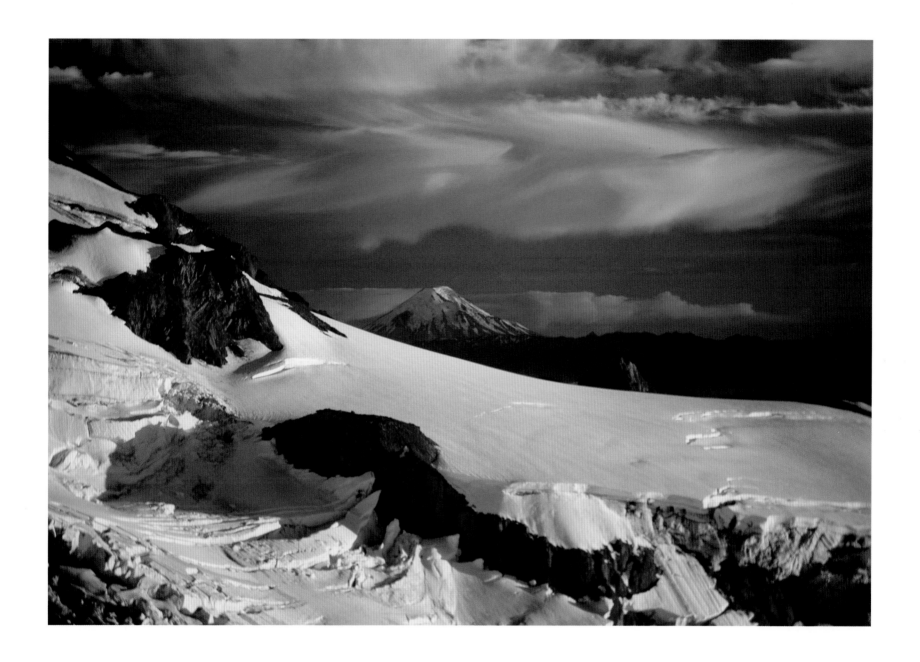

Left: The conical summit of Mount St. Helens before the 1980 blast, viewed from Mount Adams

Above: Pre-eruption Mount St. Helens looms beyond Mount Rainier's Mowich Glacier

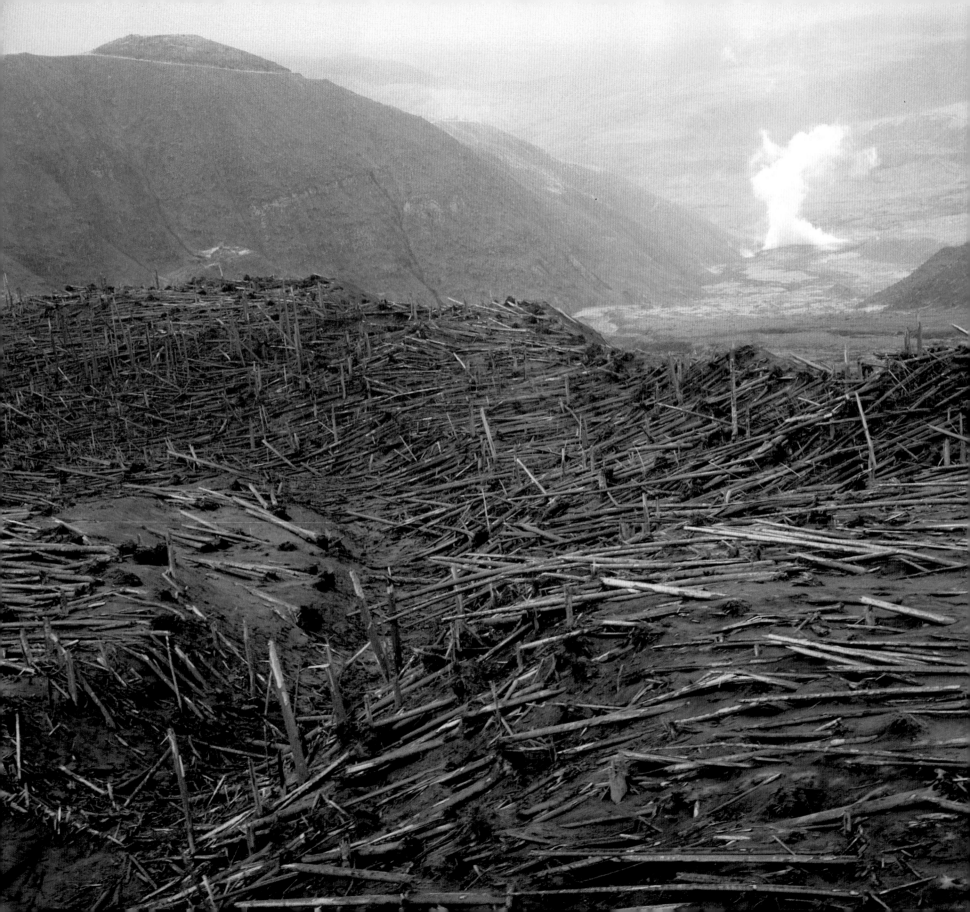

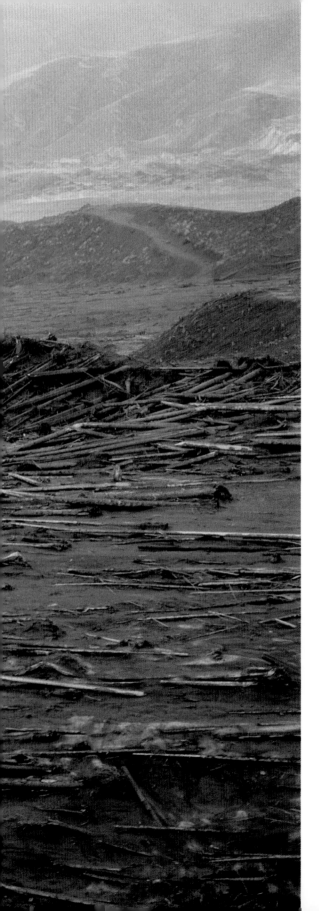

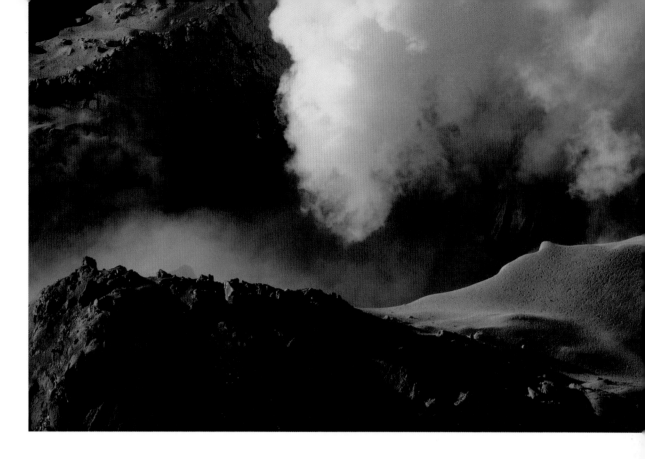

Left: Within 48 hours of the volcano's eruption, large blocks of melting glacier ice created plumes of steam when buried beneath warm volcanic ash; forests (foreground) decimated by the eruption

Above and right: Steam rises above the active crater in the weeks before the 1980 eruption

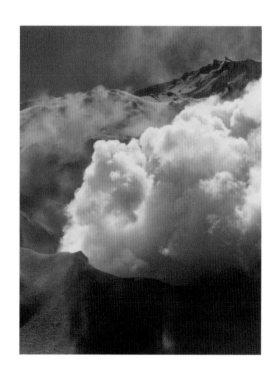

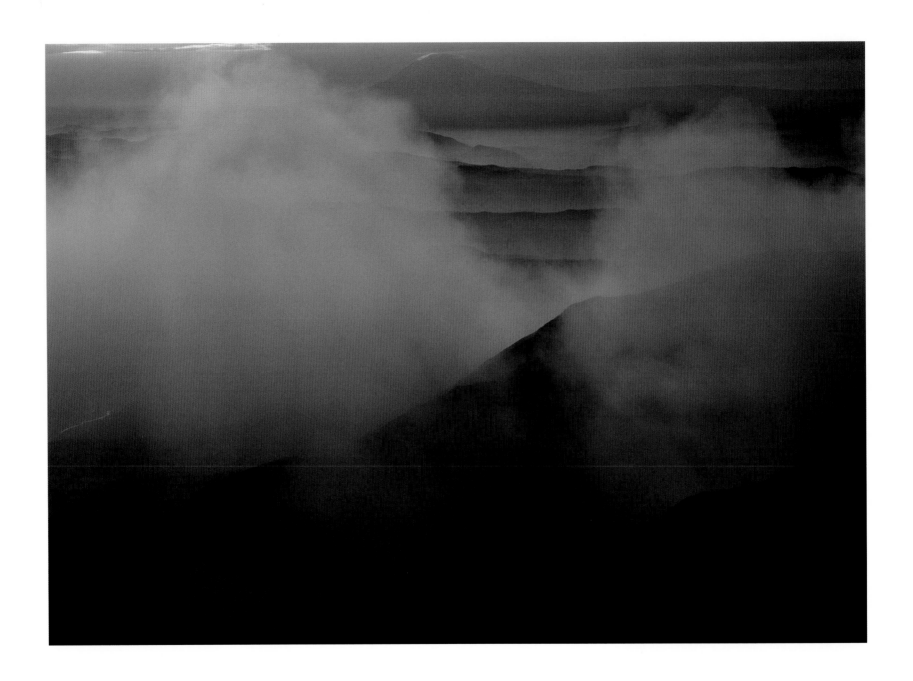

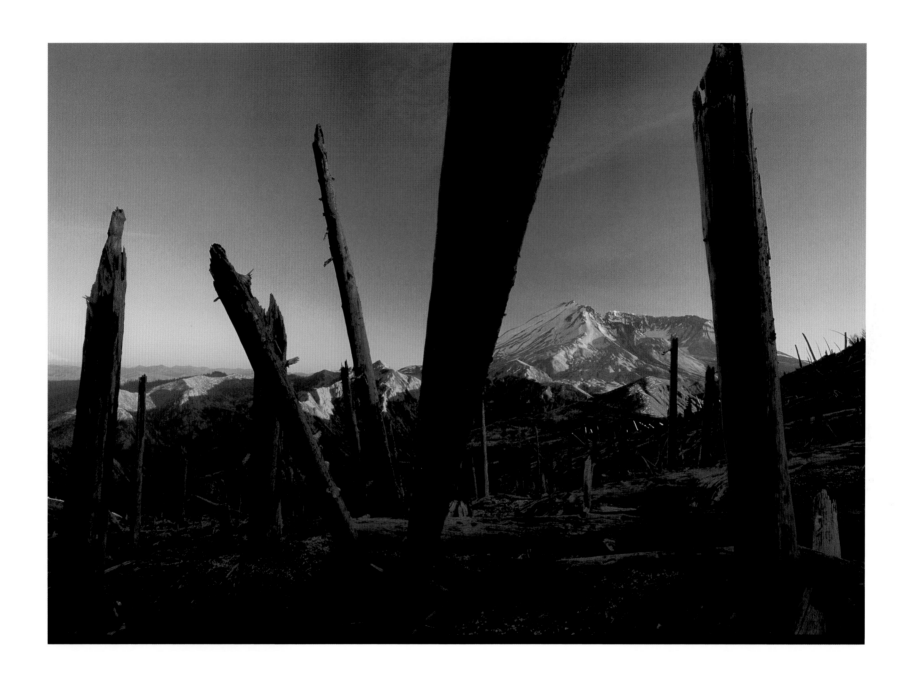

Left: An ash cloud hovers above the crater, with shadowy Mount Adams in the distance

Above: The volcano viewed through trunks of trees toppled by the 1980 eruption

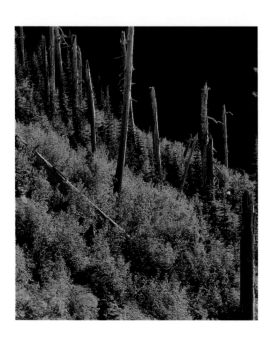

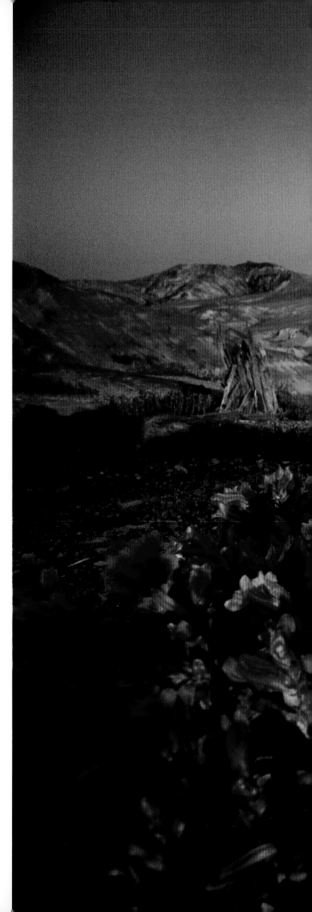

Above: Thousands of tree trunks
float on Spirit Lake

Left: Forest regeneration on the
slopes above Spirit Lake

Right: Penstemon flourish on the open
slopes north of Mount St. Helens

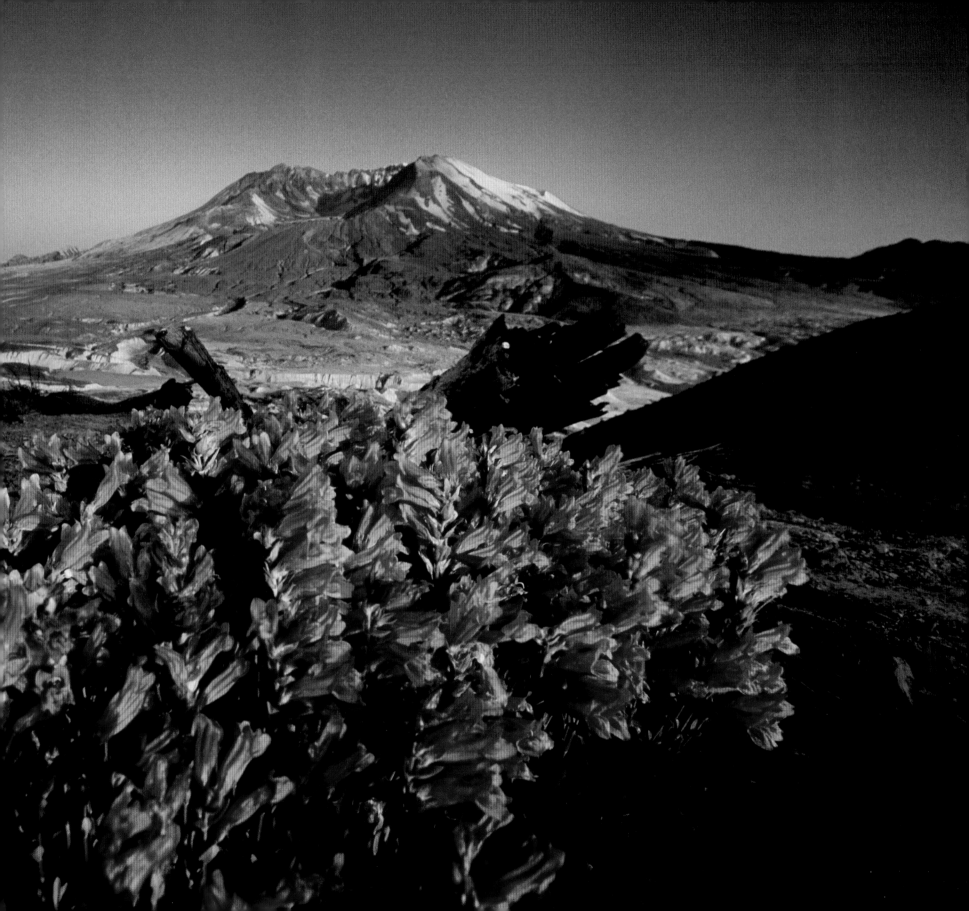

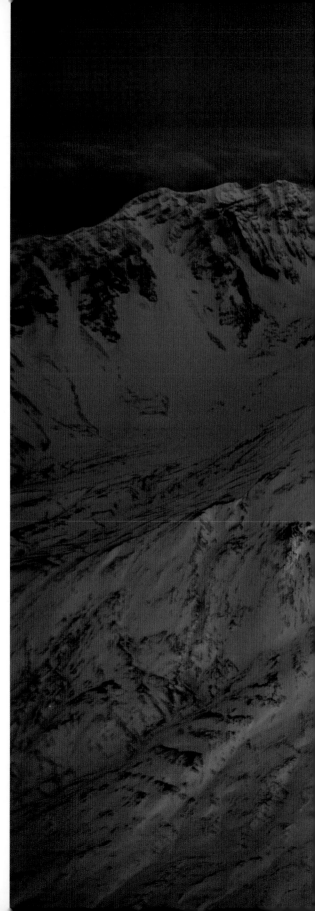

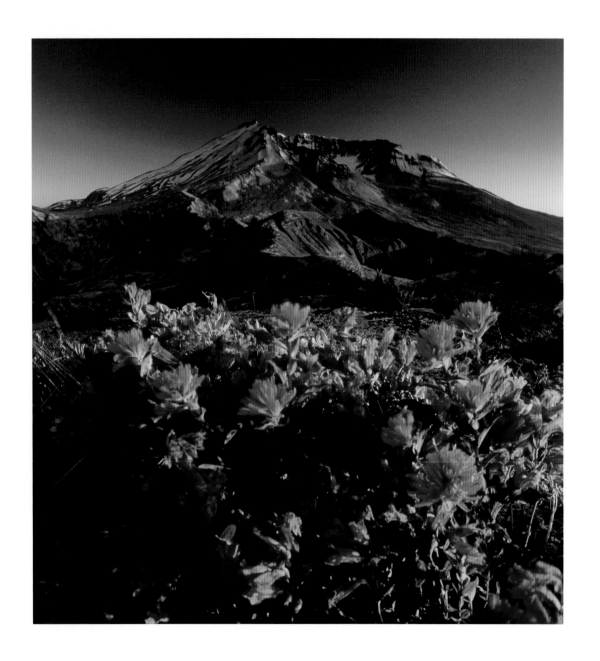

Above: Paintbrush and penstemon bloom where forests once grew

Right: The last light of a winter day illuminates Mount St. Helens's western face; Mount Hood appears on the horizon

Page 28: Forests on the southern and western slopes remained intact during the eruption

Page 29: Steam rises above the crater dome; Mount Hood is visible in the distance

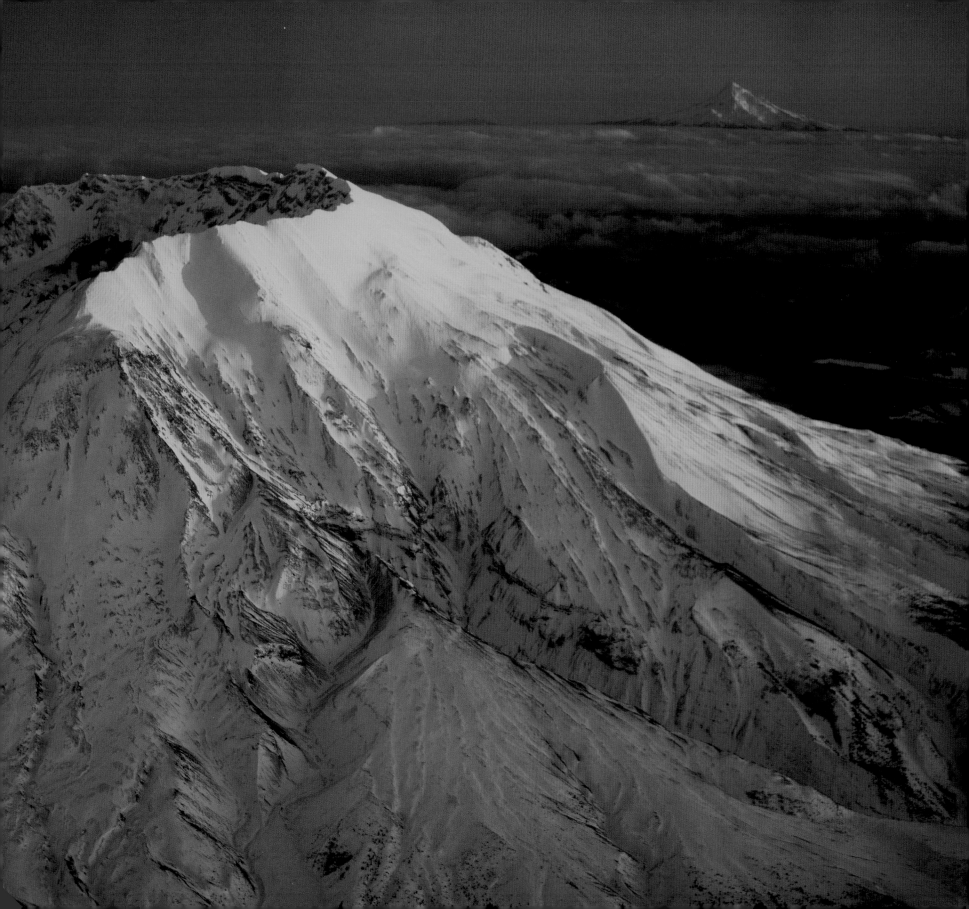

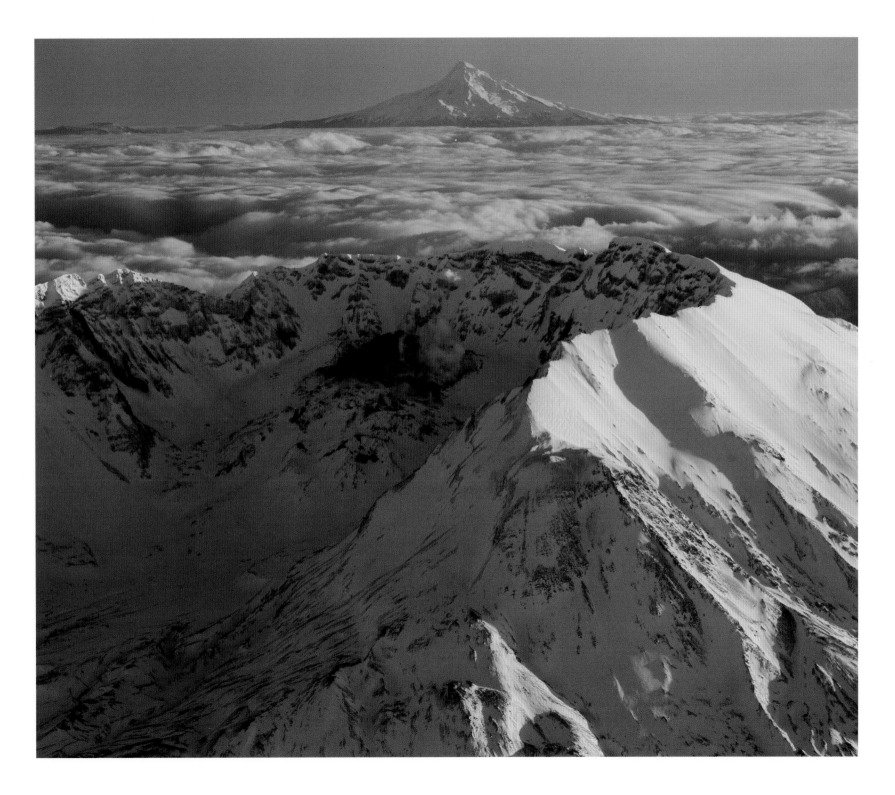

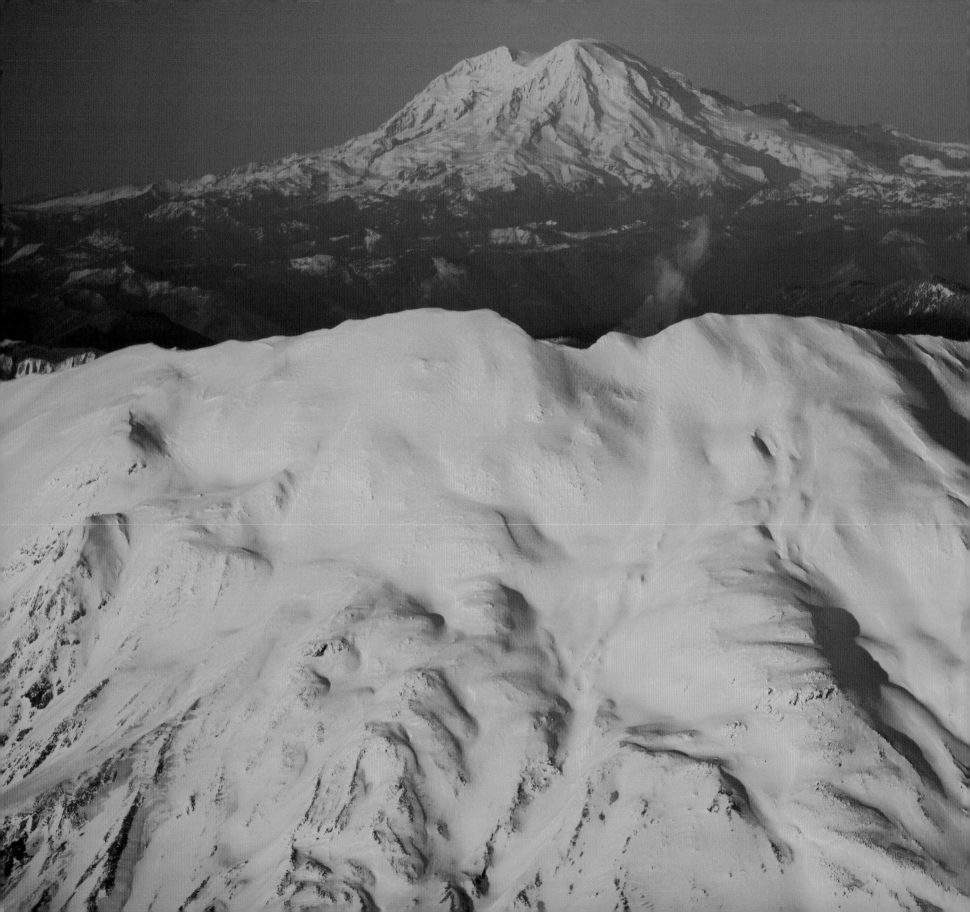

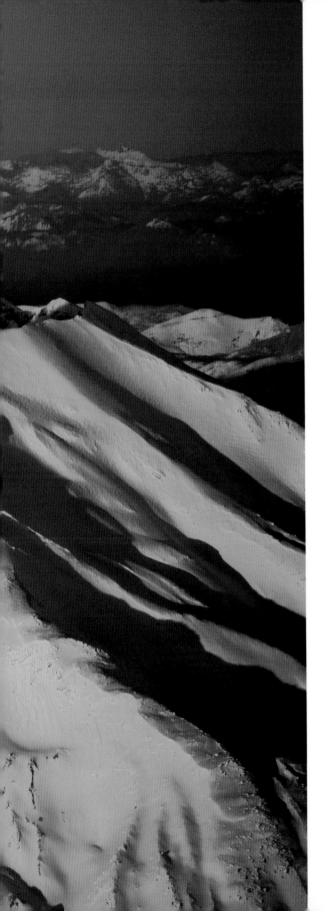

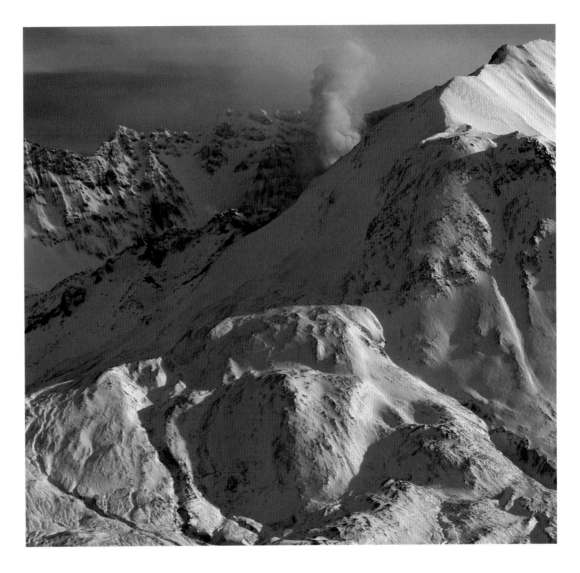

Left: A plume of ash rises above Mount St. Helens; Mount Rainier dominates the horizon

Above: An ash plume escapes from the crater

Page 32: Gifford Pinchot National Forest, immediately south of Mount St. Helens; Mount Hood appears above the clouds

Page 33: The snow-covered crater in the foreground, with Mount Adams in the distance

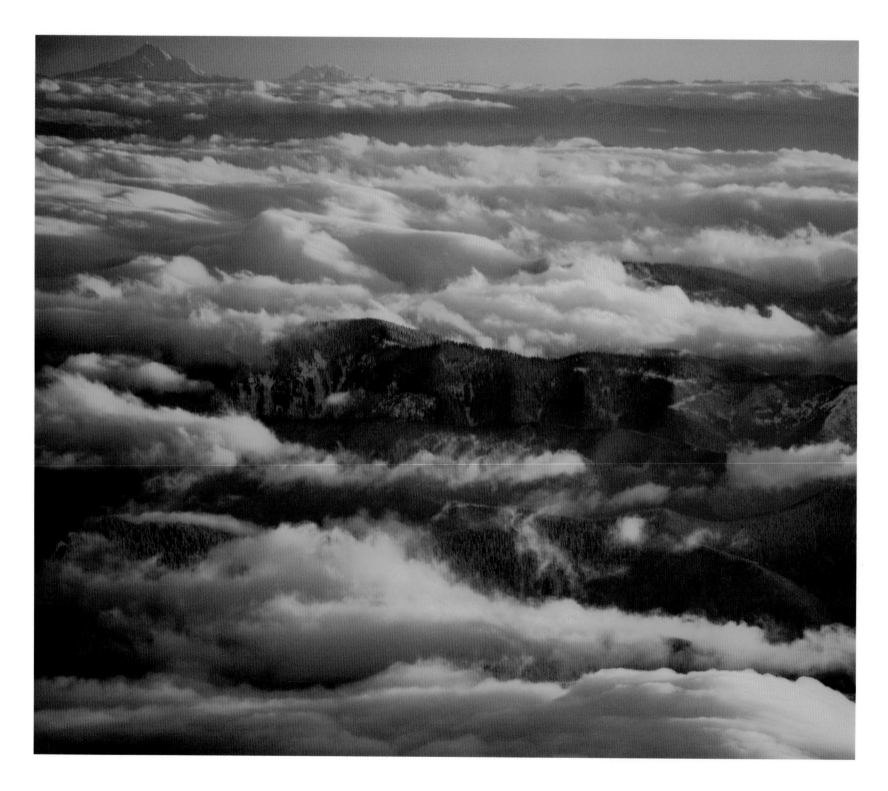

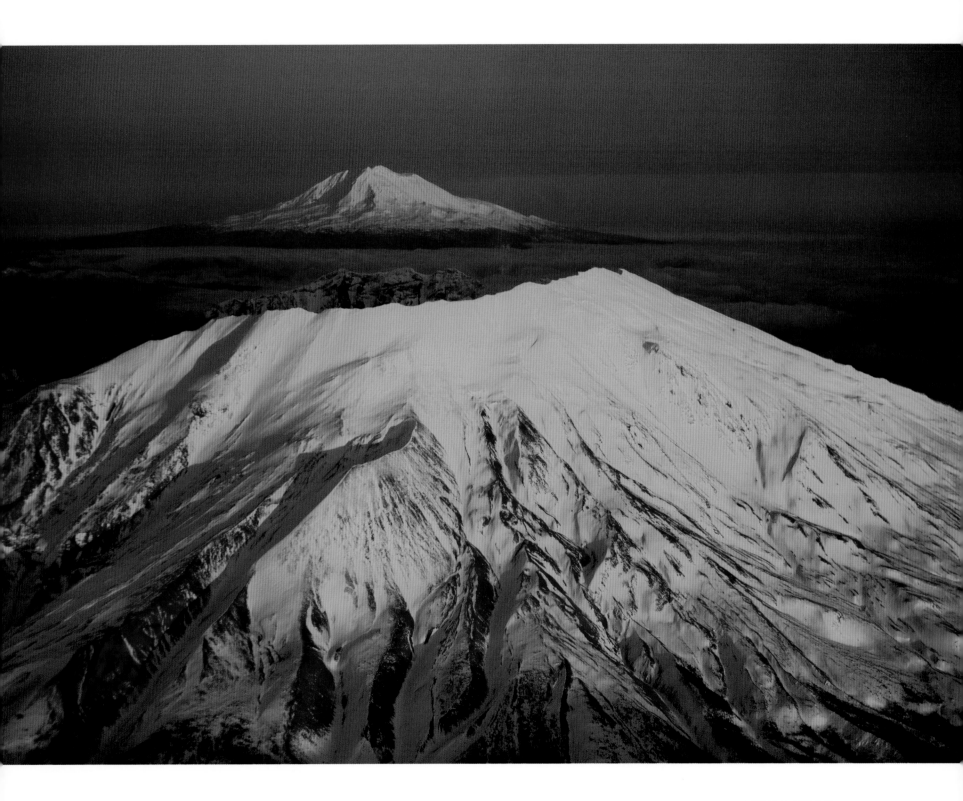

VIEWPOINTS

12,276: Elevation, in feet

46° 12' N; 121° 29' W: Latitude/longitude of summit

75: Approximate distance, in miles, from Portland, Oregon

5,000 to 7,500: Vertical feet that the elongated cone of Adams rises above surrounding highlands

12: Number of named glaciers—one of which, the Adams Glacier, flows three horizontal miles and one vertical mile from the summit down to 7,000 feet

500: Area, in square miles, covered by volcanic material from past eruptions

4: Number of rivers receiving meltwater from Adams's glaciers— the Cispus, Lewis, White Salmon, and Klickitat

Late summer, 1854: First officially recognized summit climb, probably by A. G. Aiken, Edward J. Allen, and Andrew Burge via the north ridge

Pah-to: Native American name for Adams, meaning "son of the Great Spirit"

1921: Year that a lookout cabin was built on the summit; it was staffed for several years

168: Number of pack trains that reached the summit sulphur mine in 1931, at the height of its operation, which continued until 1937

47,720: Area, in acres, of the Mount Adams Wilderness within the Gifford Pinchot National Forest (of which Mount Adams comprises about half the acreage)

Right: The southern slopes of Mount Adams, flanked by Mount Rainier

Page 36: Mount Adams at sunrise

Page 37: Southwestern slopes of Mount Adams with the Aiken Lava Bed in the foreground; also visible are Mount Rainier (left) and the Goat Rocks Wilderness (upper right)

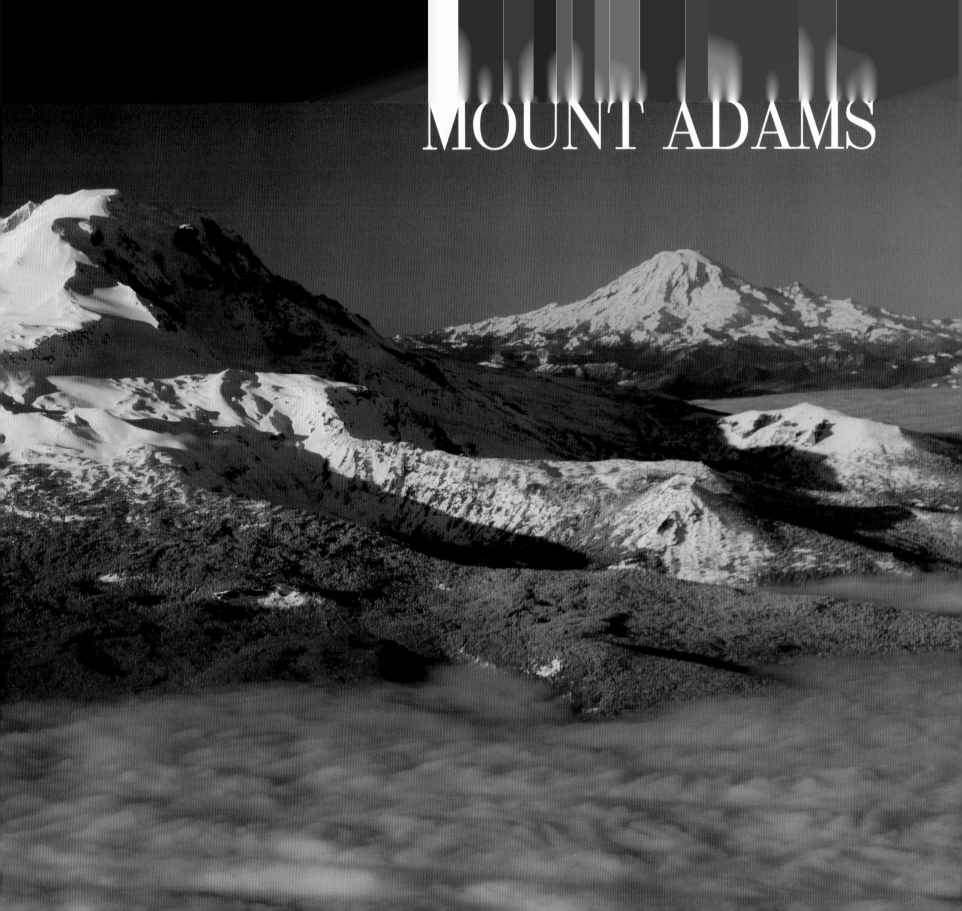

MOUNT ADAMS

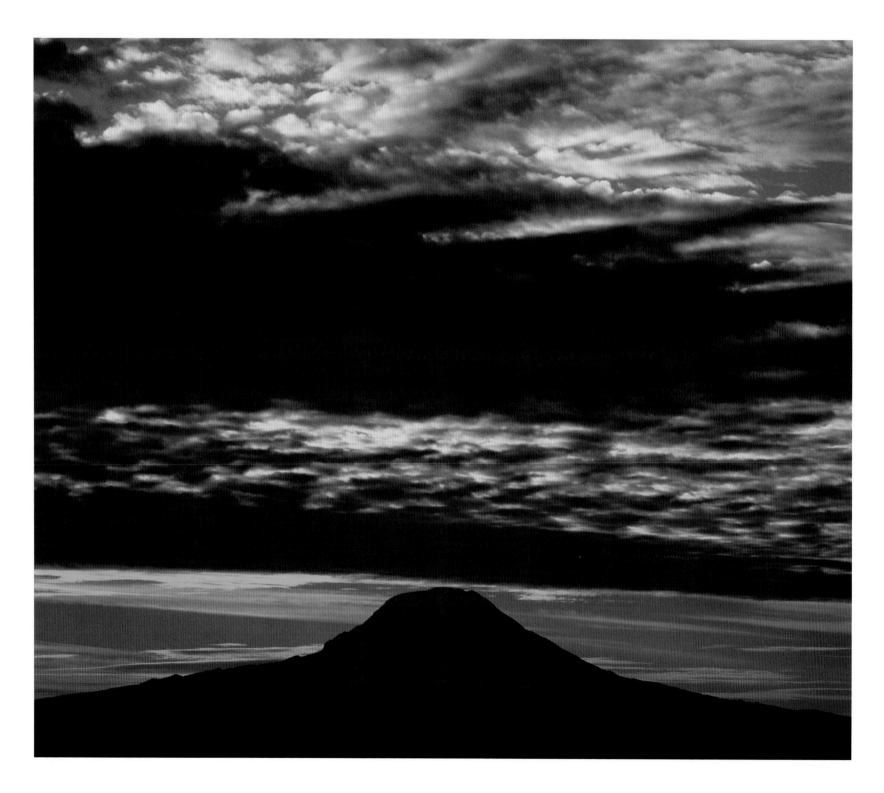

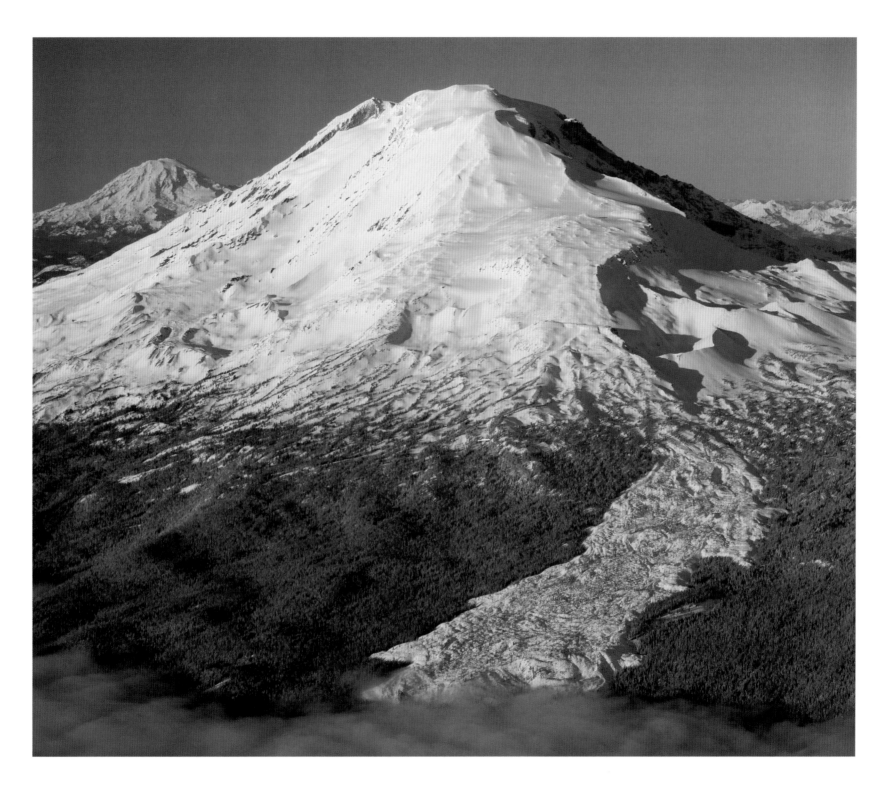

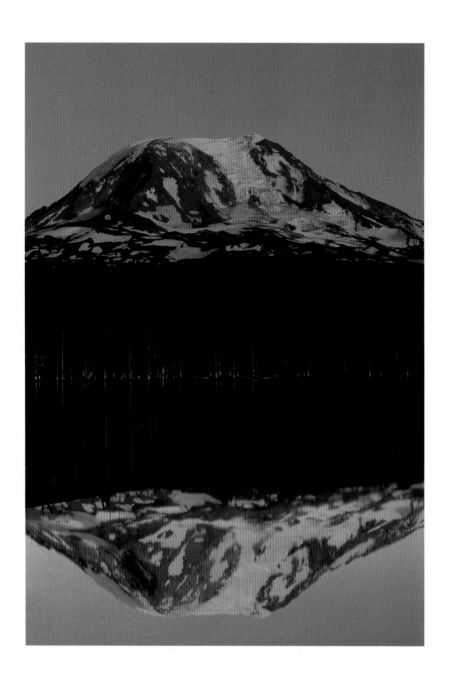

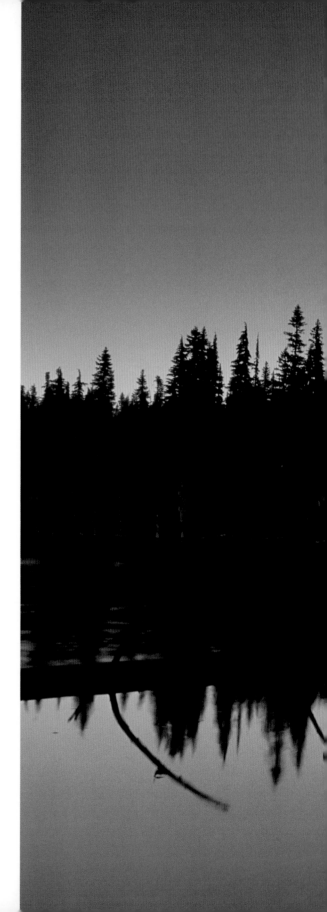

Above and right: The peak's northern slopes at sunset, from Horseshoe Lake

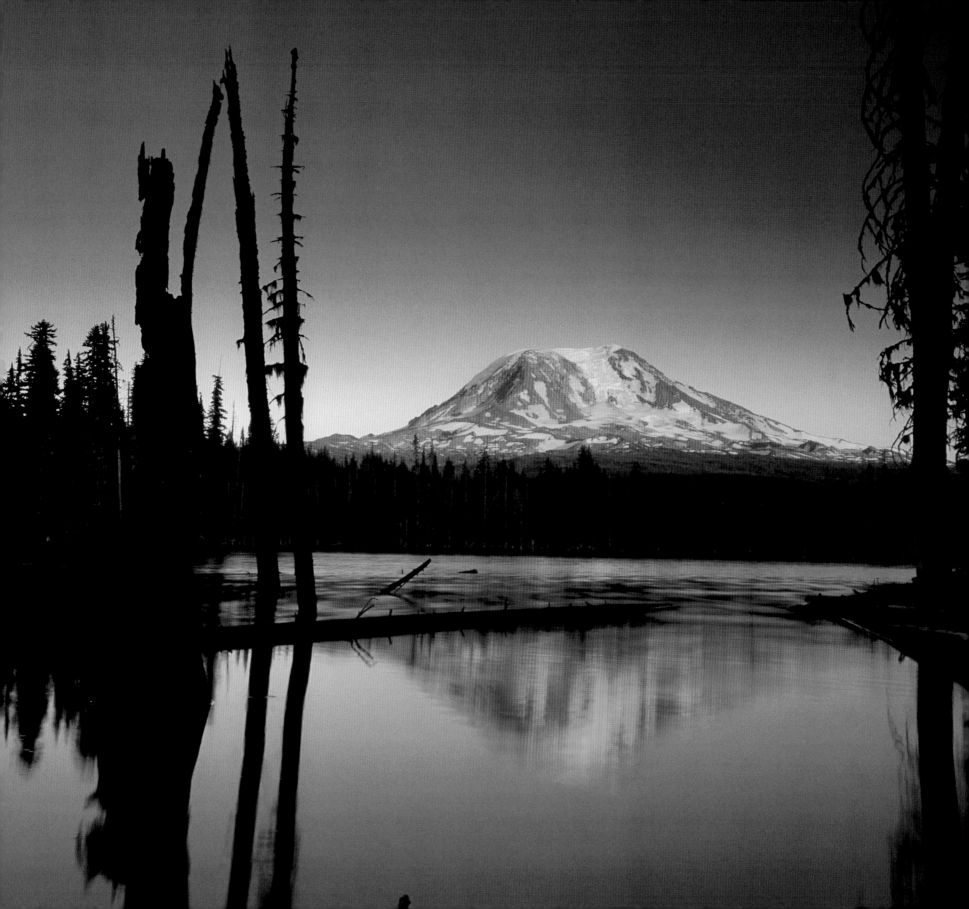

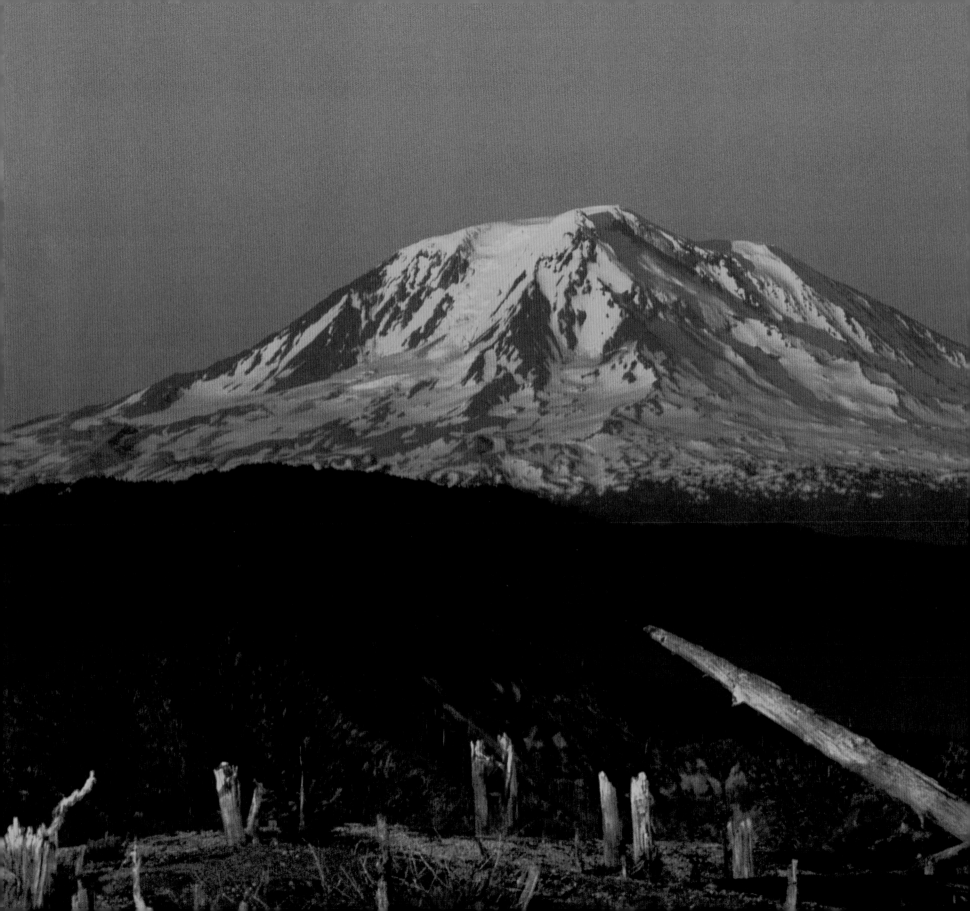

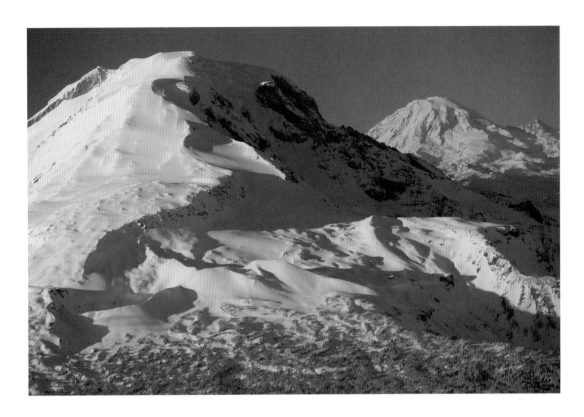

Left: Mount Adams viewed from Windy
Ridge above Spirit Lake

Above: Mount Adams and Mount Rainier

Page 42: Mount Adams, seen from
Nisqually Glacier on Mount Rainier

Page 43: Adams Glacier, with distinctive
Mount Hood in the background

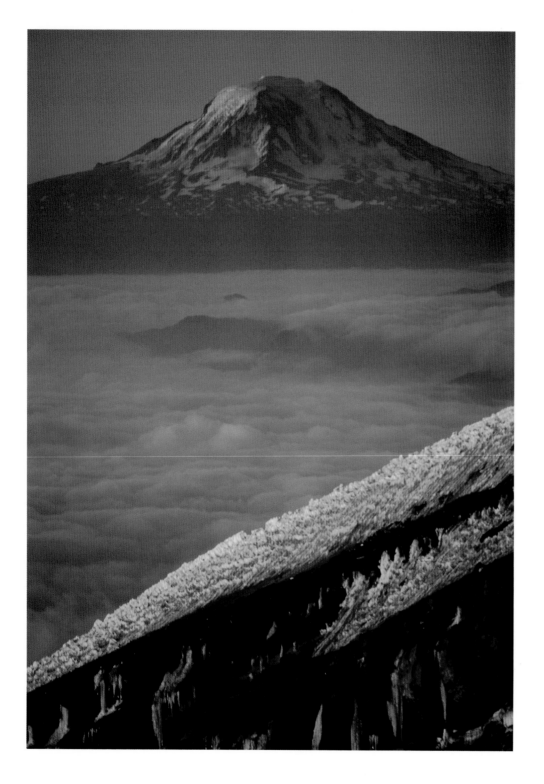

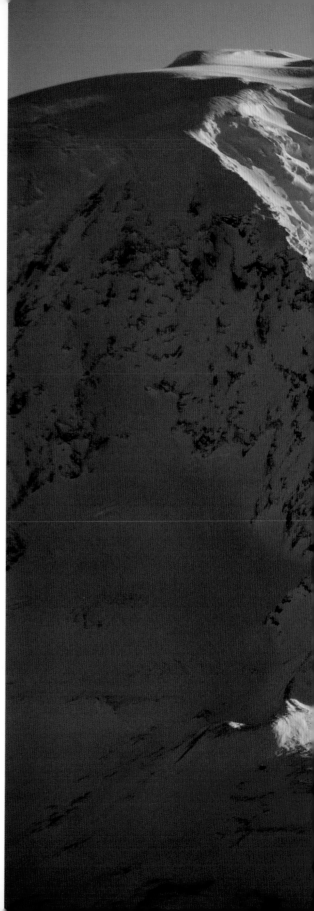

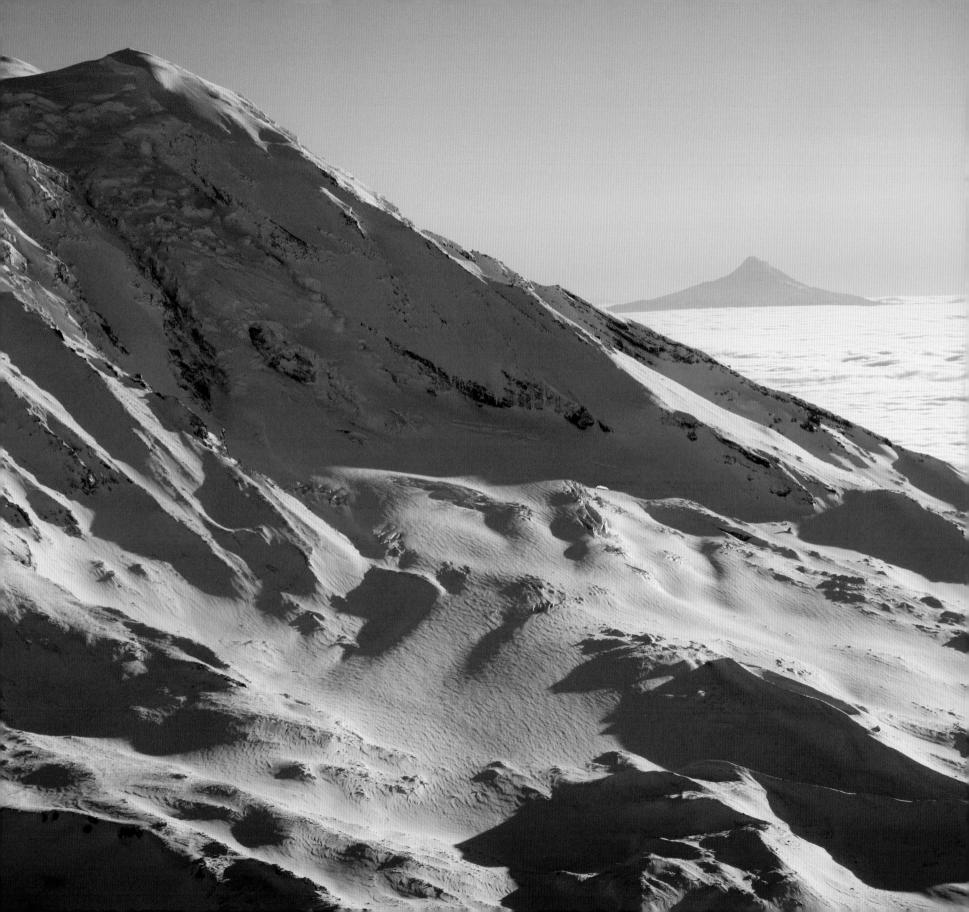

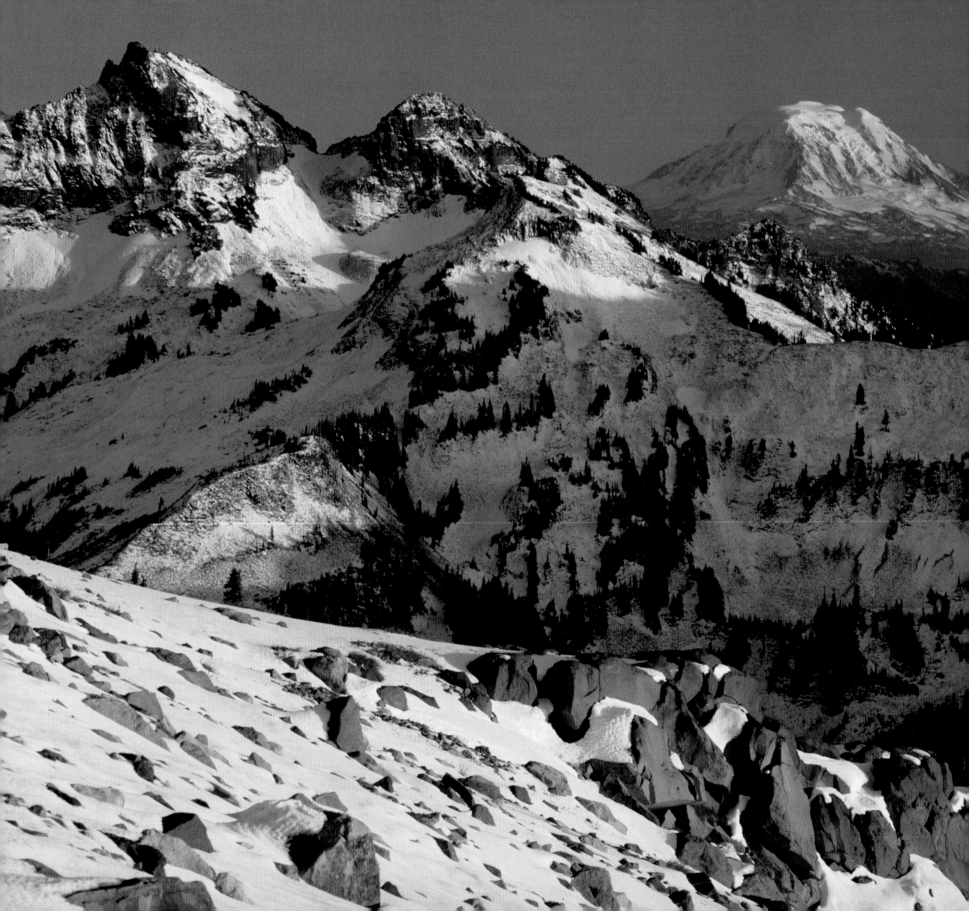

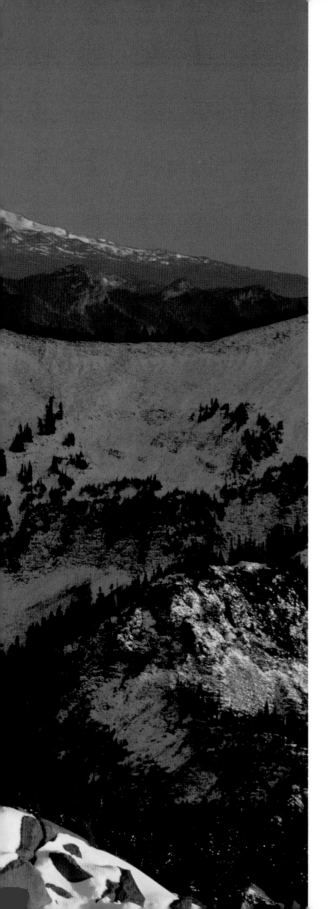

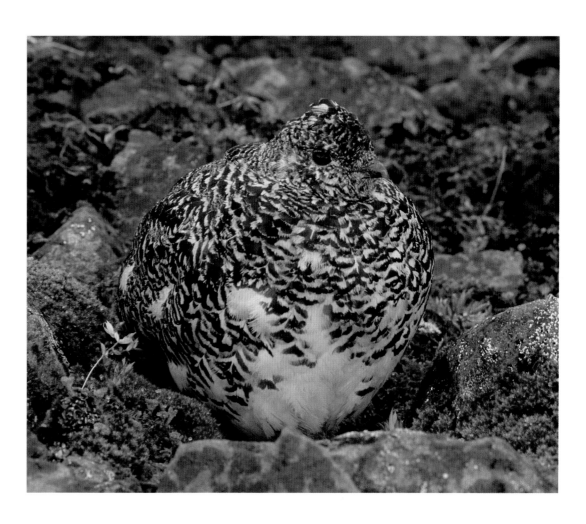

Left: Mount Adams from Alpine Lakes Wilderness Area

Above: White-tailed ptarmigan

VIEWPOINTS

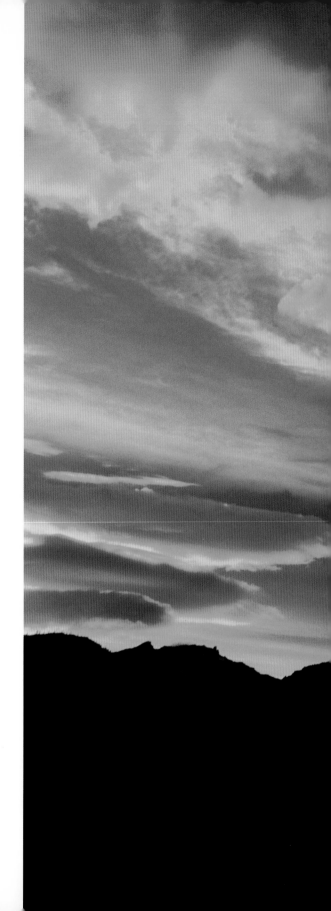

14,411.1: Official elevation, in feet, calculated by GPS triangulation

14,444: Elevation, in feet, calculated by scientists in 1870 by dipping a thermometer at the summit in boiling water

9,011: Vertical feet a climber ascends to reach the summit

46° 51′ N; 121° 46′ W: Latitude/longitude of summit

50: Miles from Seattle

150: Distance, in miles, from which Rainier is visible on a clear day

August 17, 1870: First confirmed ascent, by Hazard Stevens and Philemon B. Van Trump, who spent a night near the summit in a cavern under the ice, which they saw spewing steam

11: Number of climbers who died in a 1981 accident on Rainier, the worst mountaineering accident in North American history

25: Number of named glaciers, including the largest (Emmons, 4.3 square miles) and the lowest (Carbon, its terminus at 3,500 feet), in the contiguous United States

35: Area, in square miles, of glaciated terrain on Rainier, the largest glacier system found on any single peak in the contiguous United States

23: Number of years of potential water supply for Seattle locked up in Rainier's glaciers

1,000 to 2,300: Number of years since Rainier's last major eruption

1894: Last time Rainier spurted a light dusting of ash in a minor eruption

1: Rank of Rainier among Cascades volcanoes in terms of potential hazard from eruptions and lahars (mudflows)

235,625: Area, in acres, of Mount Rainier National Park

57: Average annual snowfall, in feet, in the Paradise area of Mount Rainier National Park

1792: Year in which Captain George Vancouver saw and named the mountain after his friend, British Royal Navy Rear Admiral Peter Rainier, who played an active role in the war against the American colonies

Tahoma, Tah-ko-bah, Ta-ko-bet: Names by which local Indian tribes knew Rainier

1890: Year that the U.S. Board of Geographic Names chose the name Mount Rainier for all government maps and publications

Right: Mount Rainier viewed from the southeast

Next page: The peak as seen from the west, with vivid mountain ash in the foreground

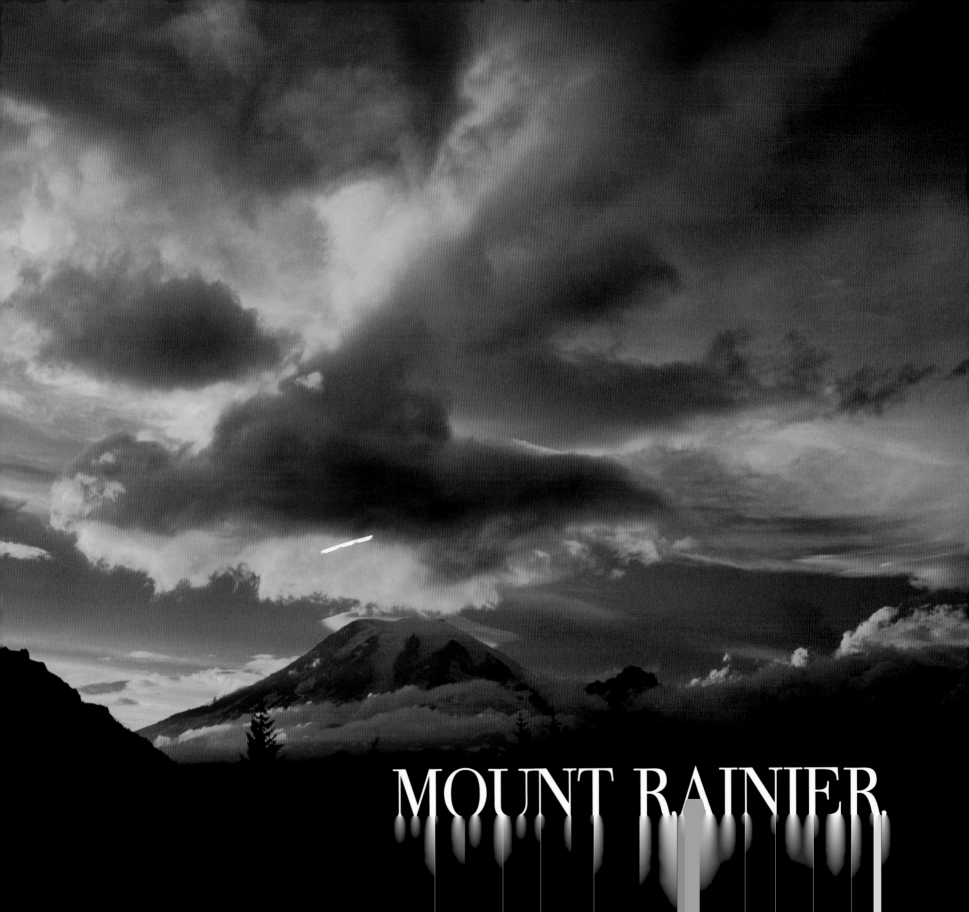

MOUNT RAINIER.

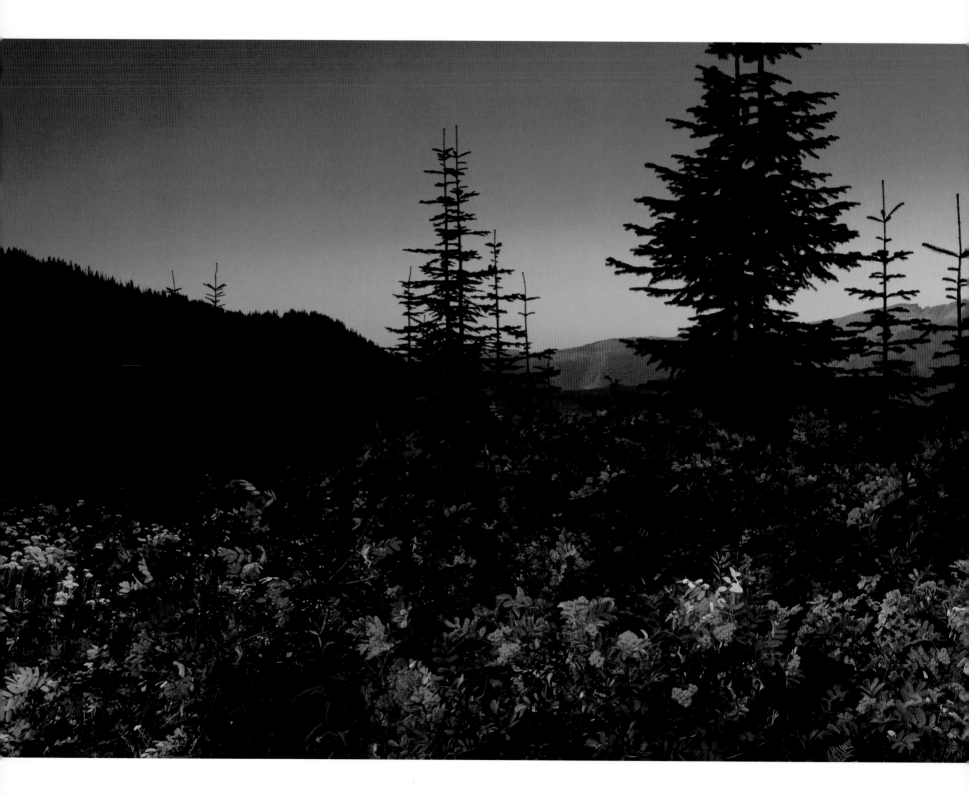

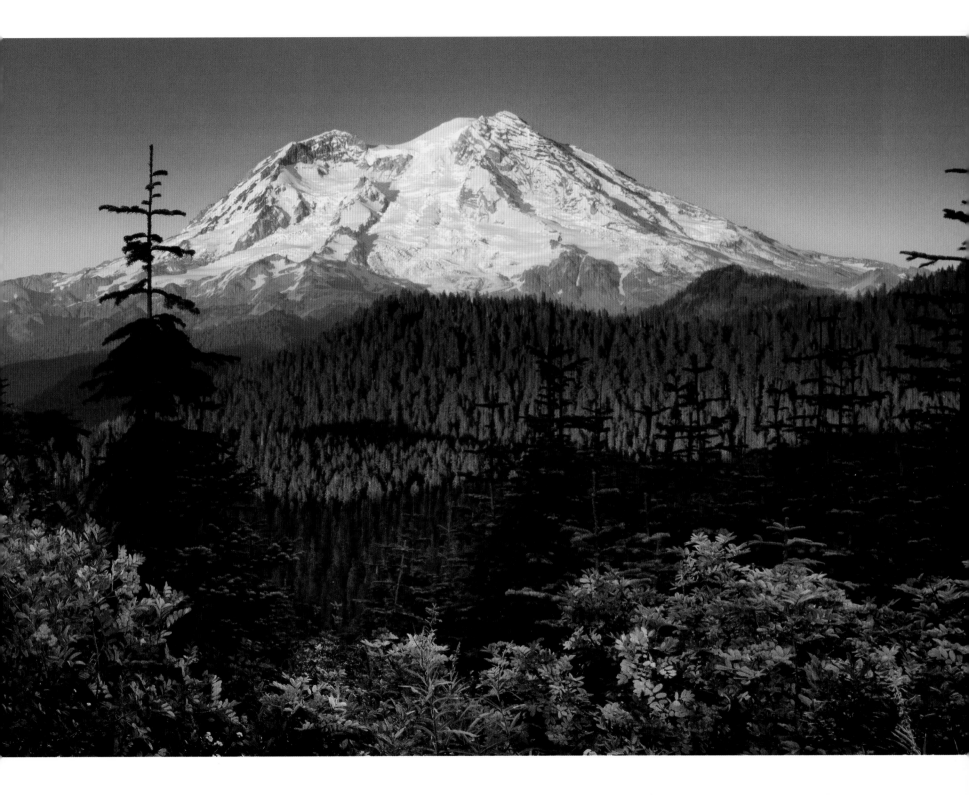

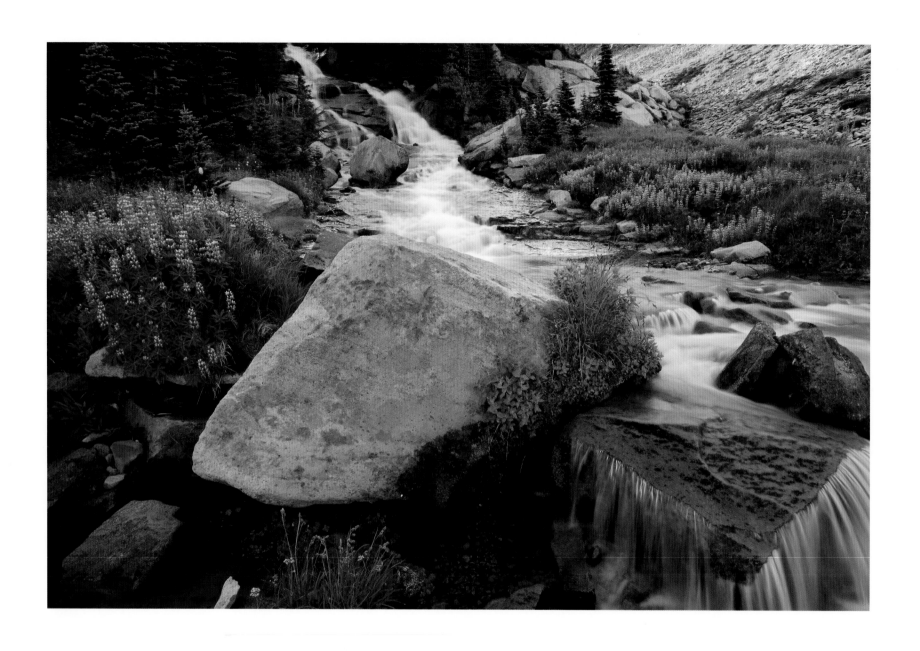

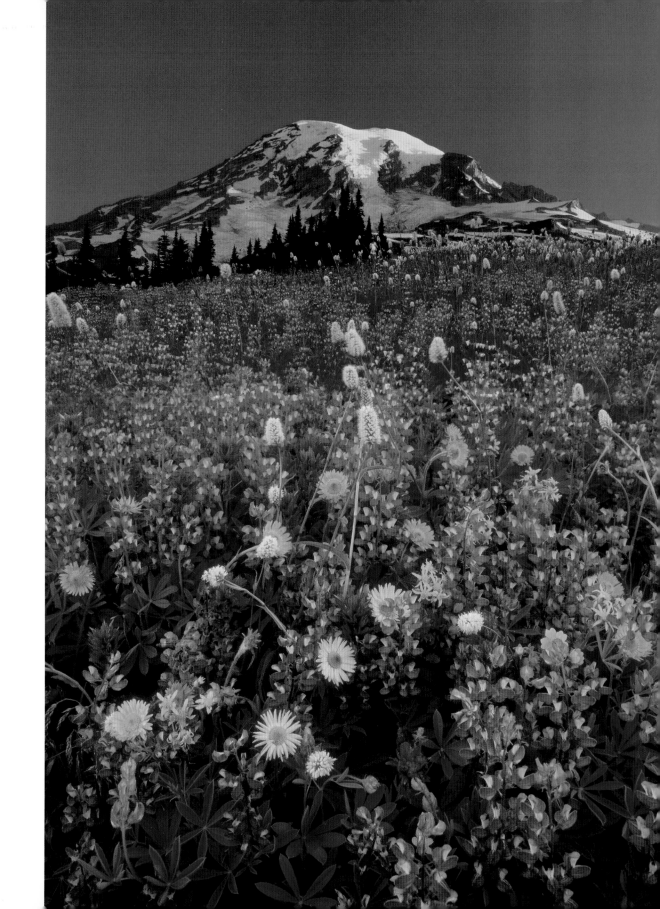

Left: Spray Creek flowing through
Mount Rainier National Park

Right: Wildflowers flourish in the
meadows of Mazama Ridge in
Mount Rainier National Park

Left: Monkeyflowers in bloom along Paradise Creek, Mount Rainier National Park

Right: Paintbrush, tiger lilies, and buttercups carpet the meadows north of Mount Rainier

Page 54: Monkeyflowers along Paradise Creek

Page 55: Mountain goat and kid cross Paradise Creek

Page 56: Sunset Amphitheater rises above the Puyallup Glacier (left), while the Tacoma Glacier (center) reaches to the summit crater

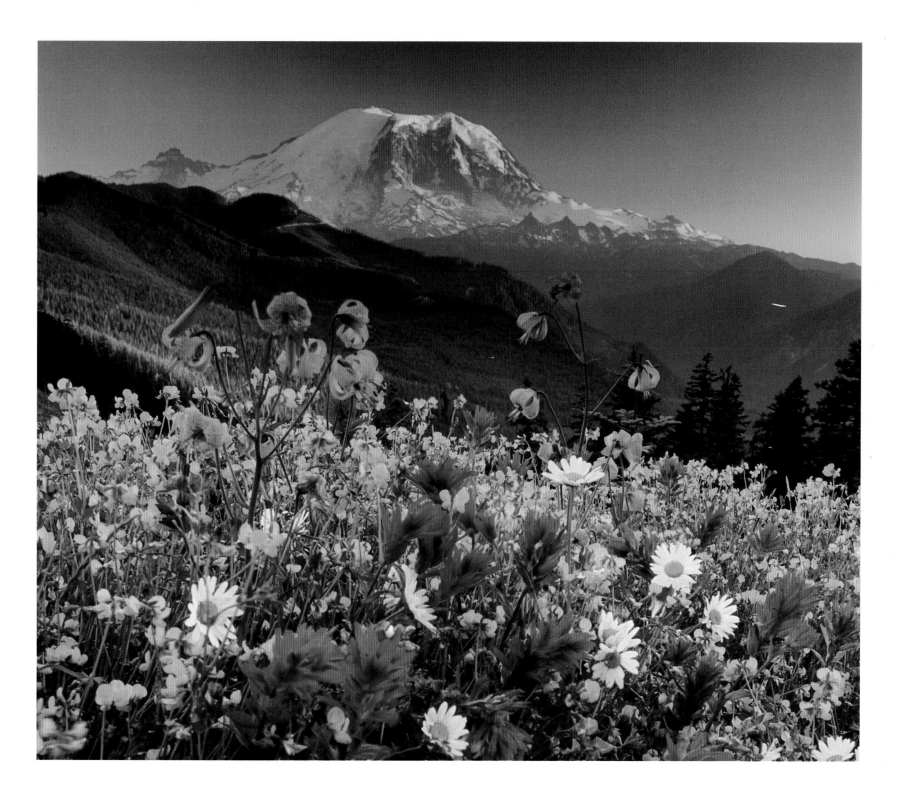

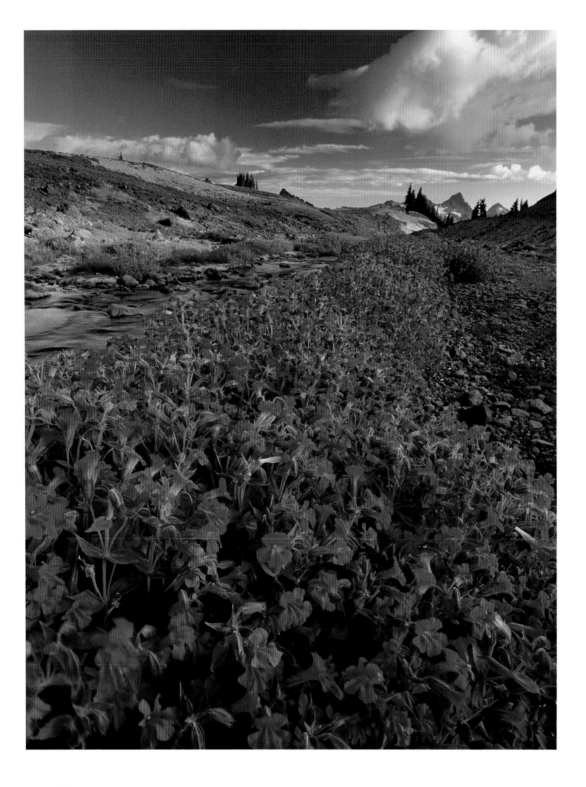

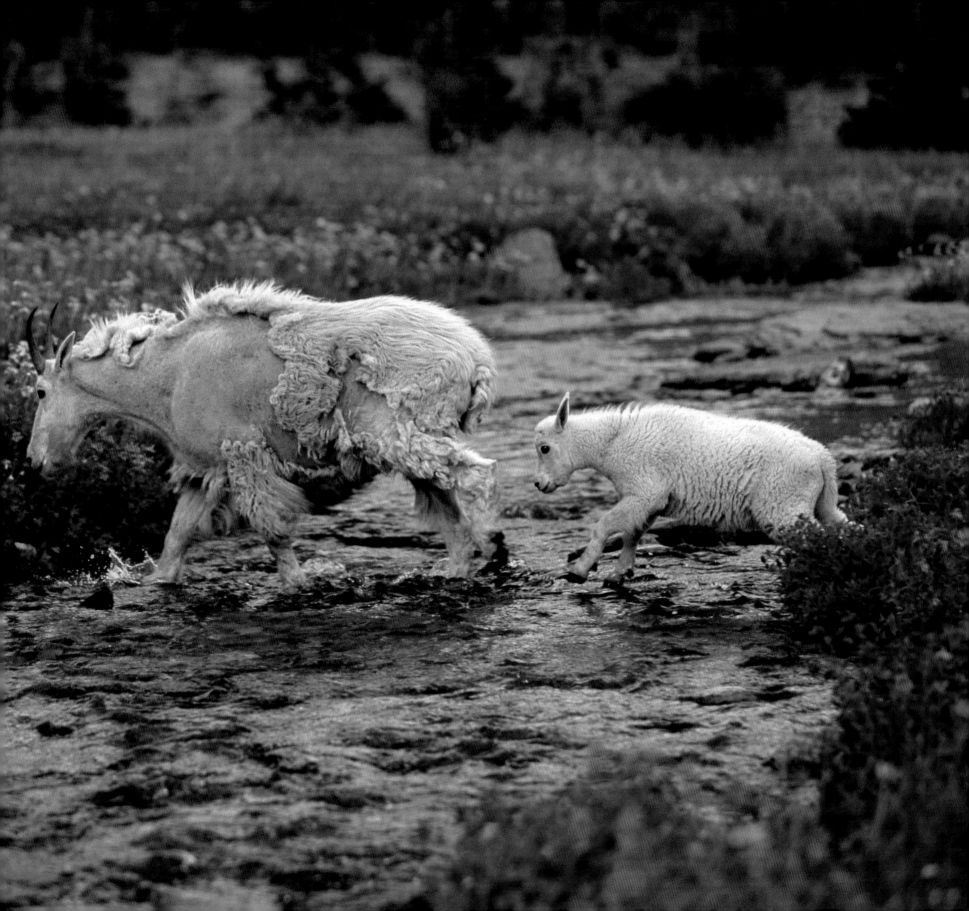

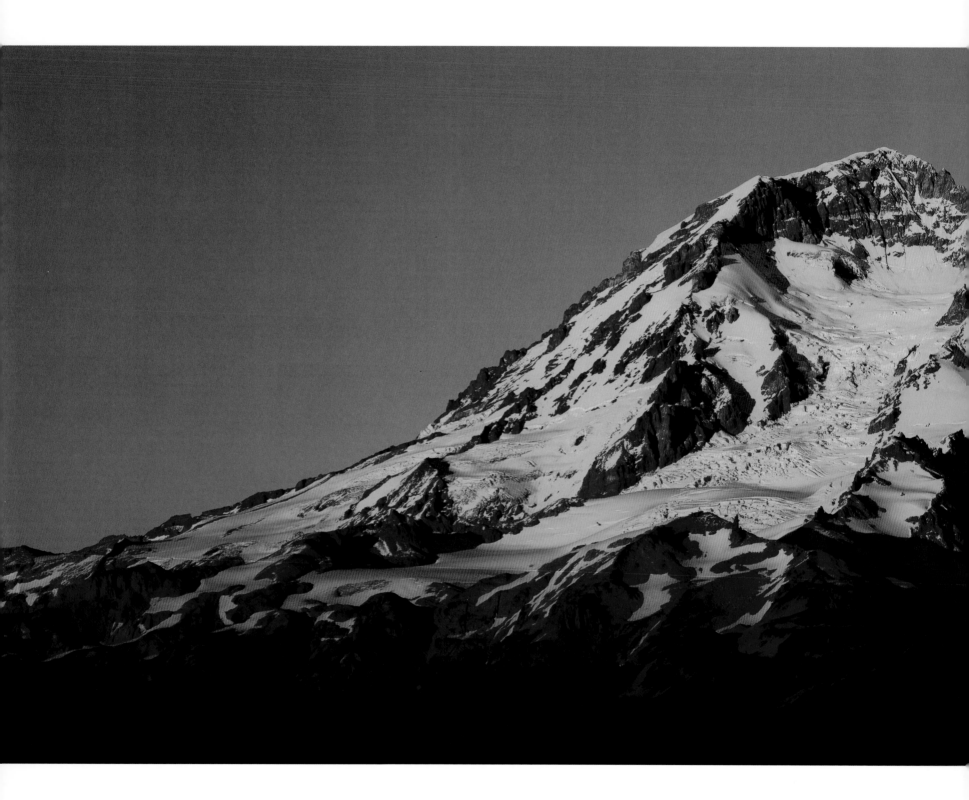

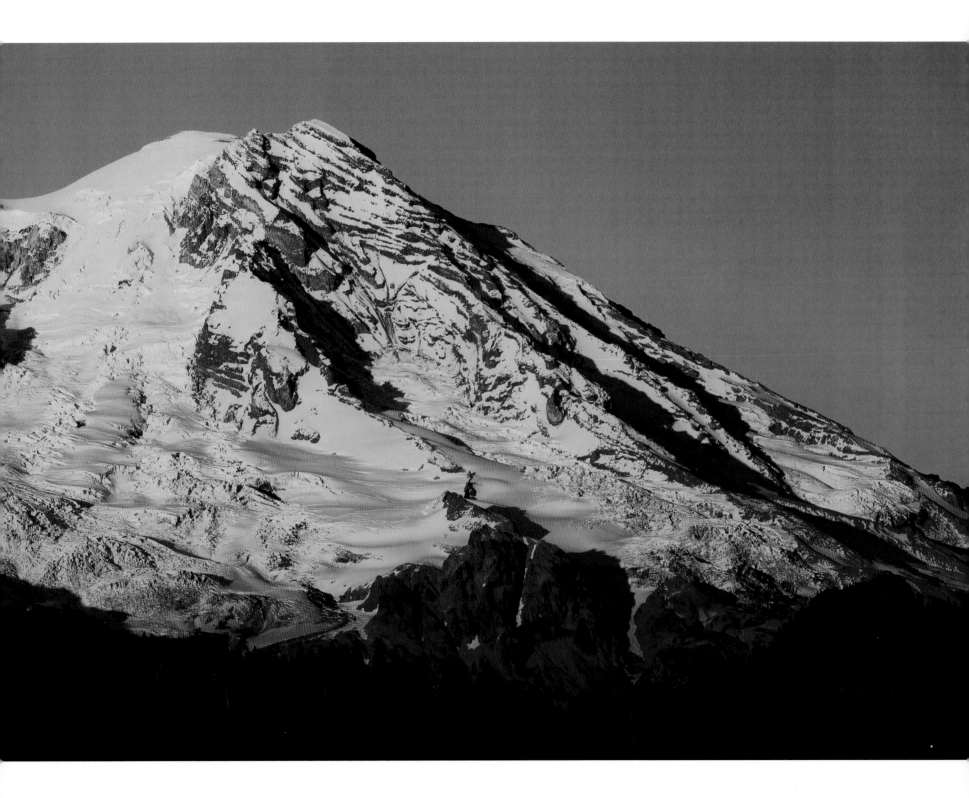

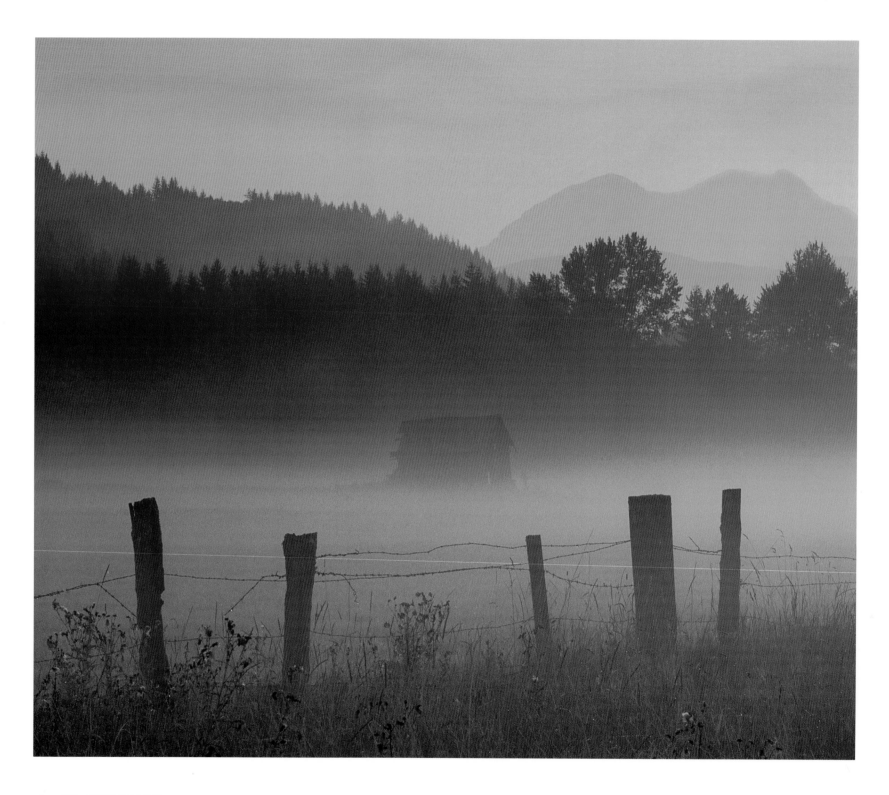

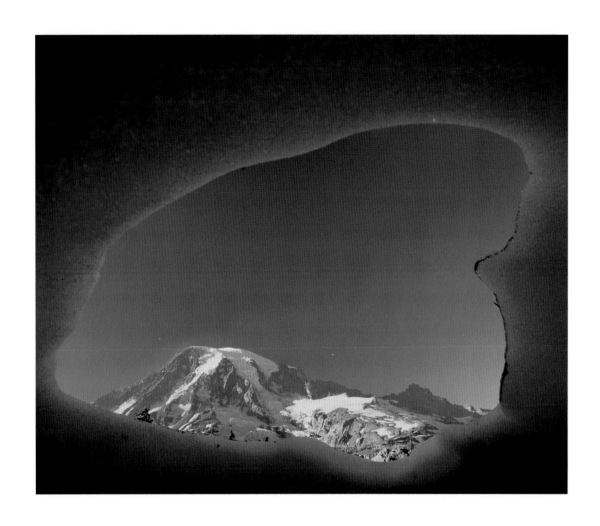

Left: Ethereal Mount Rainier beyond the misty Nisqually Valley near Ashford, Washington

Right: The peak framed within a late-summer snow patch on Plummer Peak, Mount Rainier National Park

Next page: Old-growth forest near the Grove of the Patriarchs, Cedar Flats in Mount Rainier National Park

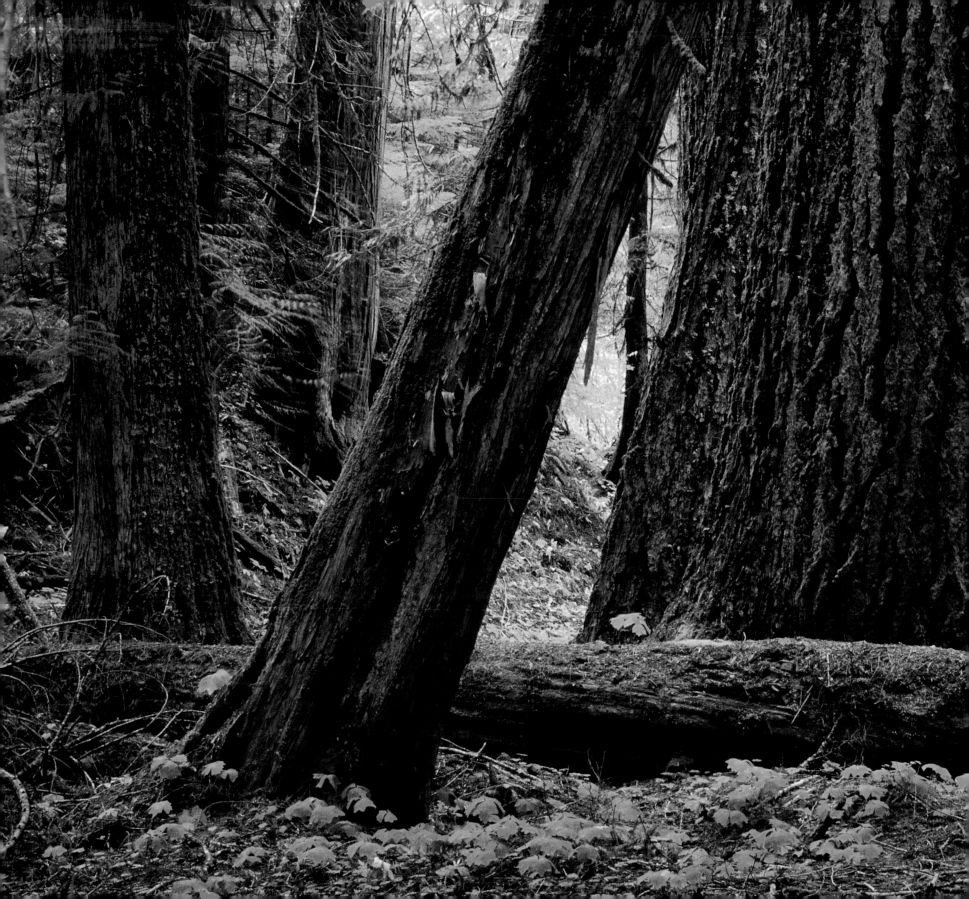

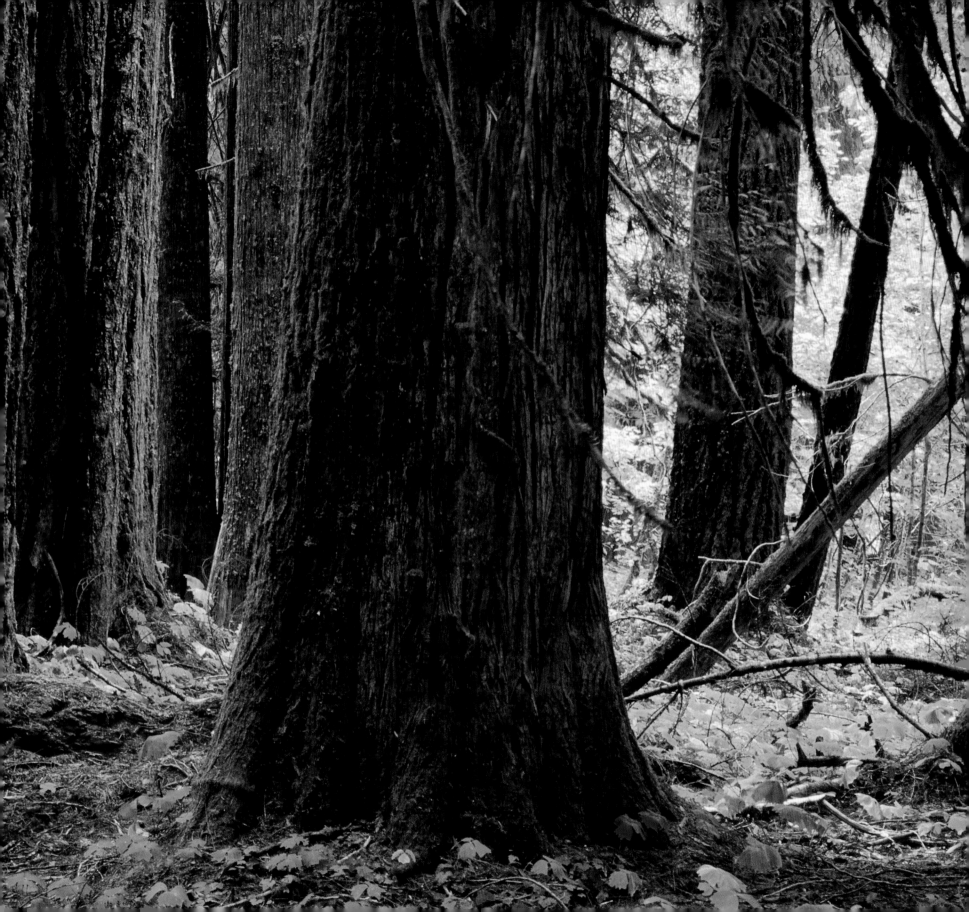

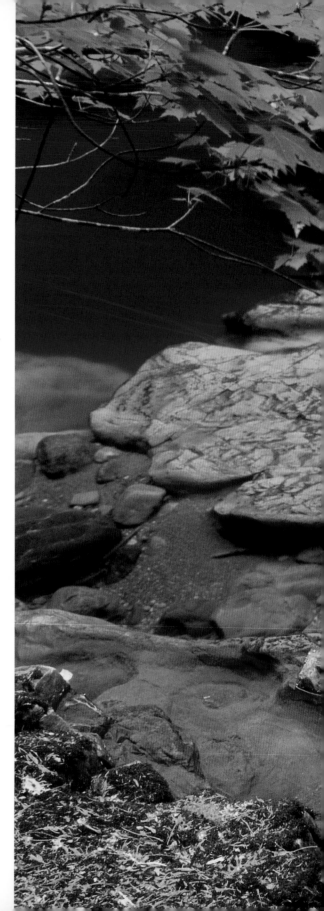

Above: Old-growth forest, Cedar Flats

Right: Chinook Creek, Mount Rainier National Park

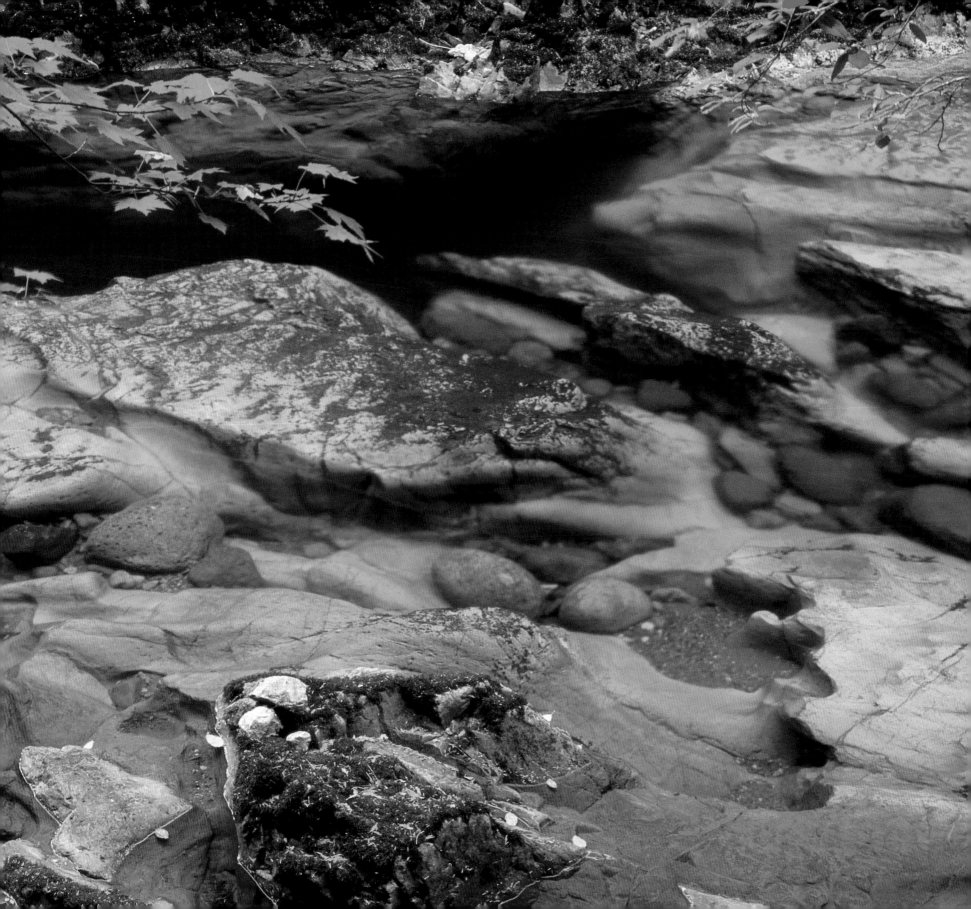

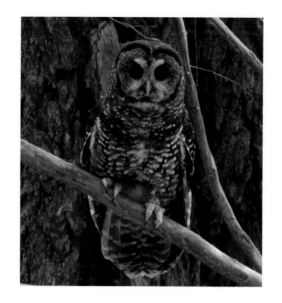

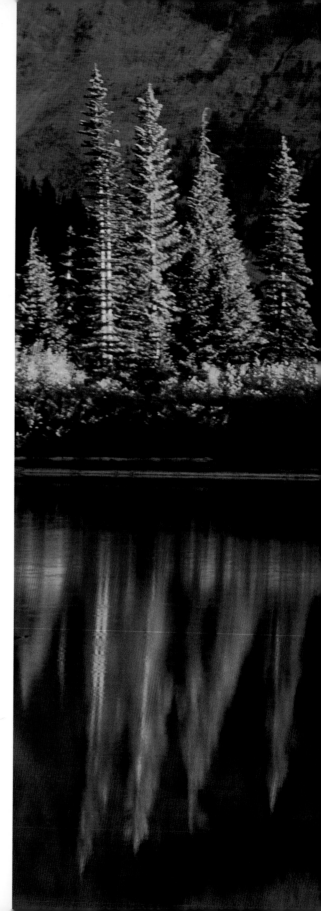

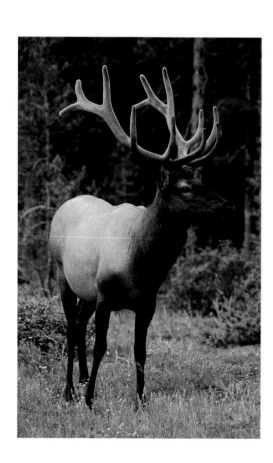

Left: Elk at Chinook Creek
Above: Spotted owl, Nisqually Valley
Right: Reflection on Bench Lake

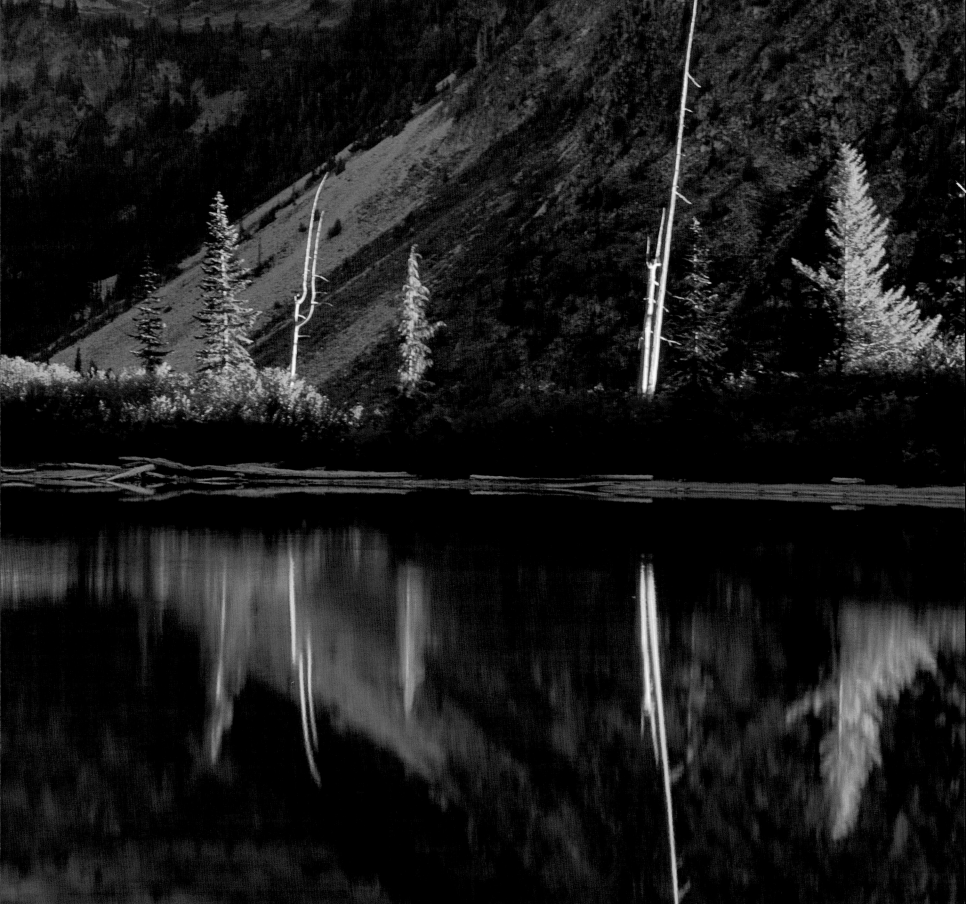

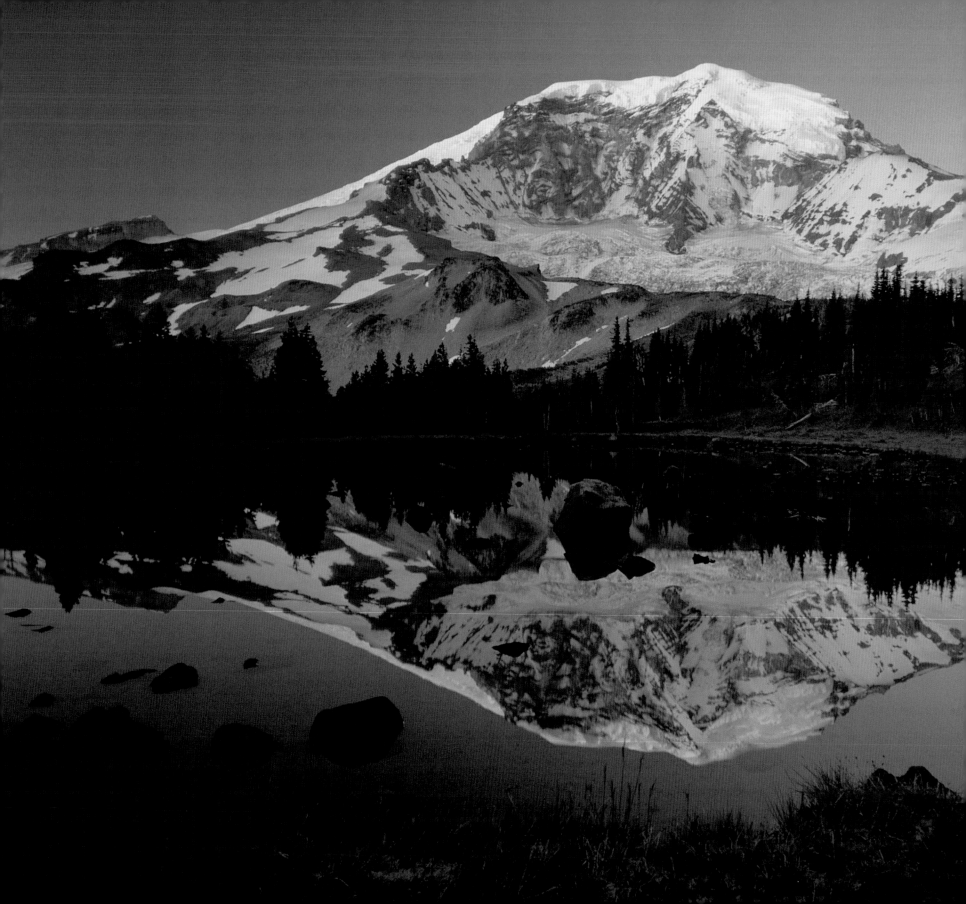

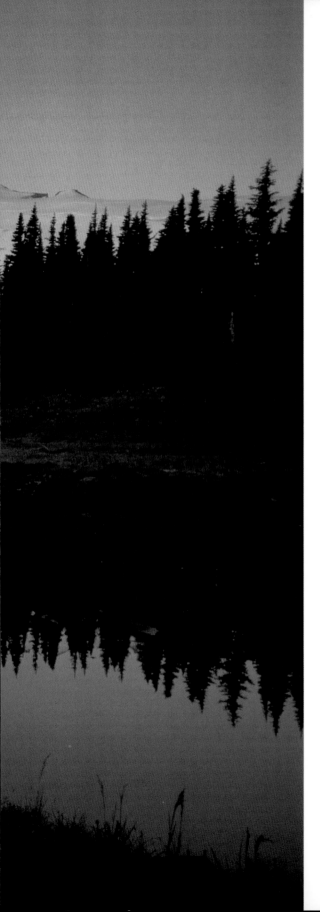

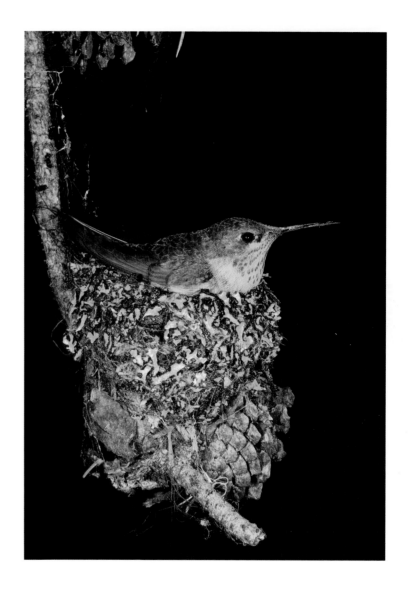

Left: Willis Wall on Mount Rainier's northern face reflects in a tarn in Moraine Park, Mount Rainier National Park

Above: North America's smallest hummingbird, a calliope hummingbird, nests atop a lodgepole pine cone, American River Valley

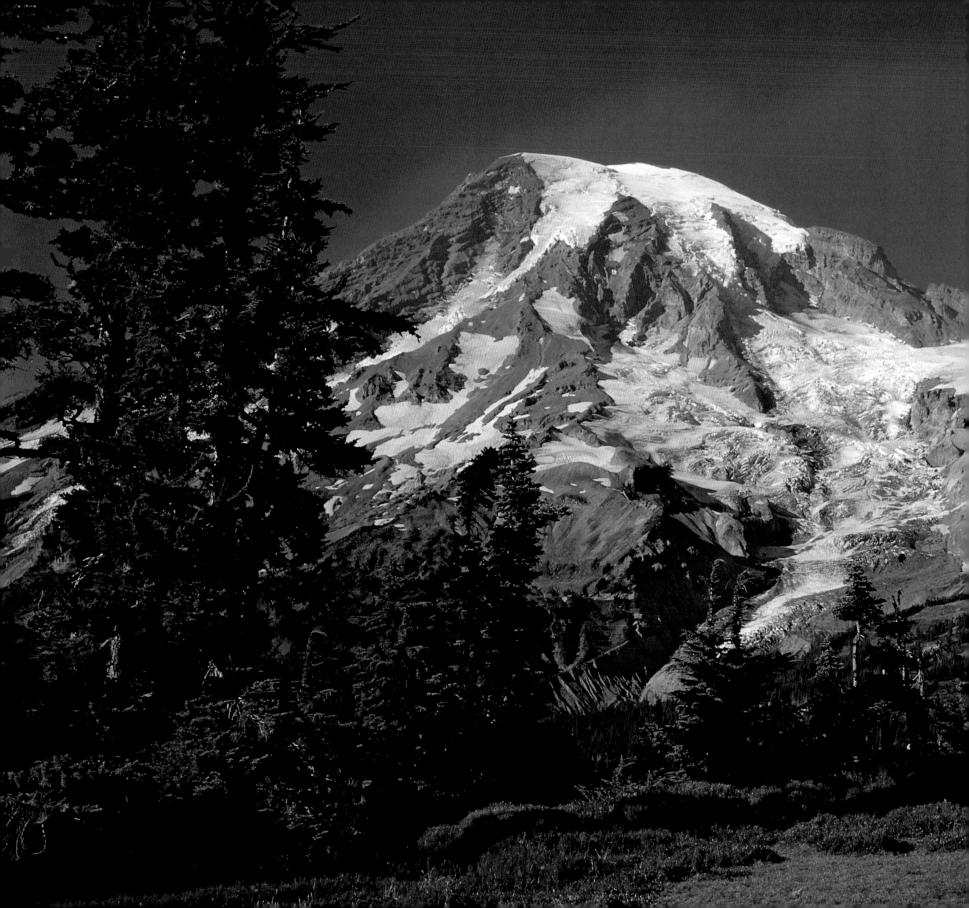

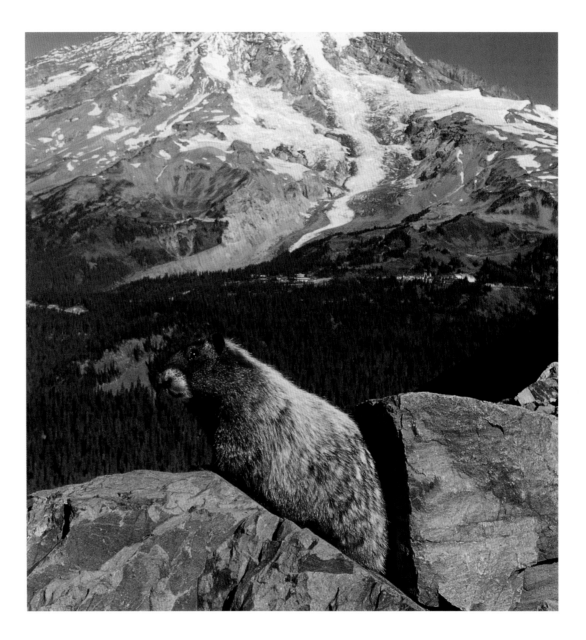

Left: Mount Rainier viewed from Plummer Peak, Tatoosh Range

Above: A hoary marmot suns itself on the slopes of Pinnacle Peak

Page 70: Cadaver Gap, viewed from Mount Rainier's Disappointment Cleaver at 12,000 feet; Mount Adams peeks above low clouds to the south

Page 71: Climbers rest atop 14,411-foot Columbia Crest, the summit of Mount Rainier

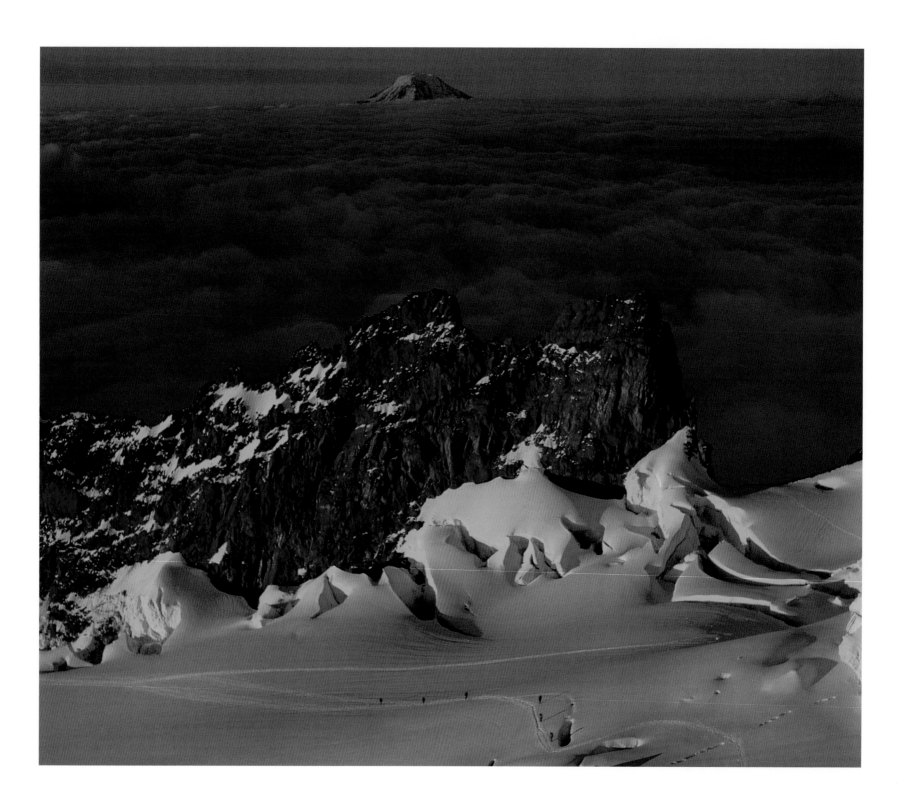

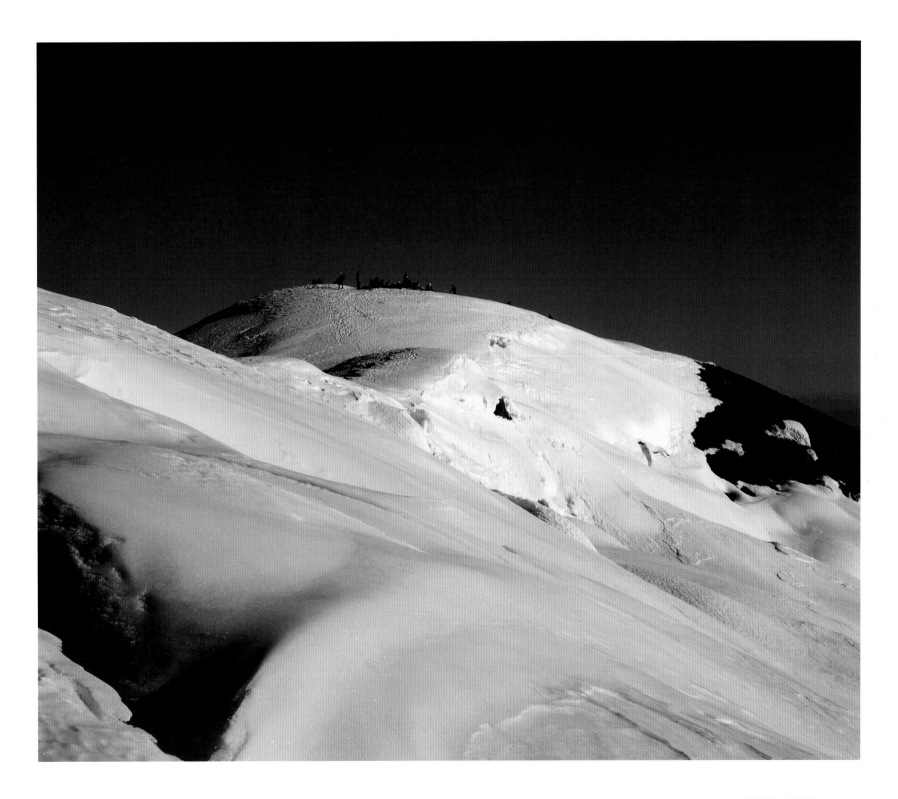

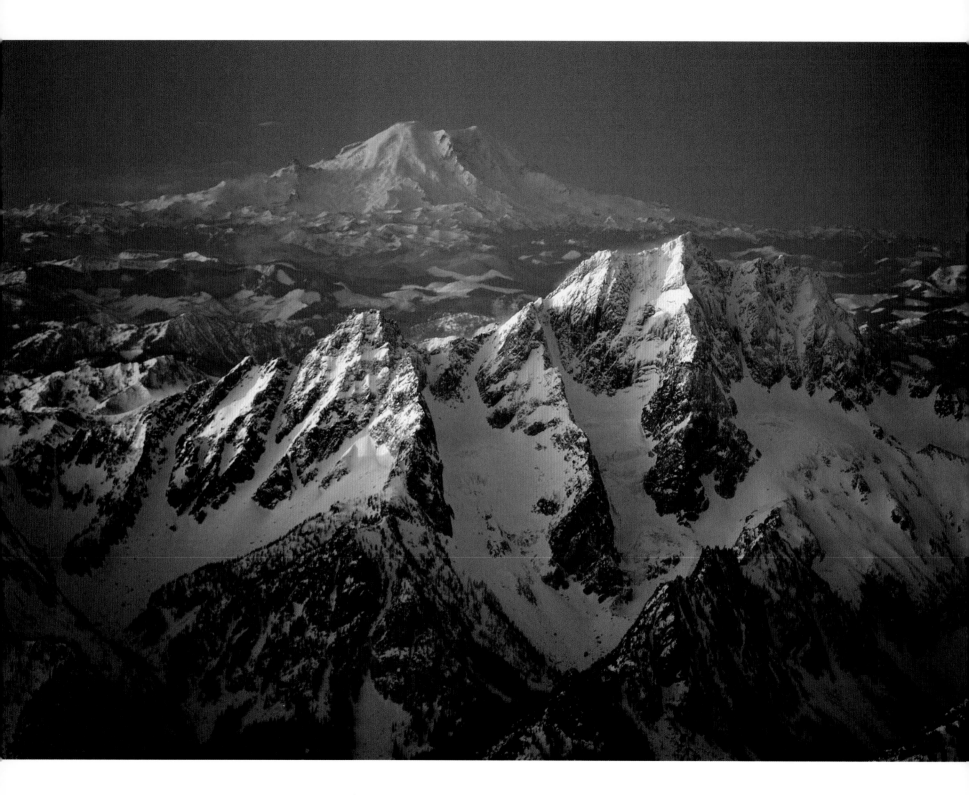

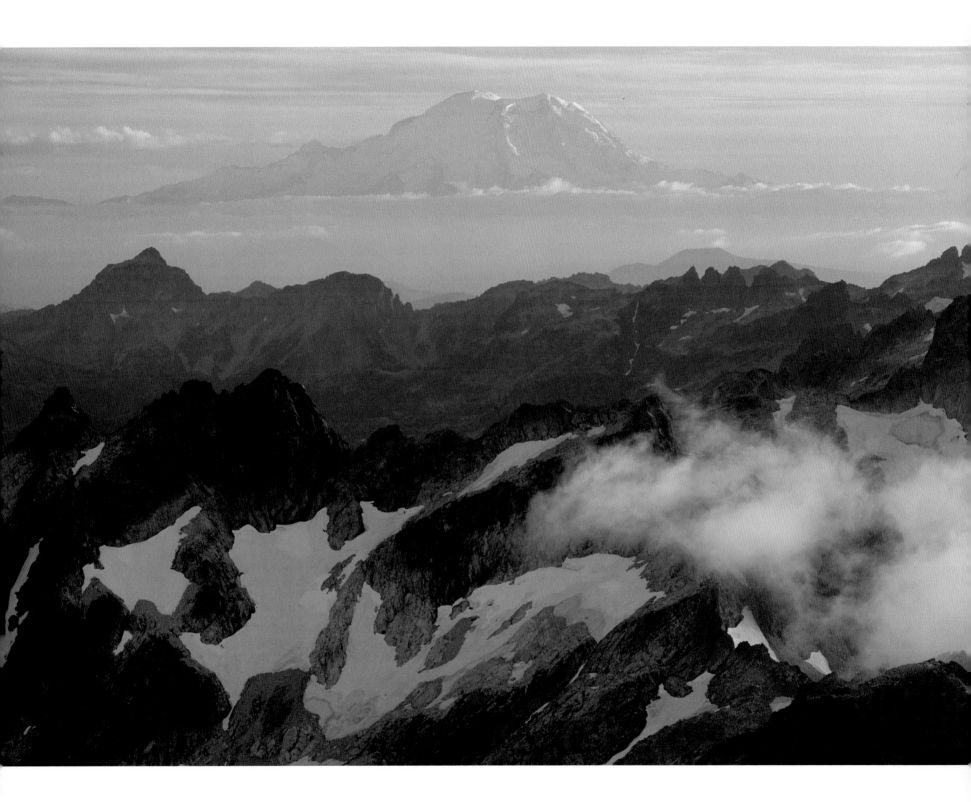

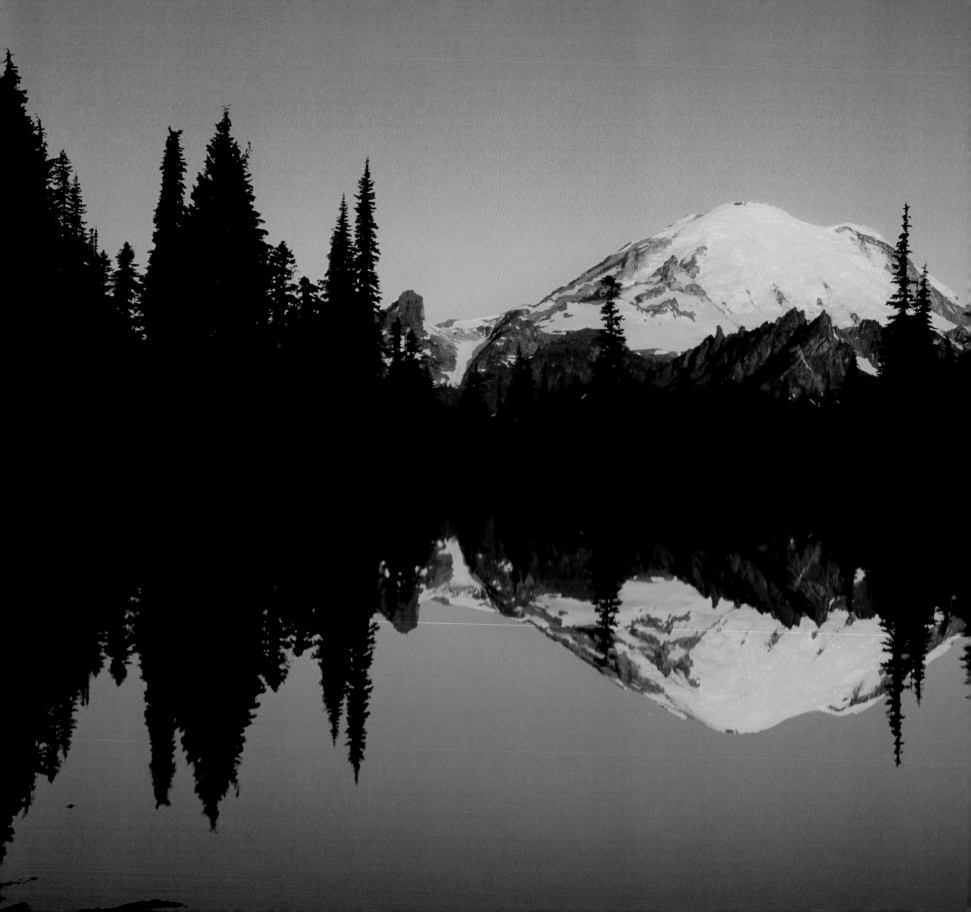

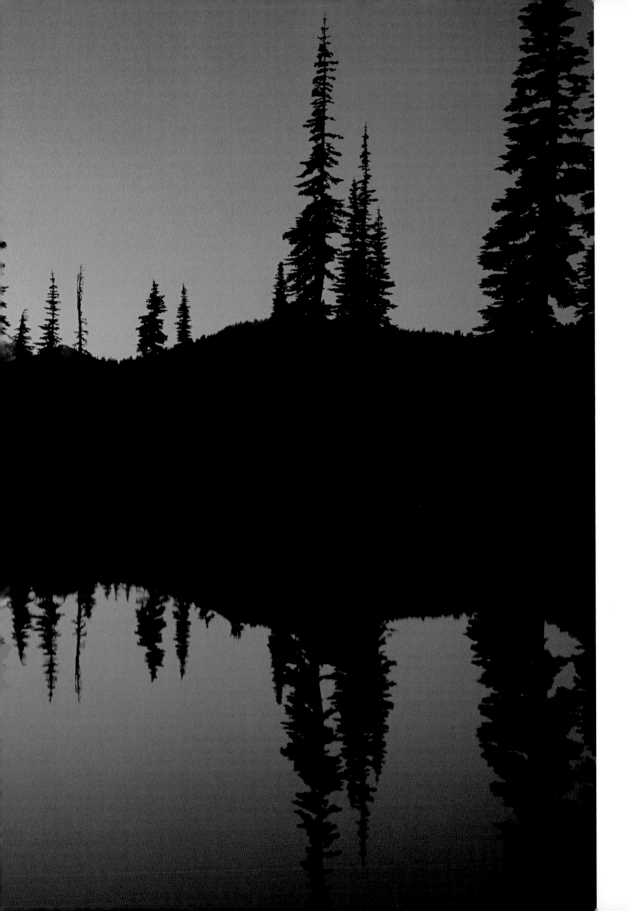

Page 72: Mount Rainier behind 9,415-foot Mount Stuart, the highest nonvolcanic peak in Washington

Page 73: Rainier seen from Dragontail Peak, Enchantment Lakes area

Left: A mirror image reflected in a small lake near Chinook Pass in Mount Rainier National Park

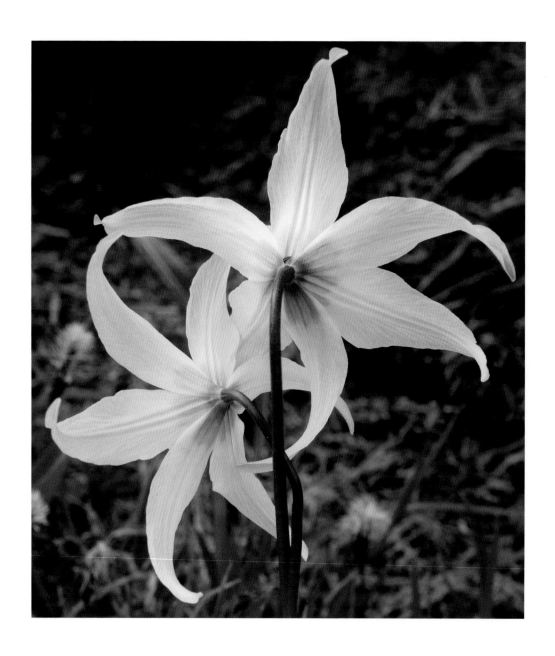

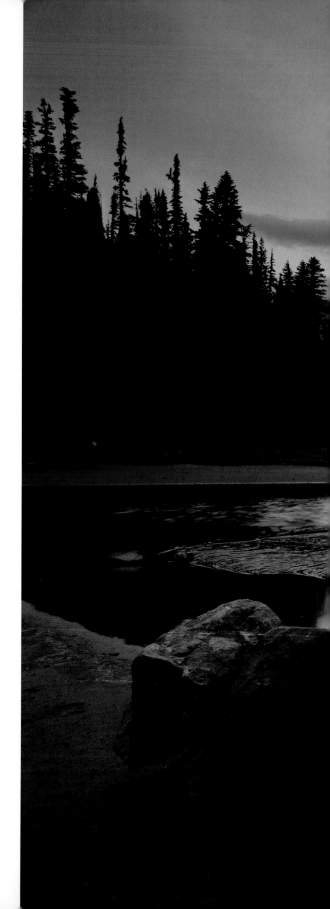

Above: Avalanche lilies in Spray Park

Right: The peak from Aurora Lake,
Klapatche Park

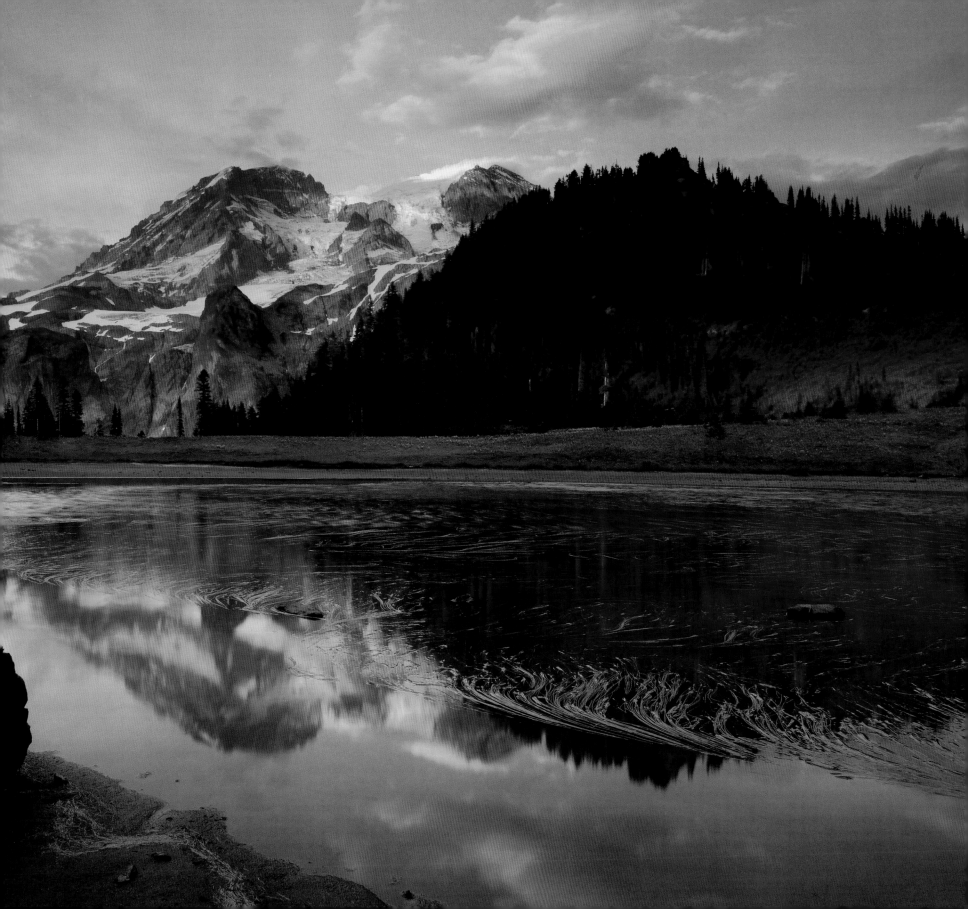

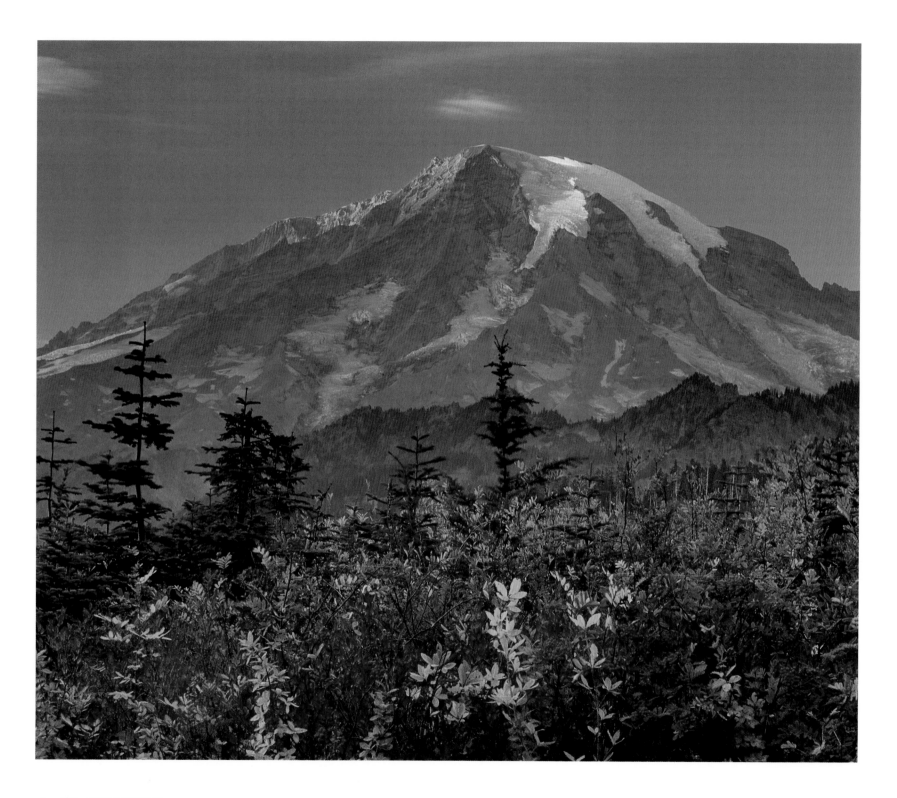

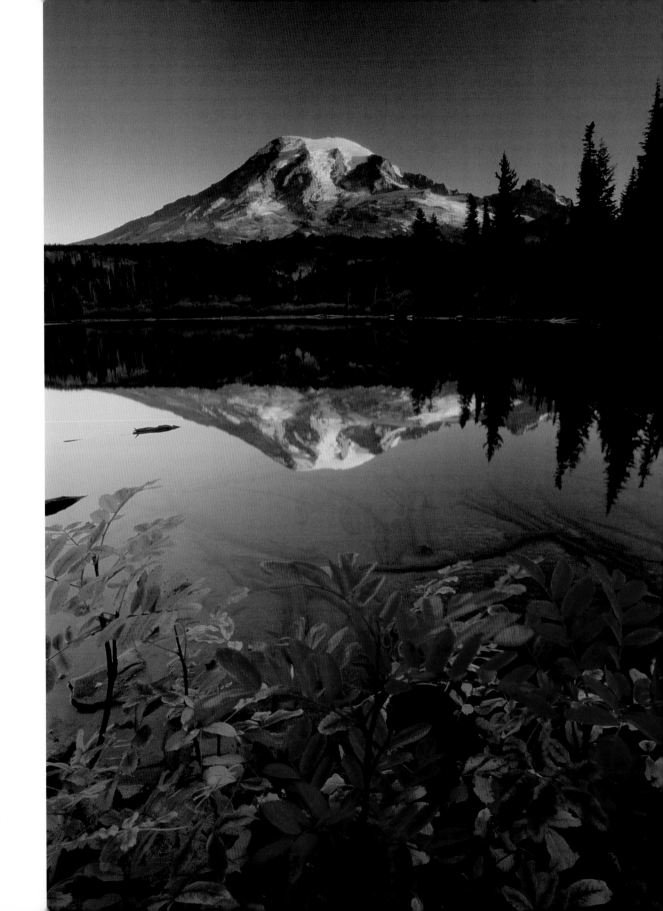

Left: Viewed from the southwest, Mount Rainier shows the effects of a winter's low snowfall

Right: The peak reflected in the calm waters of Bench Lake, with mountain ash turning brilliant red in early fall

Page 80: Fall colors abound in the high meadows around Paradise, on the south slopes of Mount Rainier

Page 81: The peak bathed in the warm glow of an autumn evening

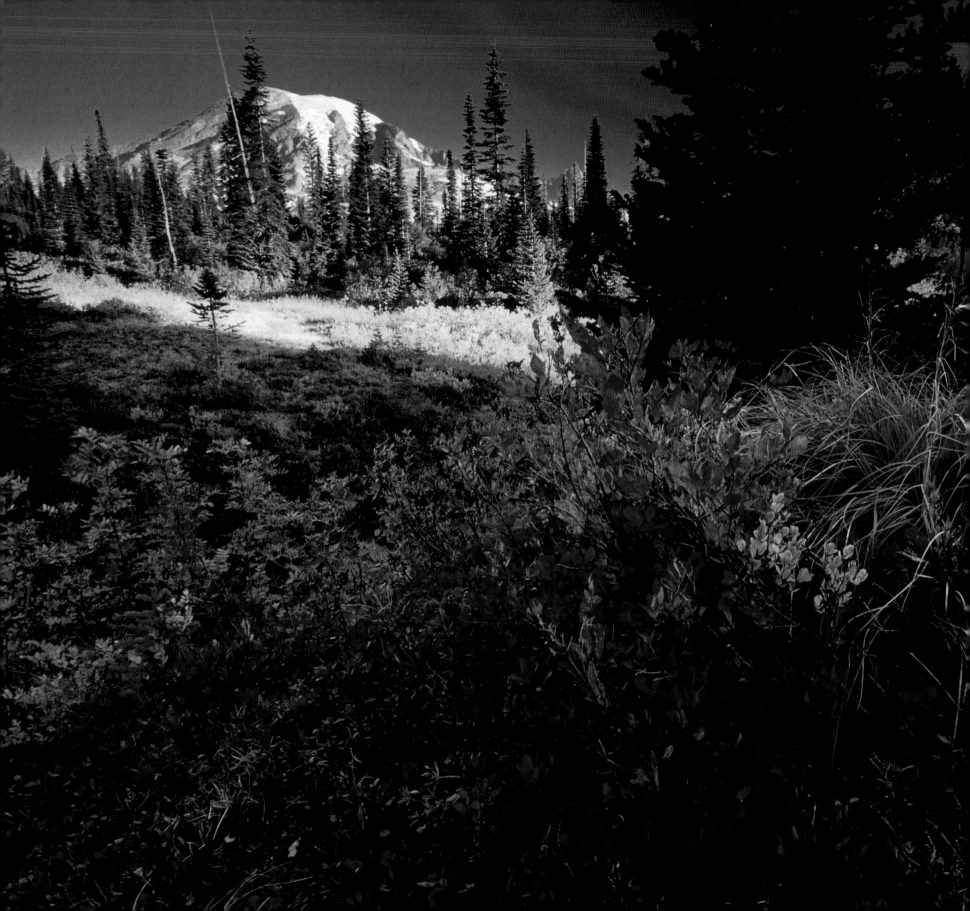

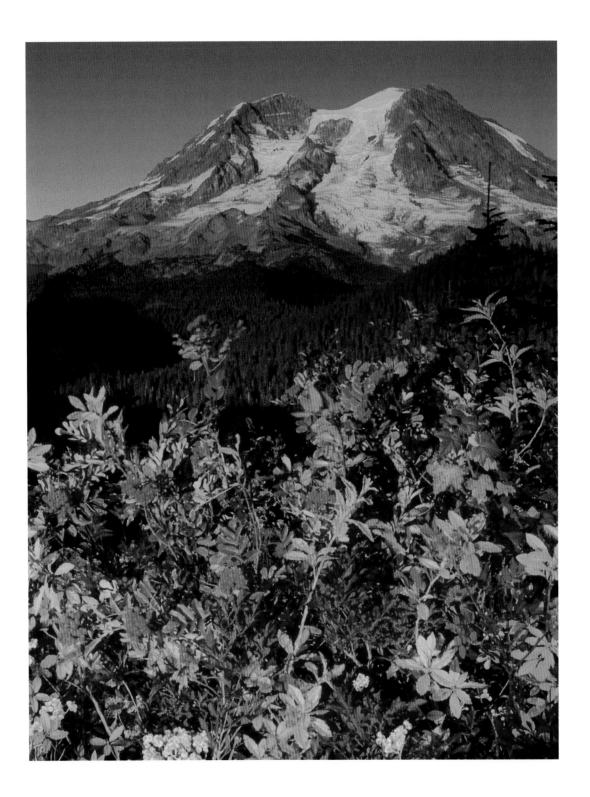

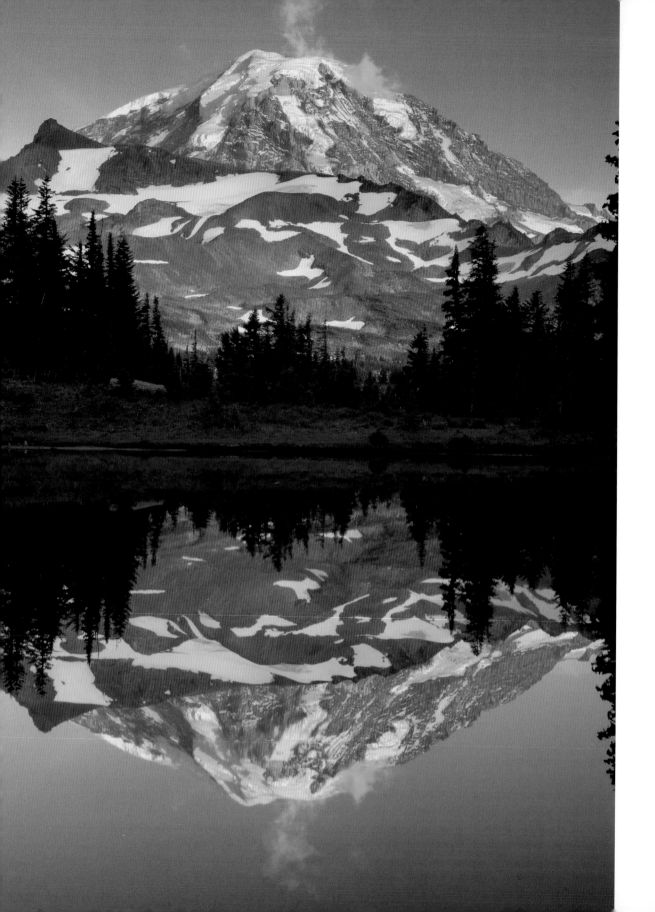

Left: Reflection in one of the many tarns of Spray Park, on the mountain's northwest slopes

Above: Golden-mantled ground squirrel

Right: Bear grass blooms in Spray Park

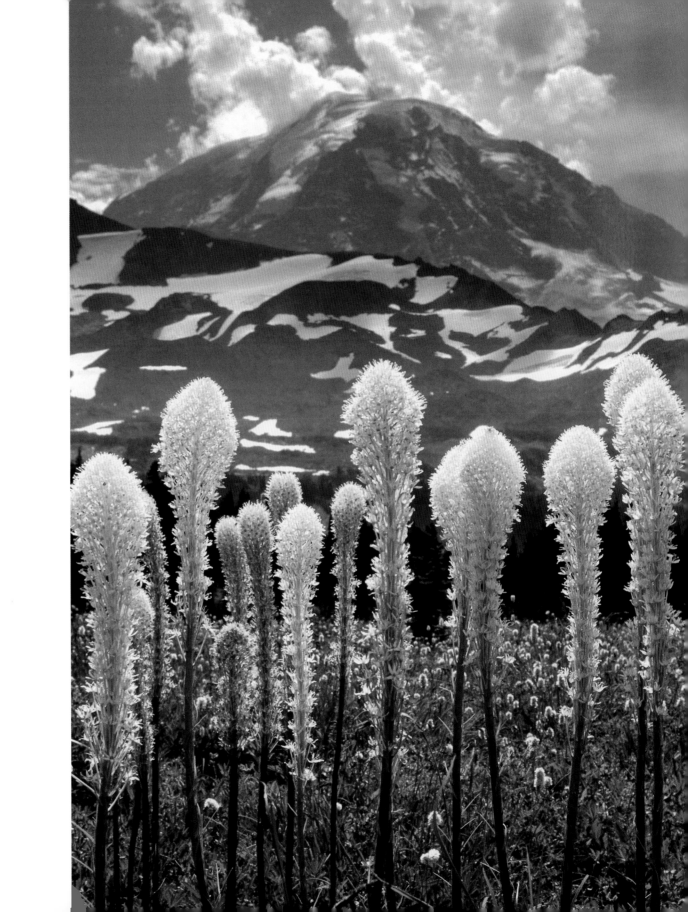

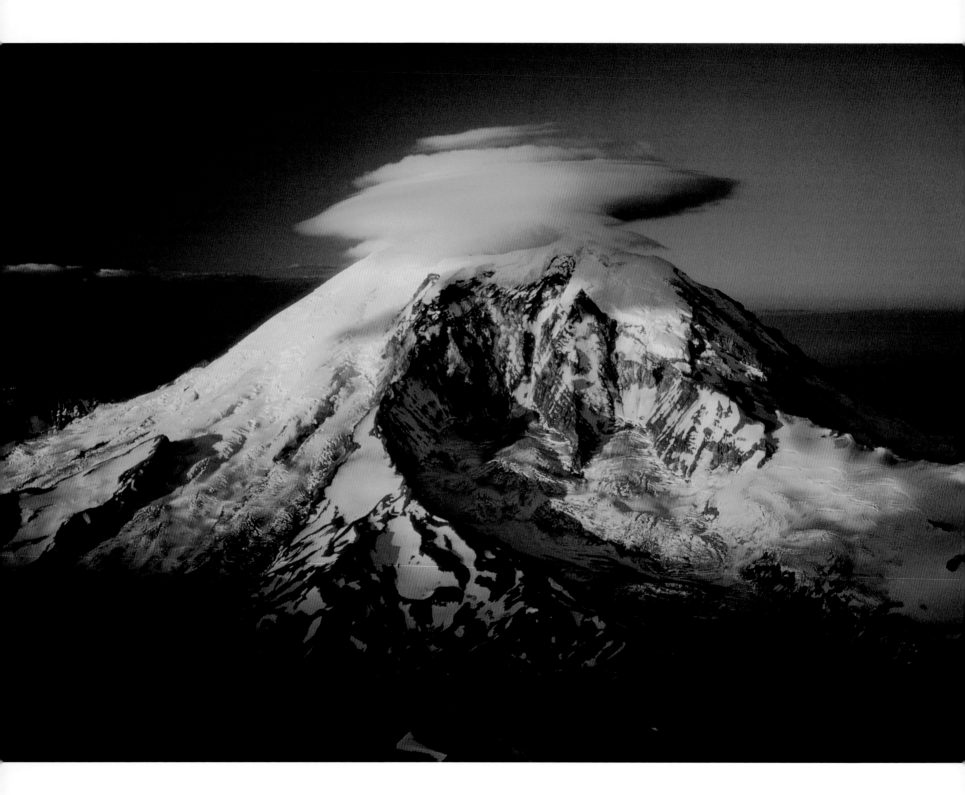

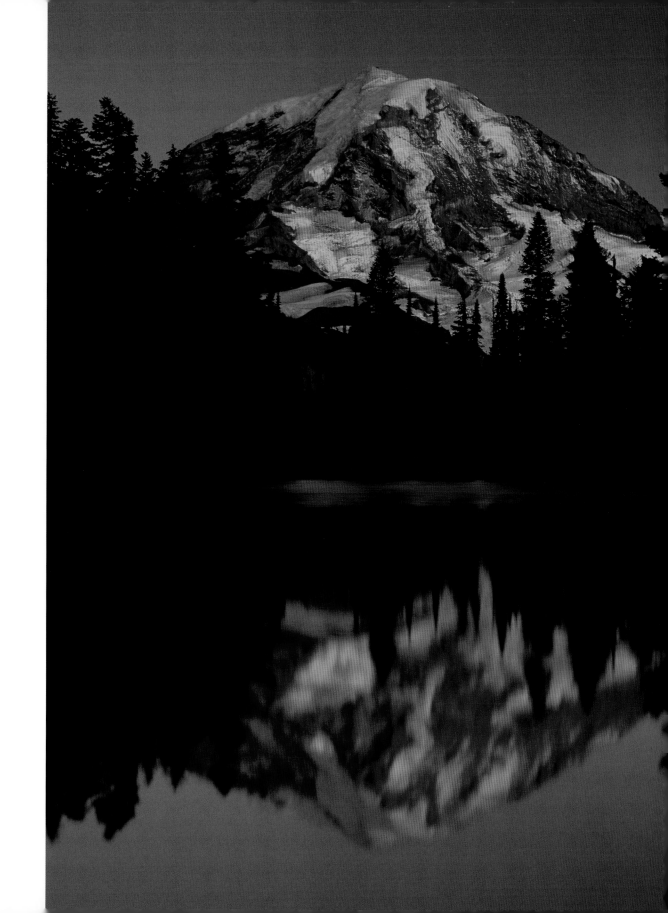

Left: A lenticular cloud swirls around
Mount Rainier's summit, an indication
that a storm front is approaching

Right: The peak viewed from Eunice Lake

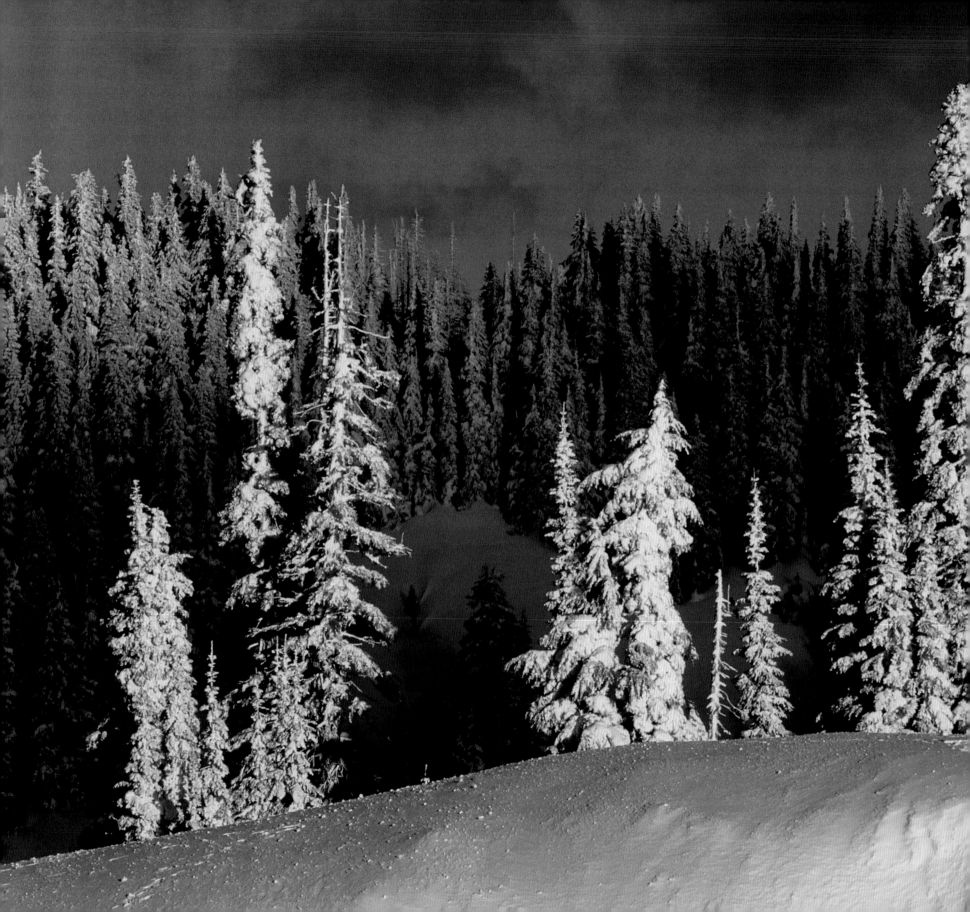

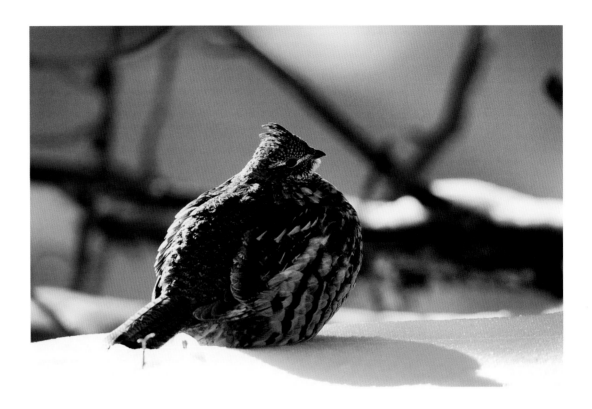

Left: Winterscape in Paradise Valley,
Mount Rainier National Park

Above: Ruffed grouse

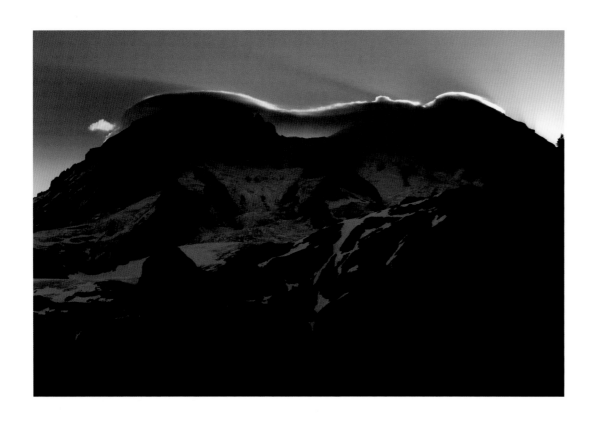

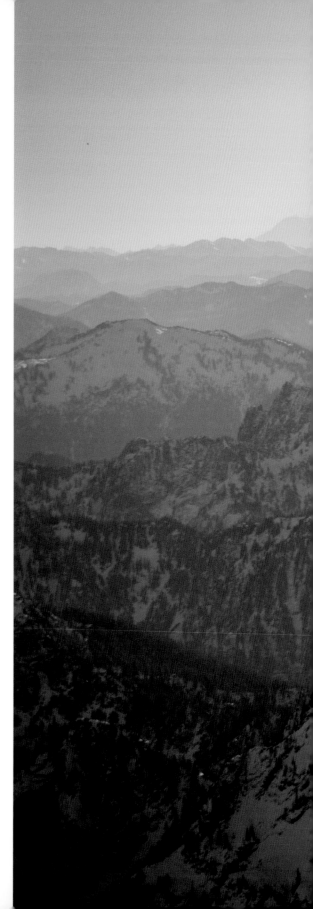

Left: A cloud cap cloaks Mount
Rainier's summit

Right: The volcano stands as a sentinel above
the surrounding Cascade Range; Mount
Adams is just visible in the distance

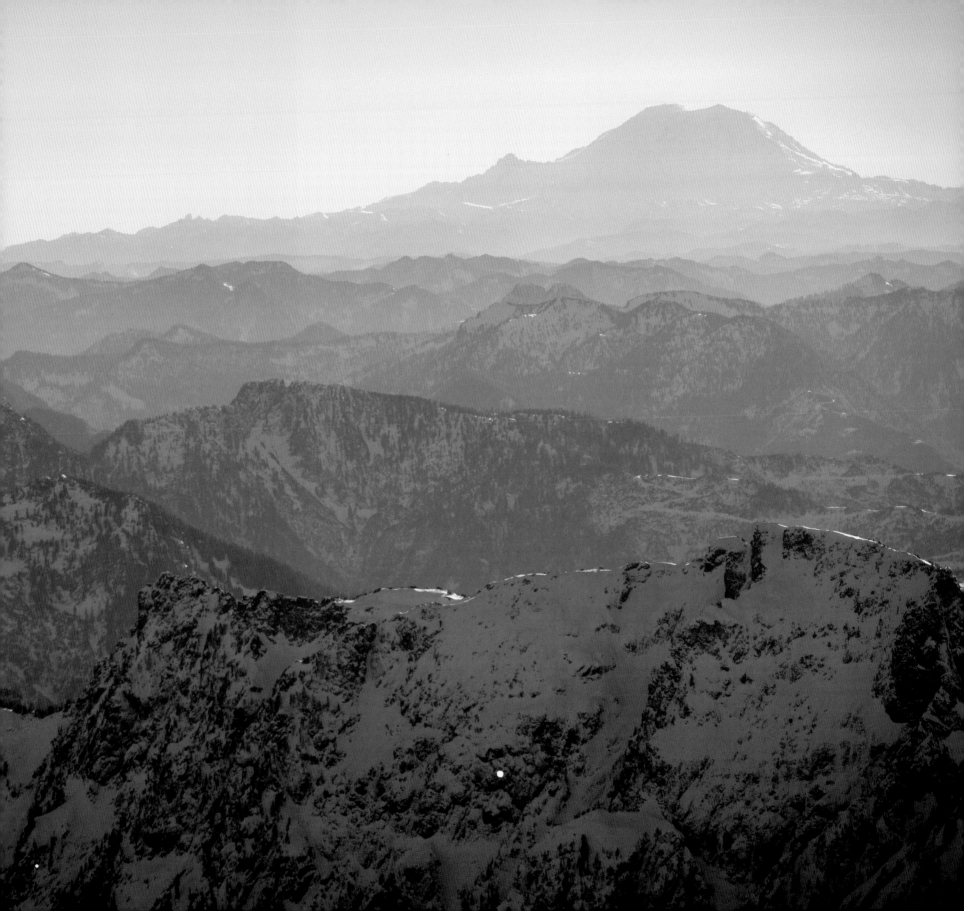

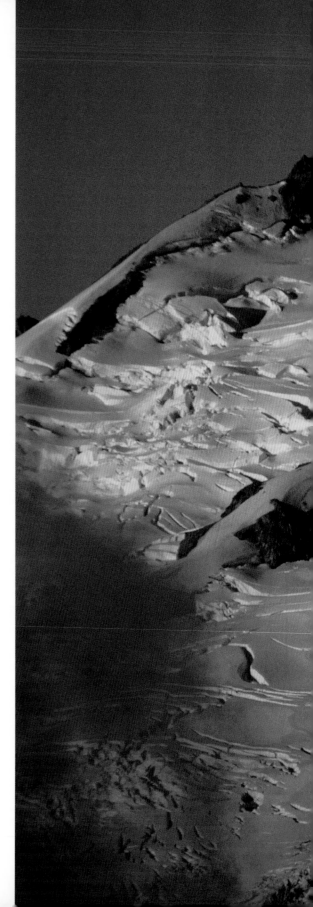

VIEWPOINTS

10,541: Elevation, in feet

48° 7' N; 121° 7' W: Latitude/longitude of summit

70: Miles from Seattle

7,000: Vertical relief, in feet, between the summit and the Suiattle River Valley 5 miles to the east

15: Number of named glaciers

8.5: Area, in square miles, covered in ice

1870: Year that the first white man, Daniel Linsley, recorded seeing Glacier Peak while surveying for a possible route for the Northern Pacific Railroad

Early summer 1897: First recorded summit climb, by Thomas Gerdine, Sam Strom, A. H. Dubor, and Darcy Bard, members of a U.S. Geological Survey crew who named the peak

1898: First year that Glacier Peak appeared on a published map with its present name

57: Number of people on a 1910 Mountaineers outing who climbed the peak

200 to 300: Number of years since the mountain last erupted

13,100: Approximate number of years since the peak generated nine tephra eruptions within less than a few hundred years, the largest ejecting more than five times the volume of tephra as the 1980 eruption of Mount St. Helens, some of it drifting hundreds of thousands of miles downwind

1964: Year that the Glacier Peak Wilderness was designated by Congress in the original Wilderness Act

570,573: Area, in acres, of the Glacier Peak Wilderness within the Mount Baker–Snoqualmie National Forest

DaKobed: Native American name for the mountain, meaning "Great Parent"

Right: Glacier Peak viewed from Miner's Ridge

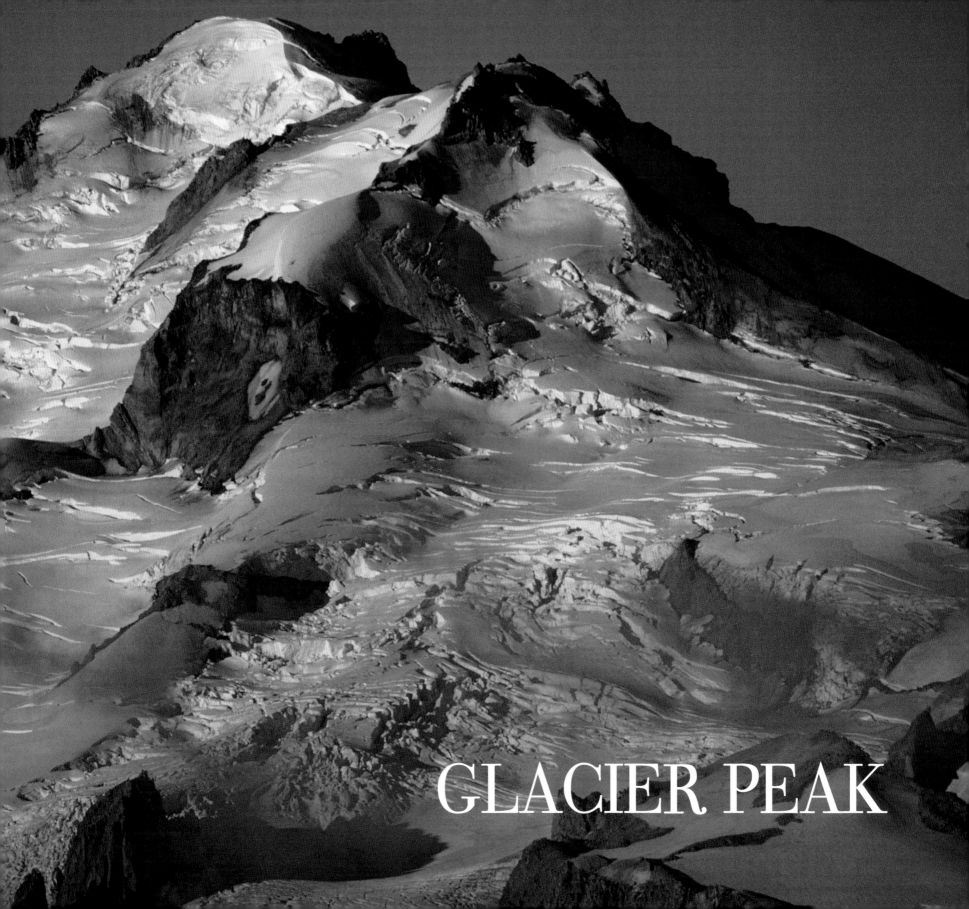

GLACIER PEAK

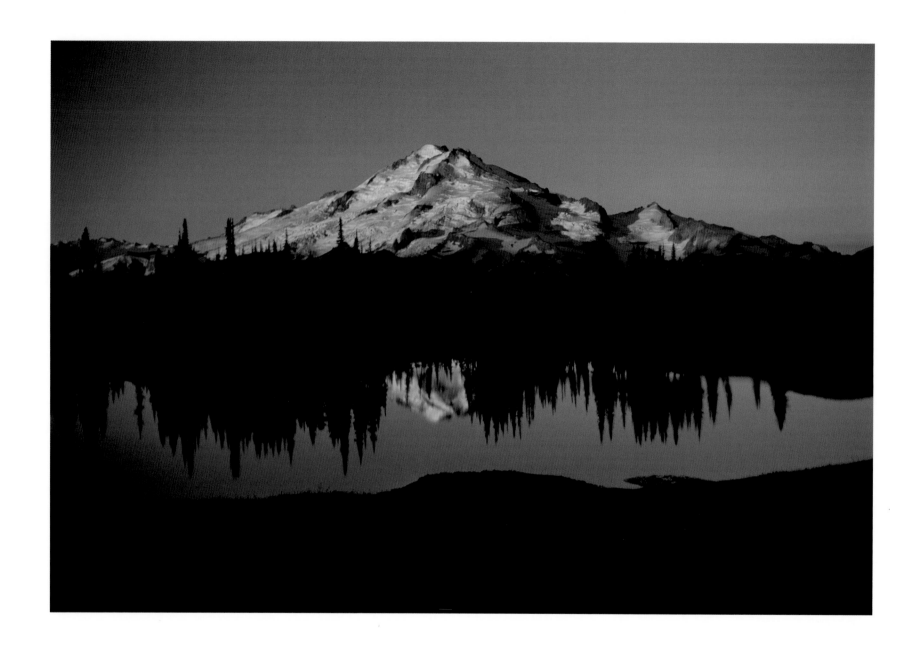

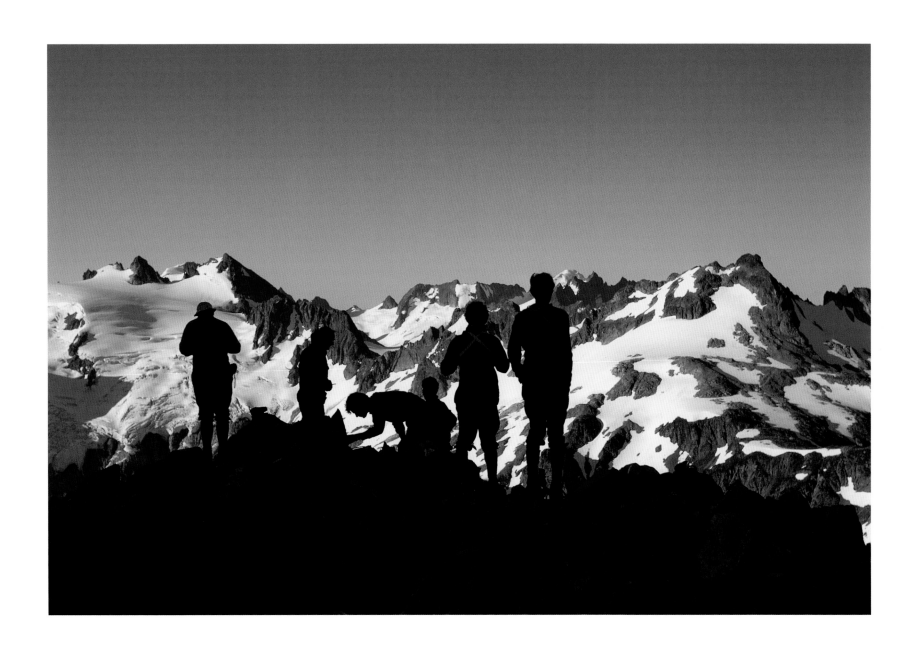

Left: Glacier Peak from Image Lake

Above: Climbers along the Ptarmigan Traverse, with
Glacier Peak on the horizon (right center)

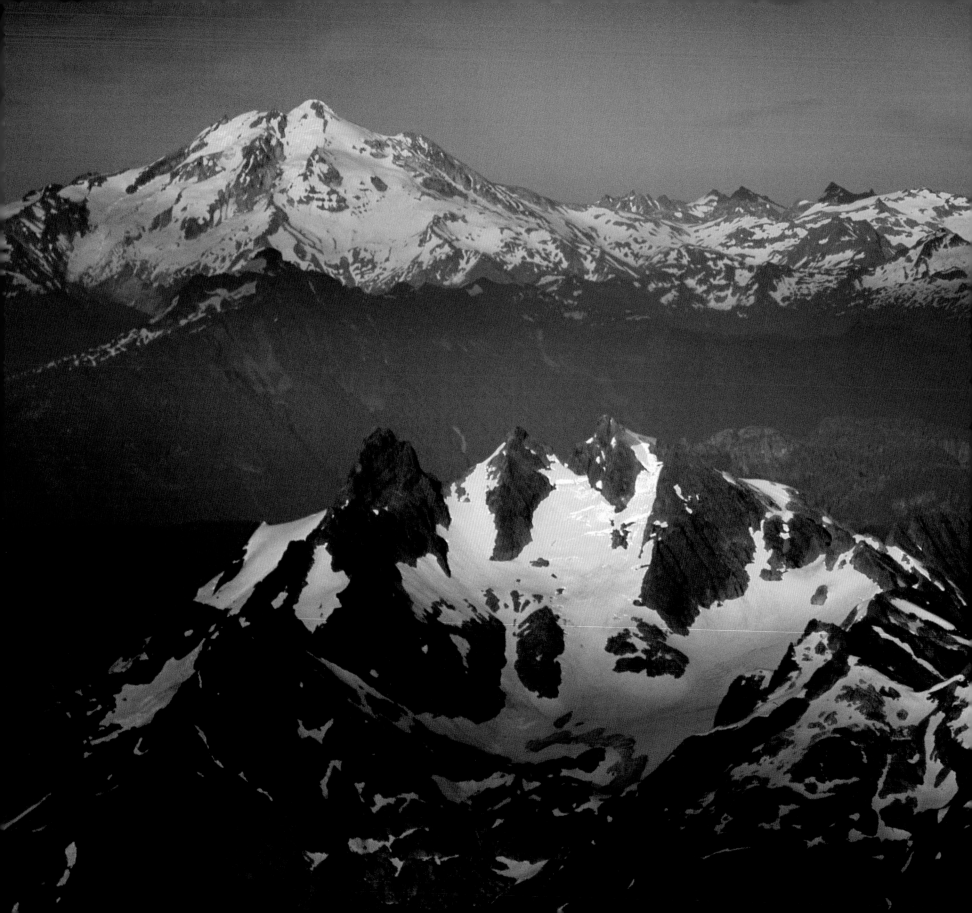

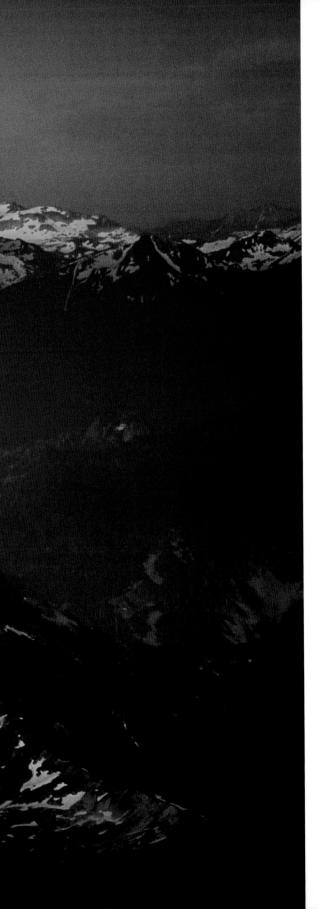

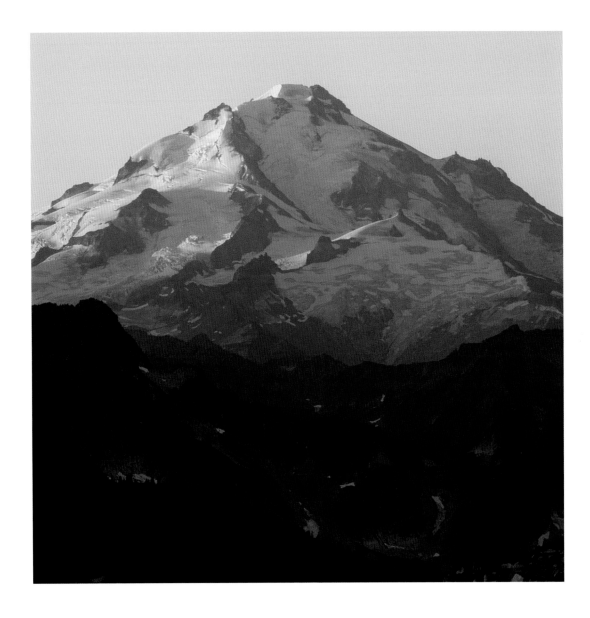

Left: Glacier Peak towers over the distinctive Three Fingers massif

Above: The mountain viewed from the south

Page 96: Glacier Peak from Miner's Ridge

Page 97: Sunset from Miner's Ridge

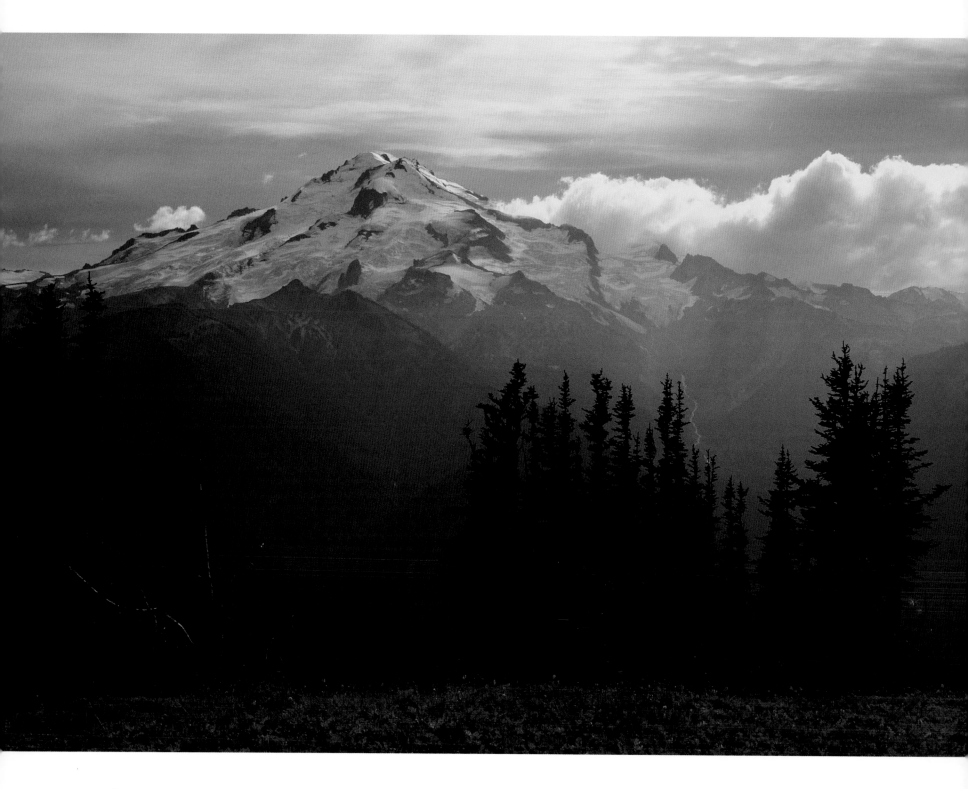

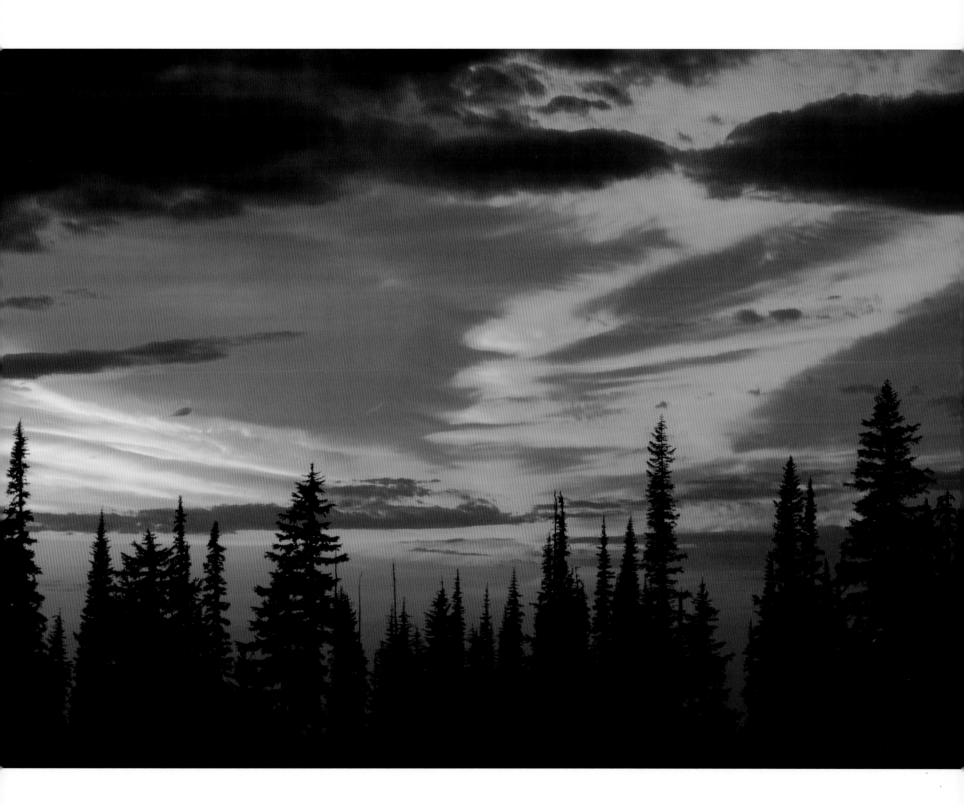

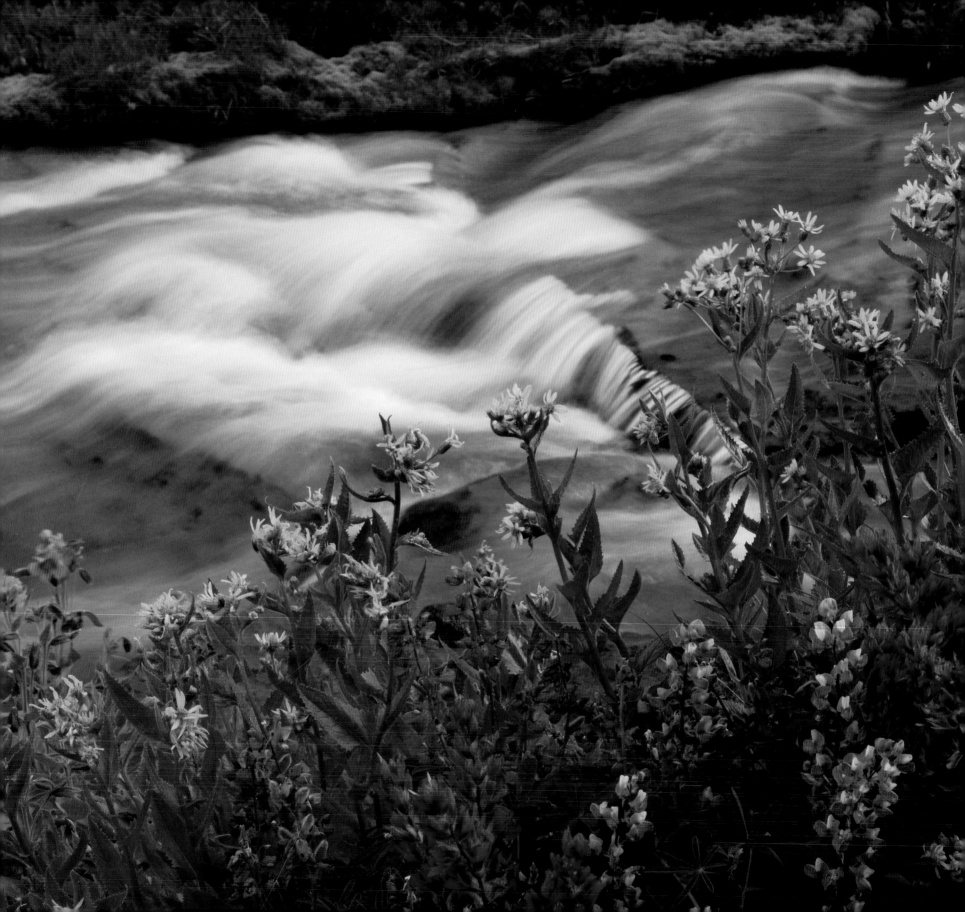

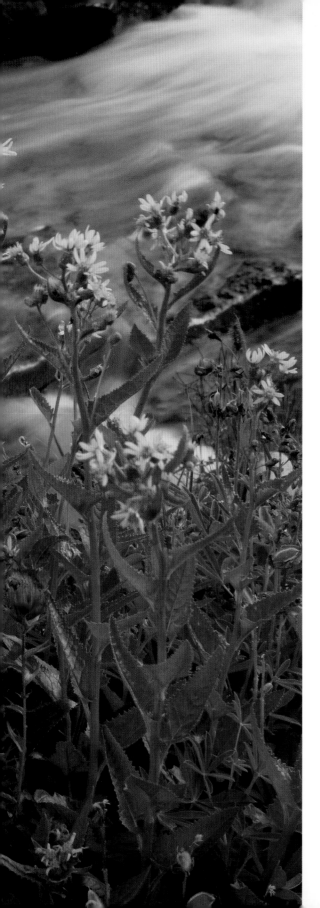

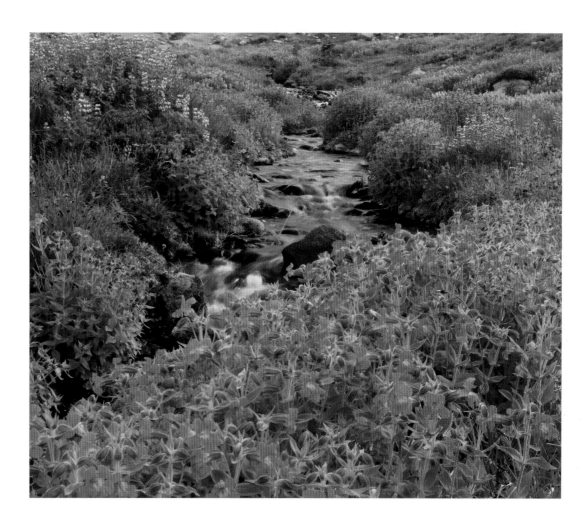

Left: Downey Creek, Glacier Peak Wilderness

Above: Cascade Creek, Glacier Peak Wilderness

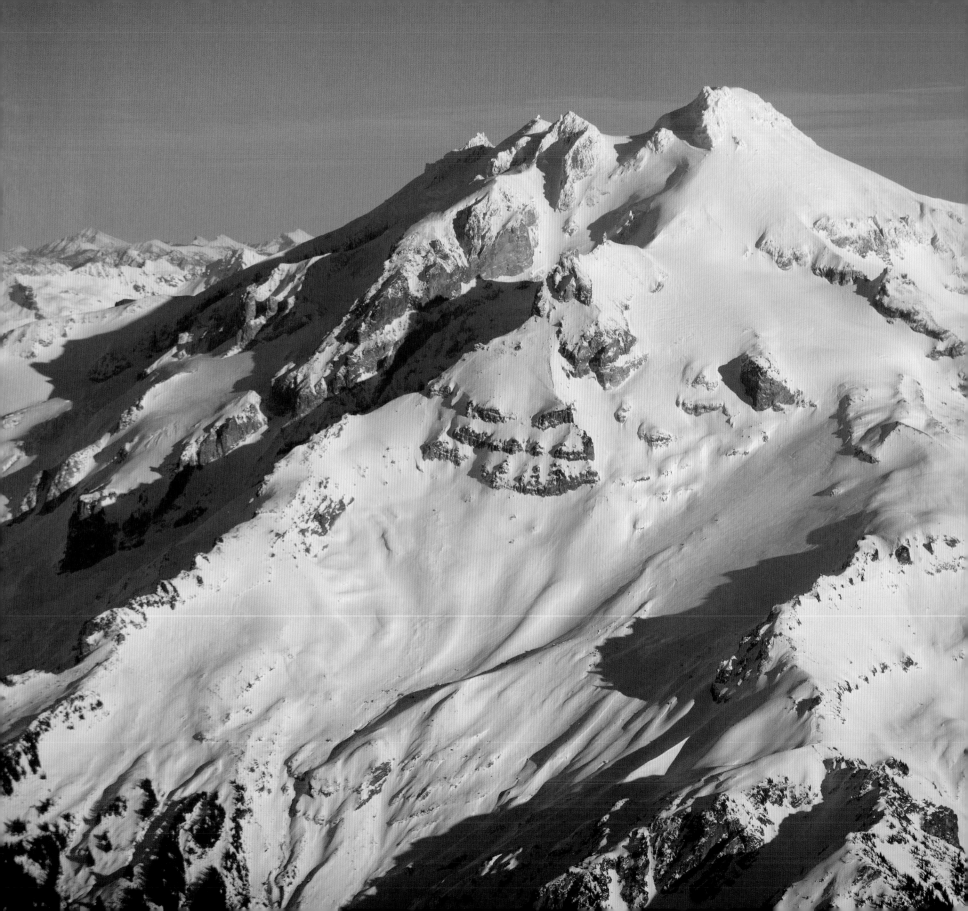

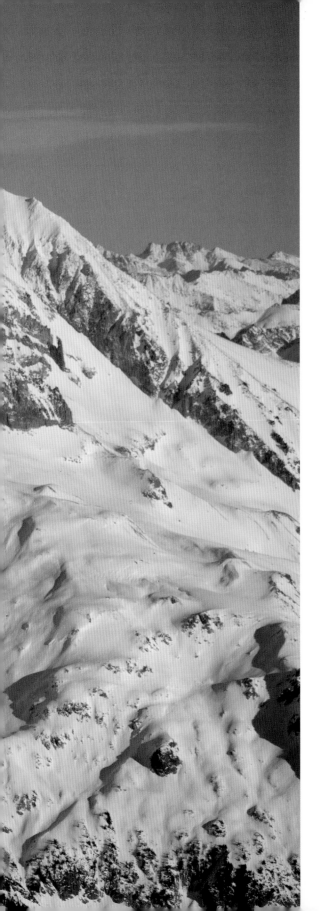

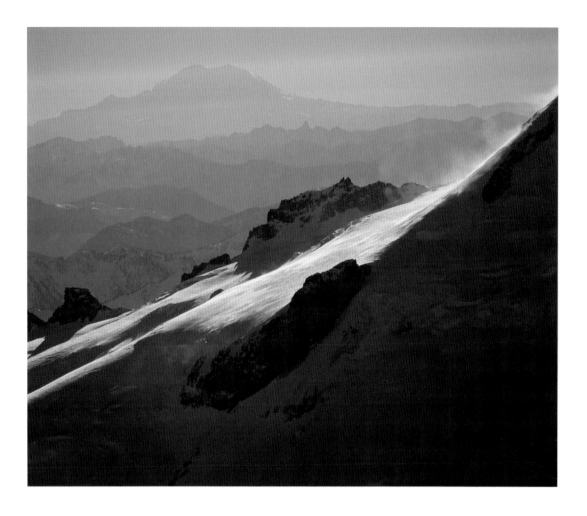

Left: North face of Glacier Peak

Above: Mount Rainier as seen from the east slopes of Glacier Peak

Page 102: Southeast face, with Mount Baker on the horizon

Page 103: Glacier Peak's east face

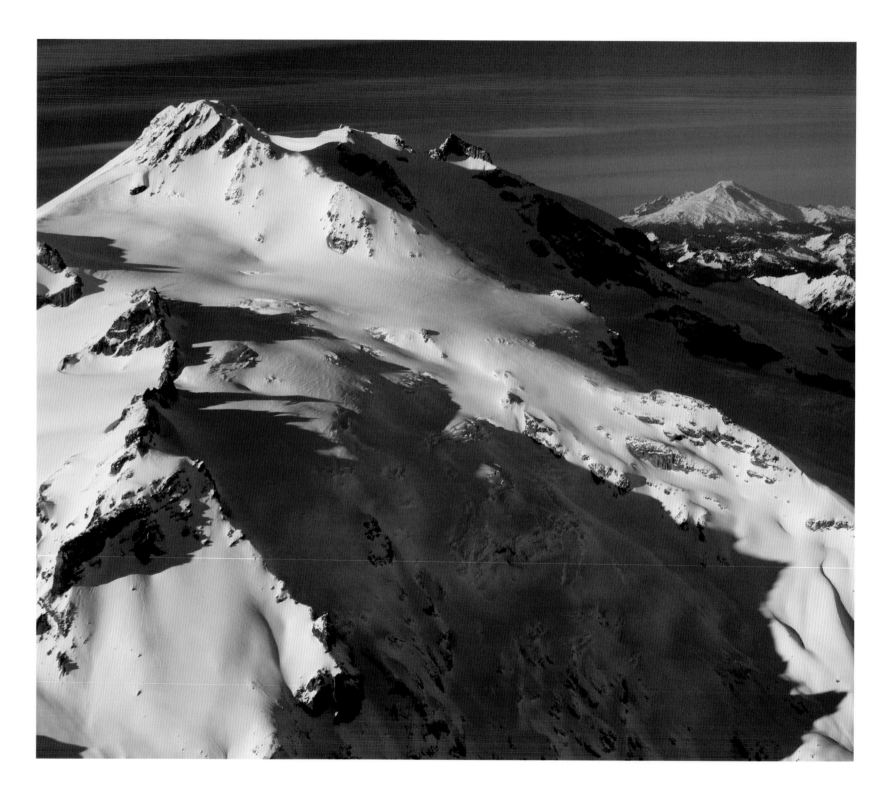

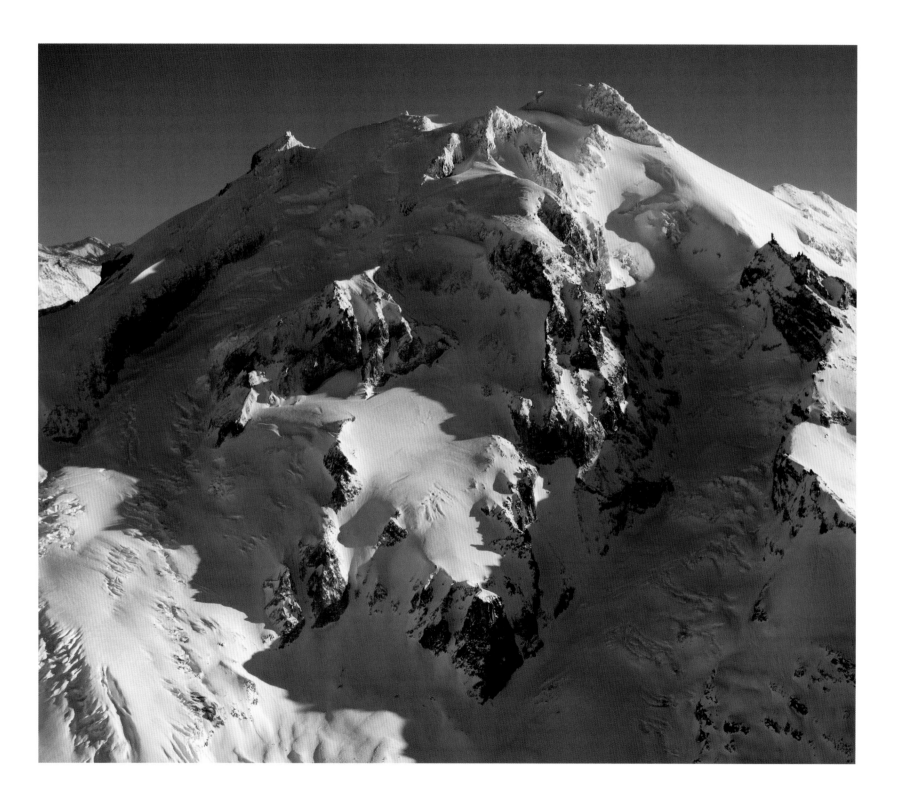

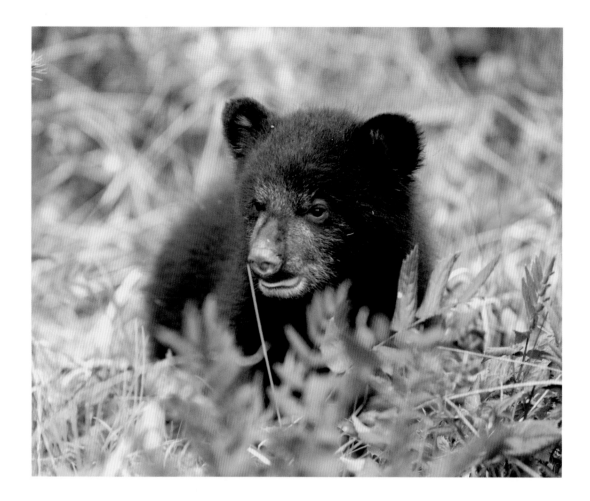

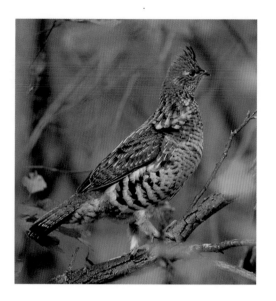

Left: Black bear cub

Above: Ruffed grouse

Right: Skunk cabbage, White
Chuck River Valley

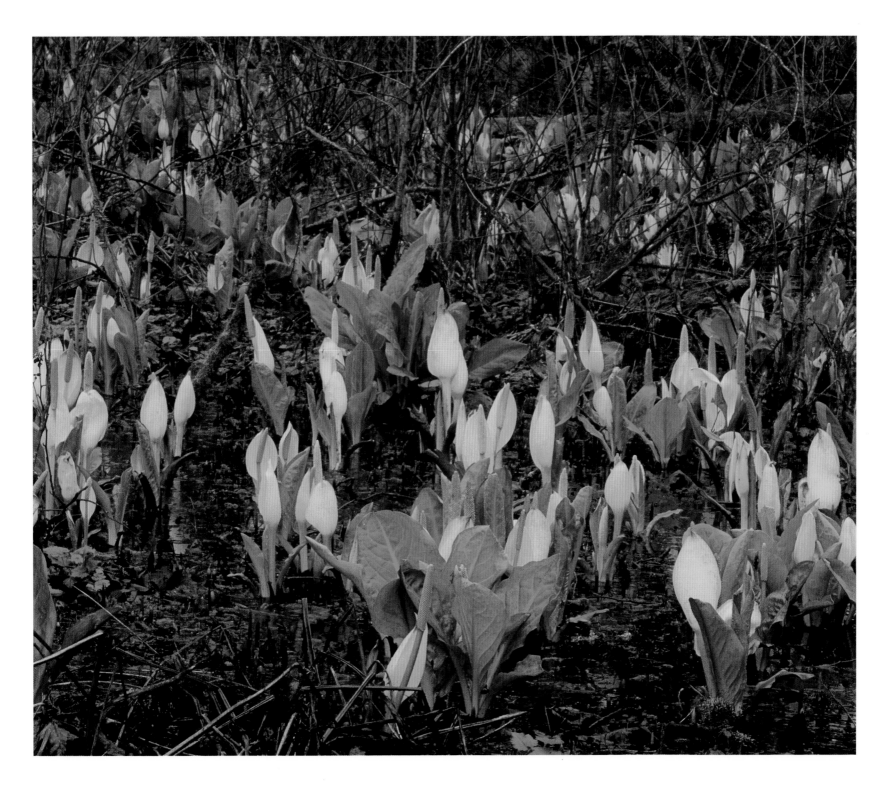

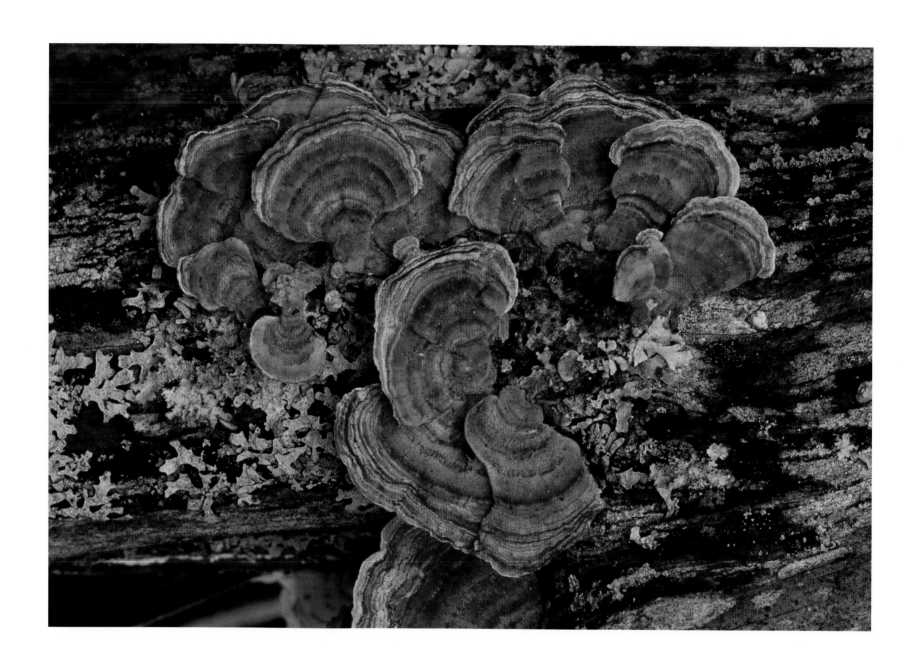

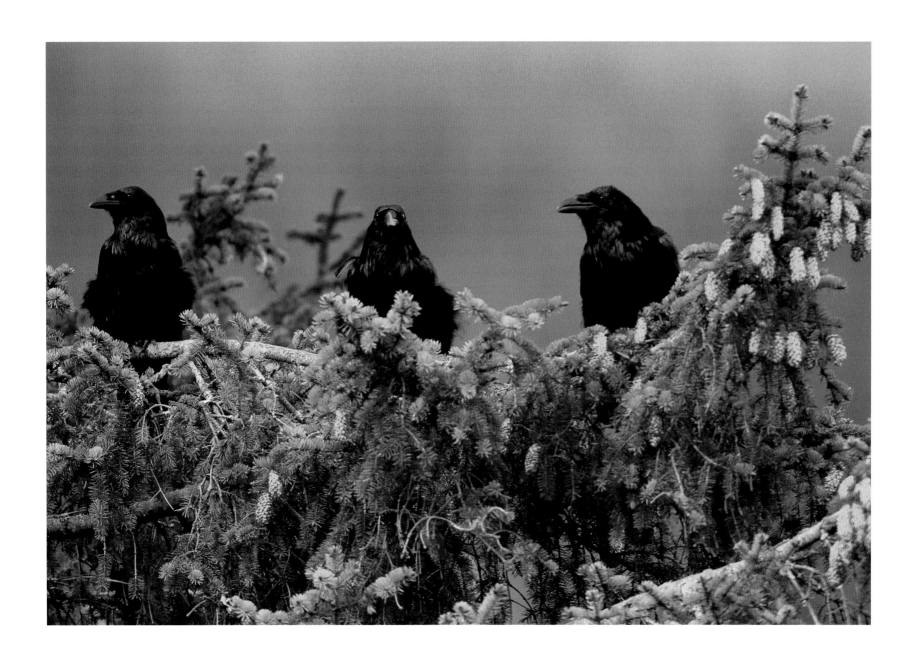

Left: Turkey tail fungus, Suiattle River Valley

Above: Ravens in Glacier Peak Wilderness

Page 108: The lower southern slopes of
Glacier Peak, sculpted with snow

Page 109: Aerial view of Glacier Peak Wilderness

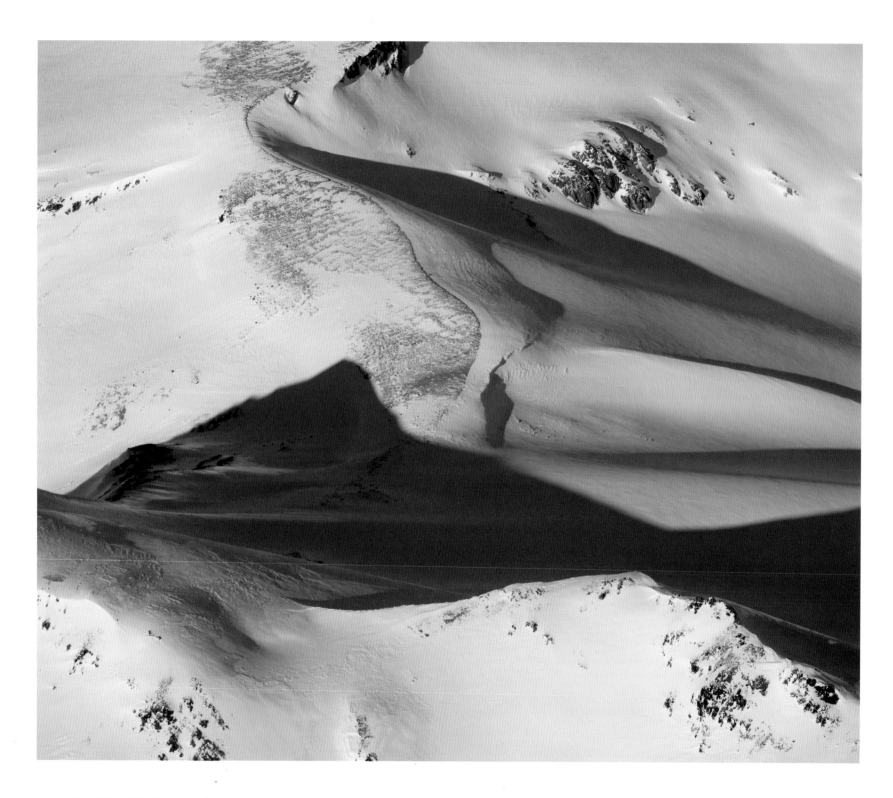

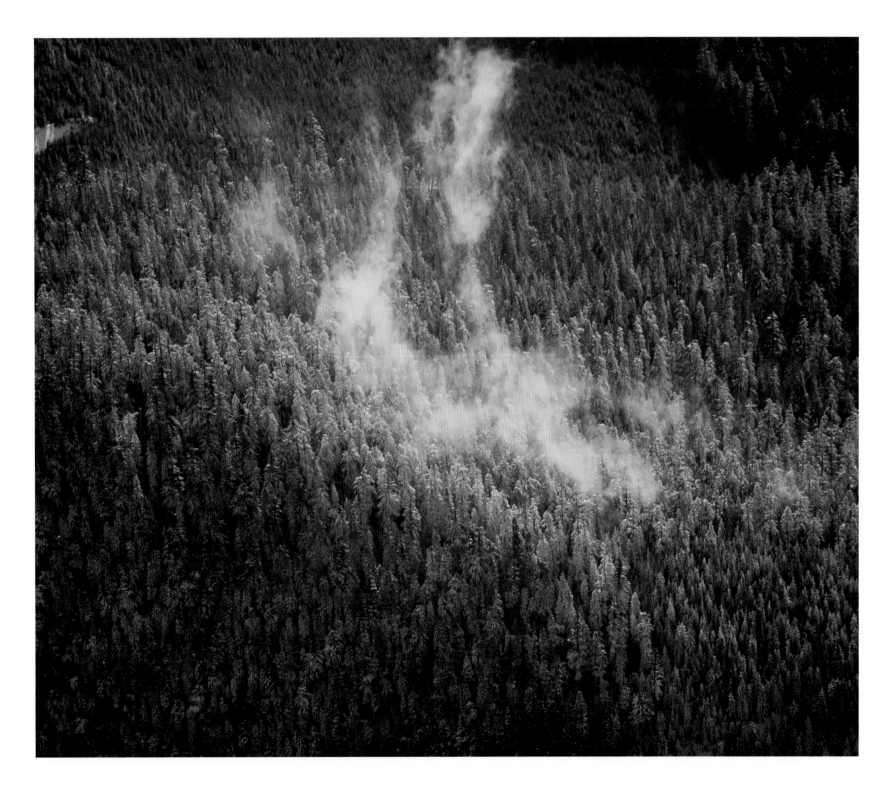

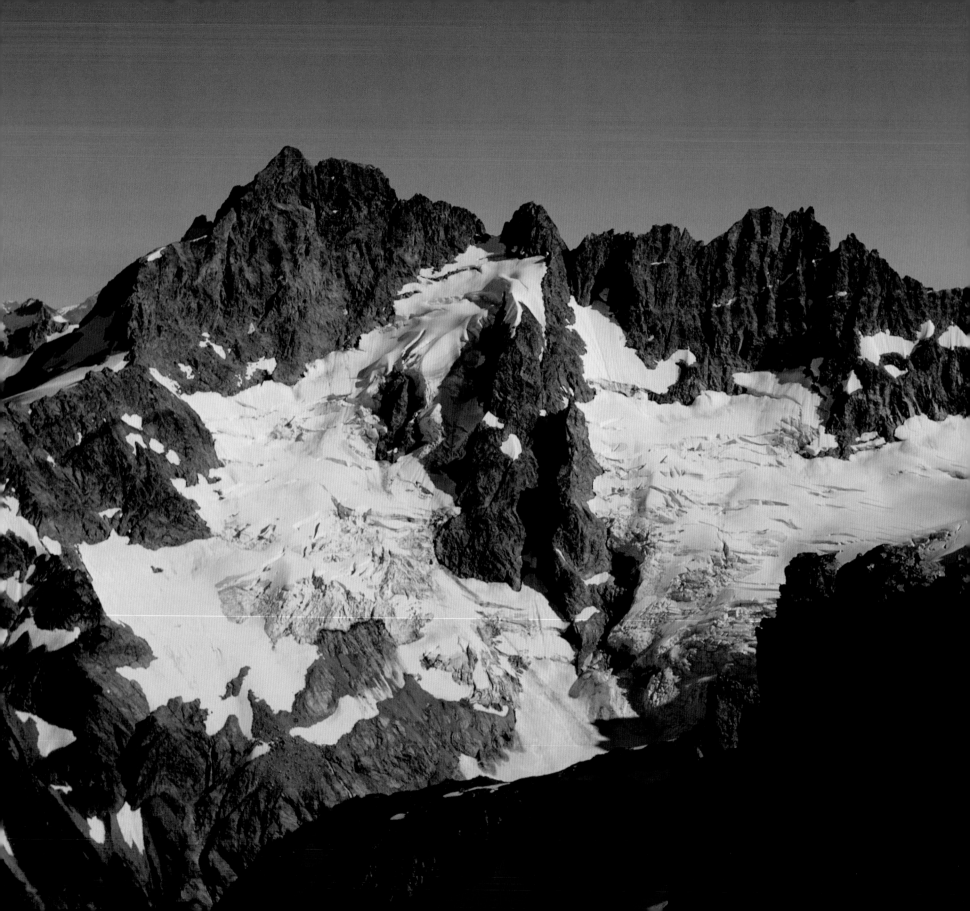

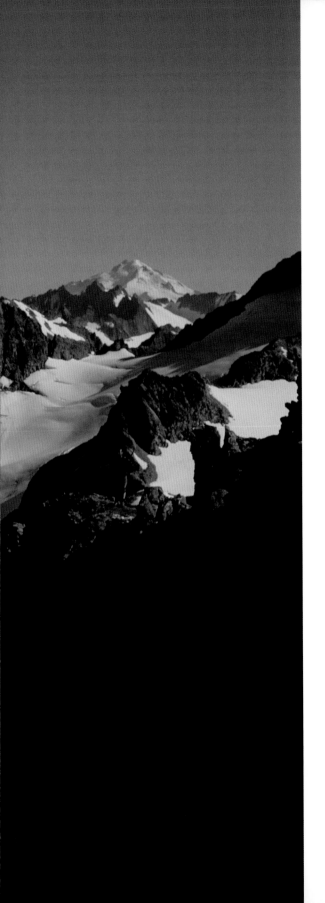

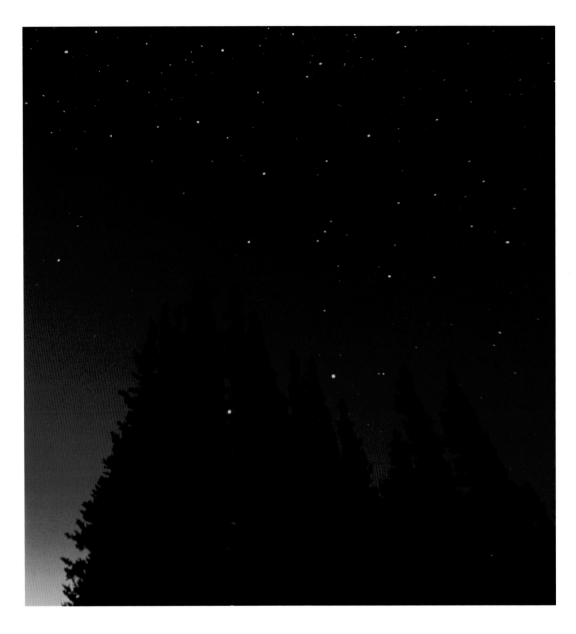

Left: Aptly named Mount Formidable (foreground),
with Glacier Peak on the far right horizon

Above: Stars above Miner's Ridge

VIEWPOINTS

10,778:	Elevation, in feet
48° 47' N; 121° 49' W:	Latitude/longitude of summit
31:	Miles due east of Bellingham, Washington
14:	Number of named glaciers
35:	Acreage of the nearly level, ice- and snow-covered summit, which is named Grant Peak
0.43:	Volume, in cubic miles, of snow and ice covering the entire mountain, greater than that of all other Cascades volcanoes combined, excluding Rainier
20:	Approximate area, in square miles, of glaciers, the largest of them being Coleman and Roosevelt
1790:	Year that the Spanish navigator Manuel Quimper became the first European to identify the peak, which his pilot named La Gran Montana del Carmelo
1792:	Year that Joseph Baker, an officer under the command of Captain George Vancouver, saw the mountain, which Vancouver then named for him
August 17, 1868:	First recorded summit climb, led by Edmund Thomas Coleman via the glacier now bearing his name
1911:	First year of the Mount Baker Marathon, a 118-mile route—24 miles on foot, the remainder via auto and train—from Bellingham to Baker's summit and back
1913:	Last year of the Mount Baker Marathon, canceled after a competitor fell into a hidden crevasse and nearly died
May 4, 1930:	Ed Loness and Robert B. Sperlin skied to and from the summit, in the first known ski ascent of a major Northwest summit
July 22, 1939:	Six members of a college group were killed by an avalanche while climbing the Deming Glacier
1984:	Year that the Mount Baker Wilderness was designated by Congress as part of the Washington Wilderness Act
117,528:	Area, in acres, of the Mount Baker Wilderness, which is within the Mount Baker–Snoqualmie National Forest
1891:	Year that approximately 20 million cubic yards of rock fell, causing a lahar, or mudflow, that traveled more than 6 miles
March 1975:	Last time the volcano began emitting steam, sparking concerns about an imminent eruption
Koma Kulshan:	Name given the mountain by the Lummi tribe of Puget Sound, first translated as "broken" or "damaged," then later given the more grand translation "Great White Watcher"

Right: Mount Baker and the Black Buttes

Page 114: Mount Baker dominates the skyline above Bellingham, Washington

Page 115: The peak viewed from above the San Juan Islands

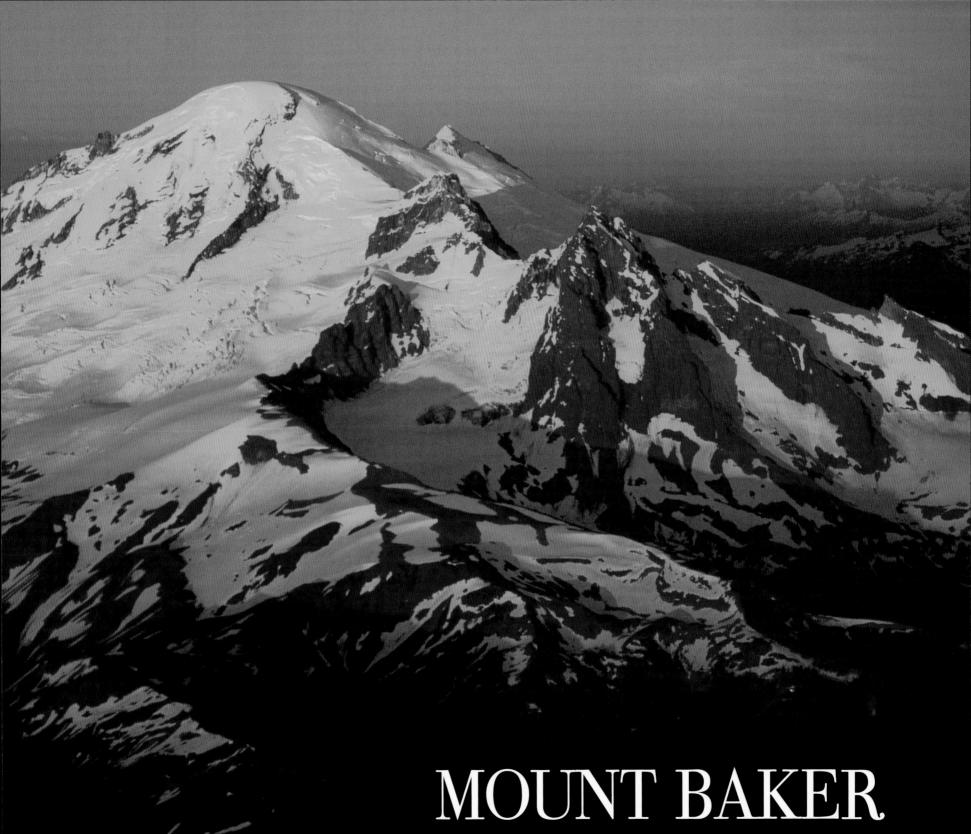

MOUNT BAKER

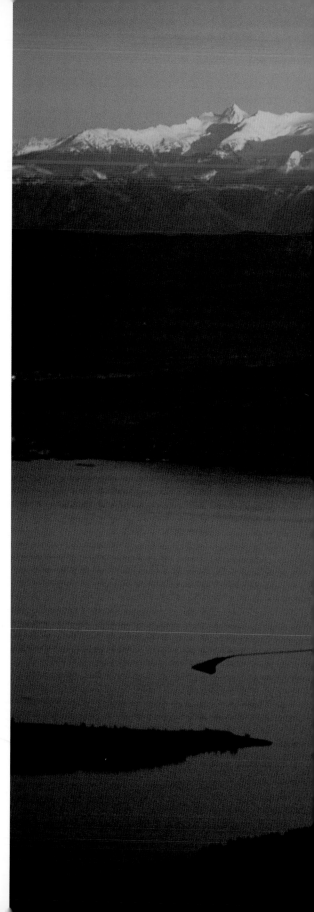
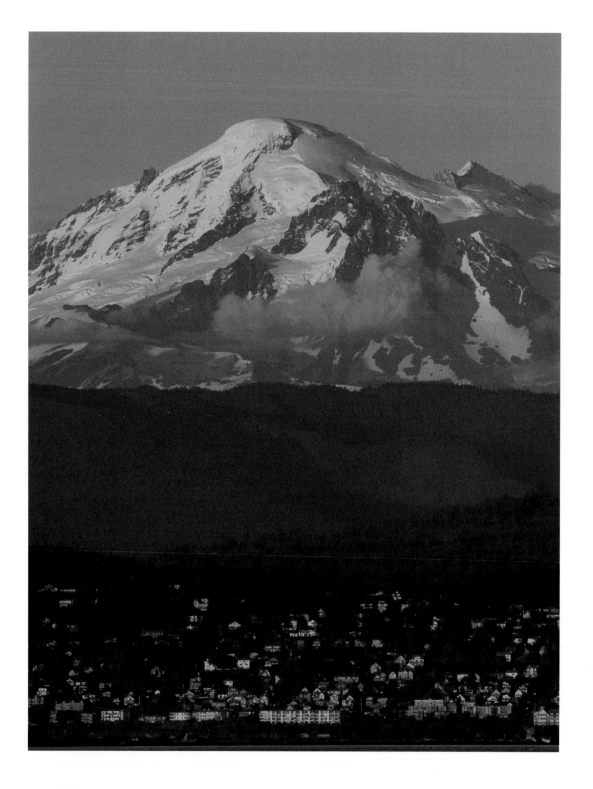

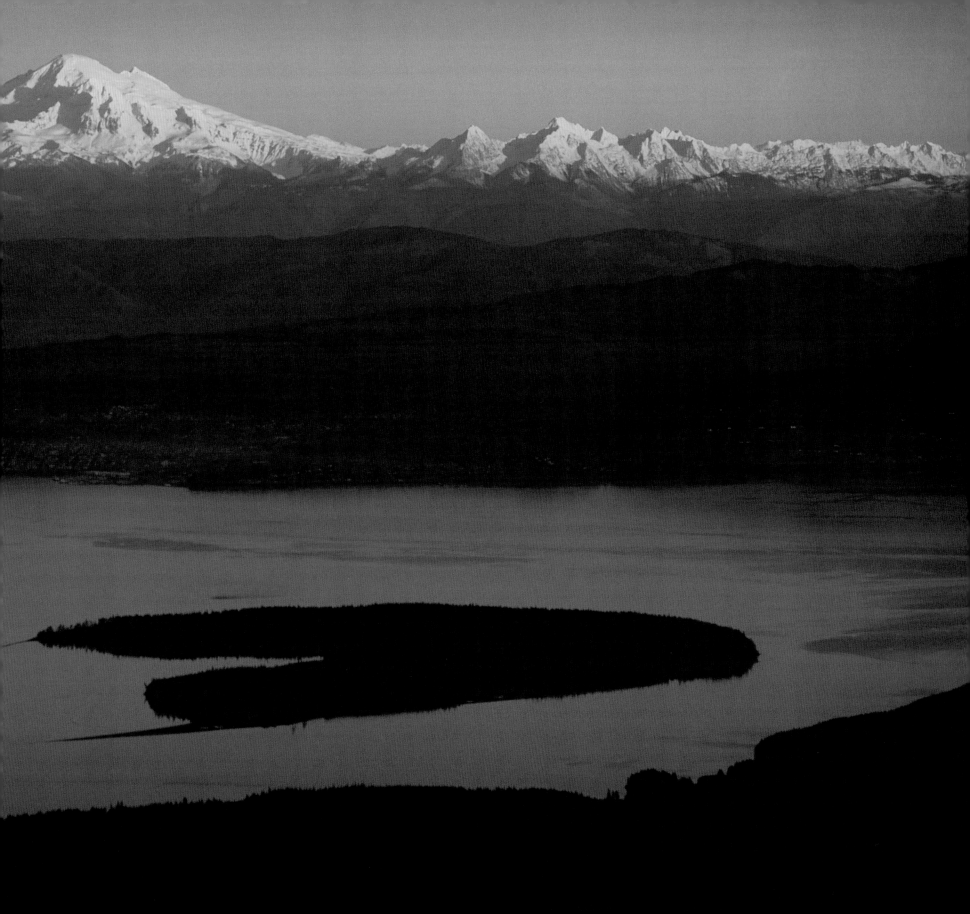

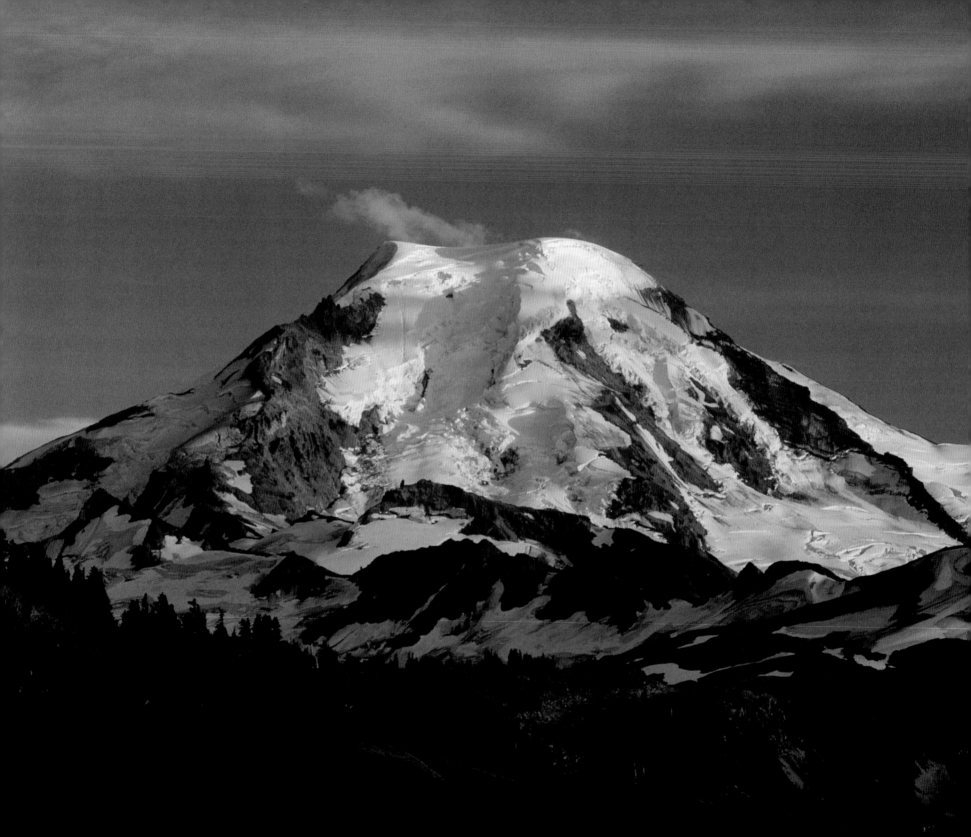

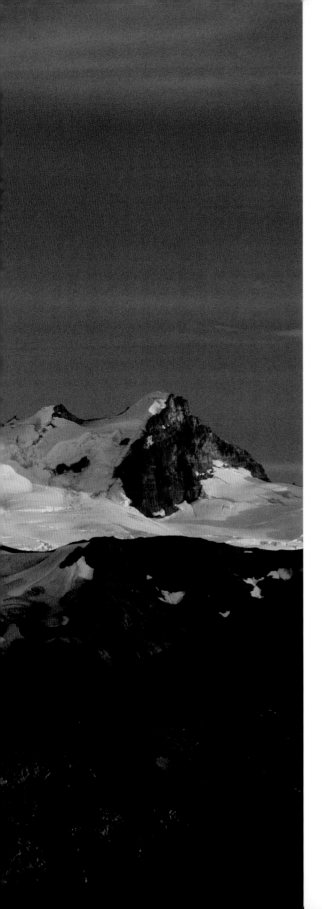

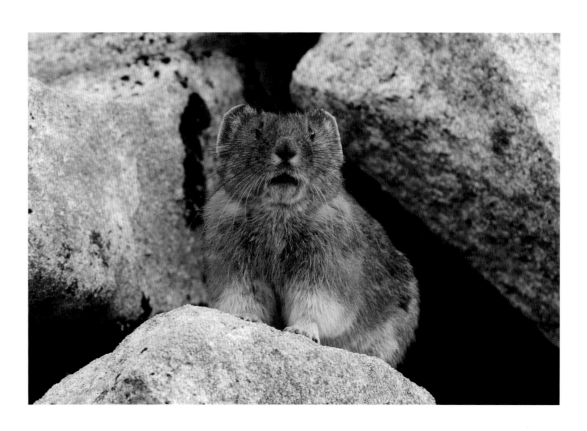

Left: Mount Baker's north face

Above: A curious pika

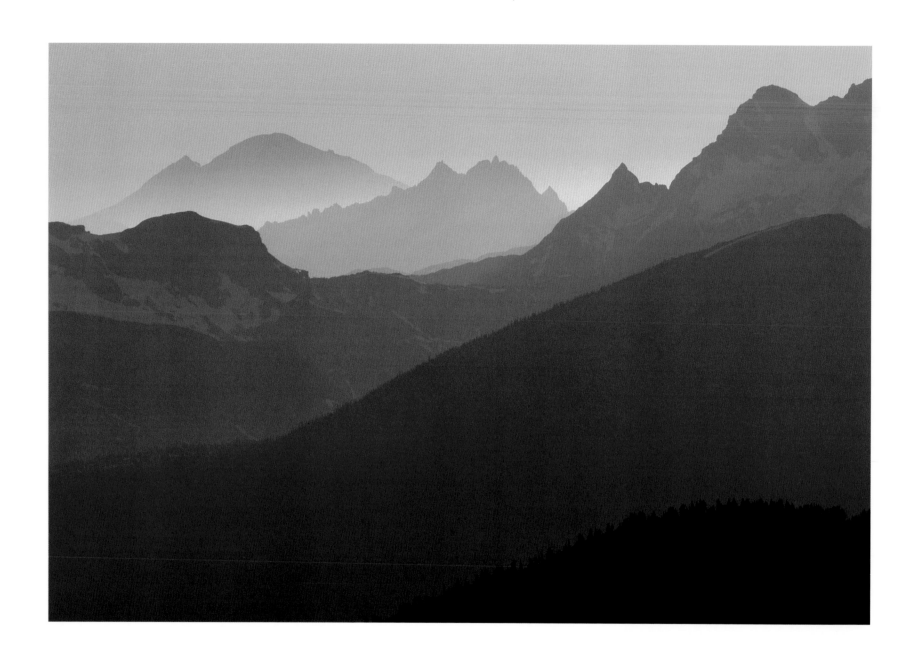

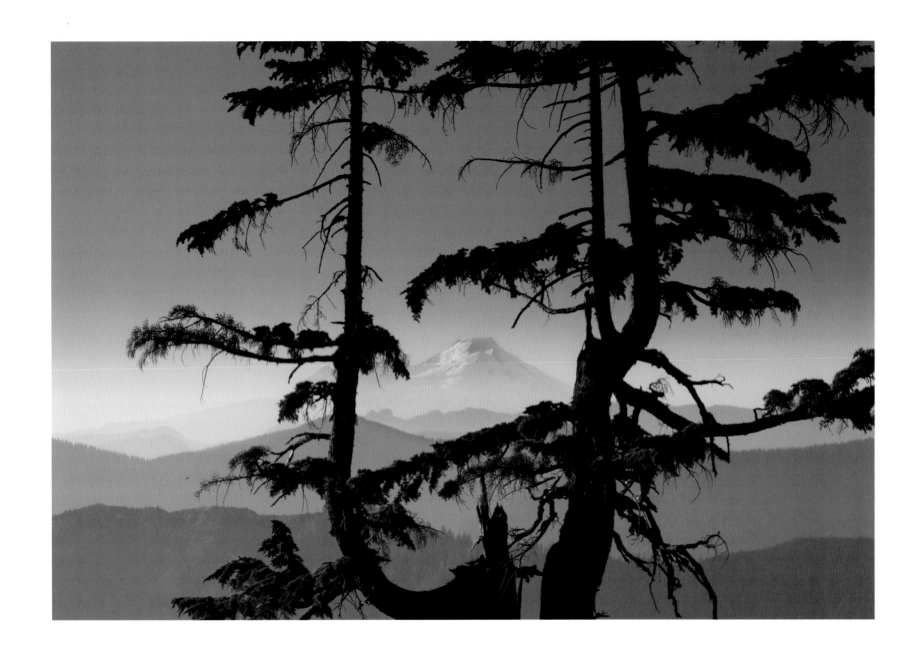

Left: Mount Baker and Mount Shuksan, viewed from Hidden Peak

Above: Mount Baker from Mount Pilchuck

Page 120: Sunrise near Austin Pass, Mount Baker Wilderness

Page 121: Mount Baker from Austin Pass

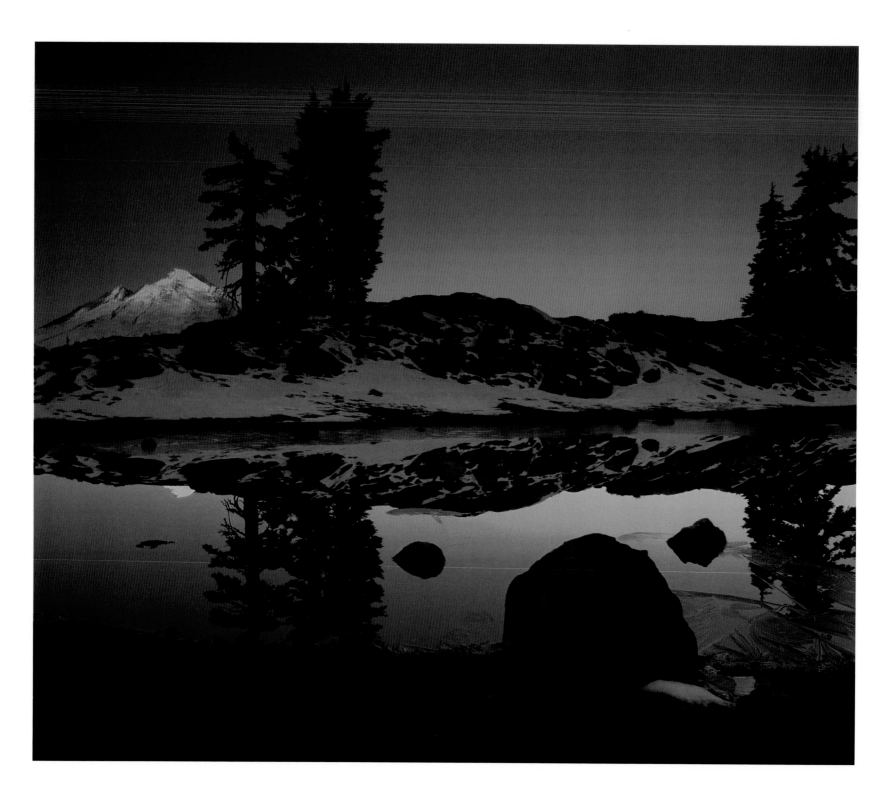

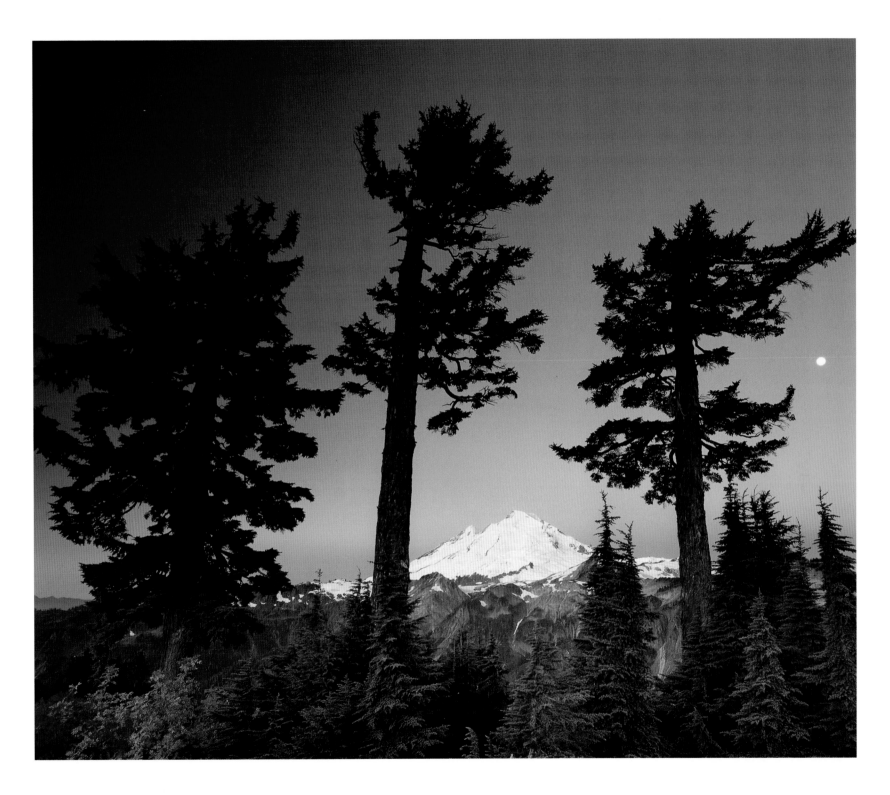

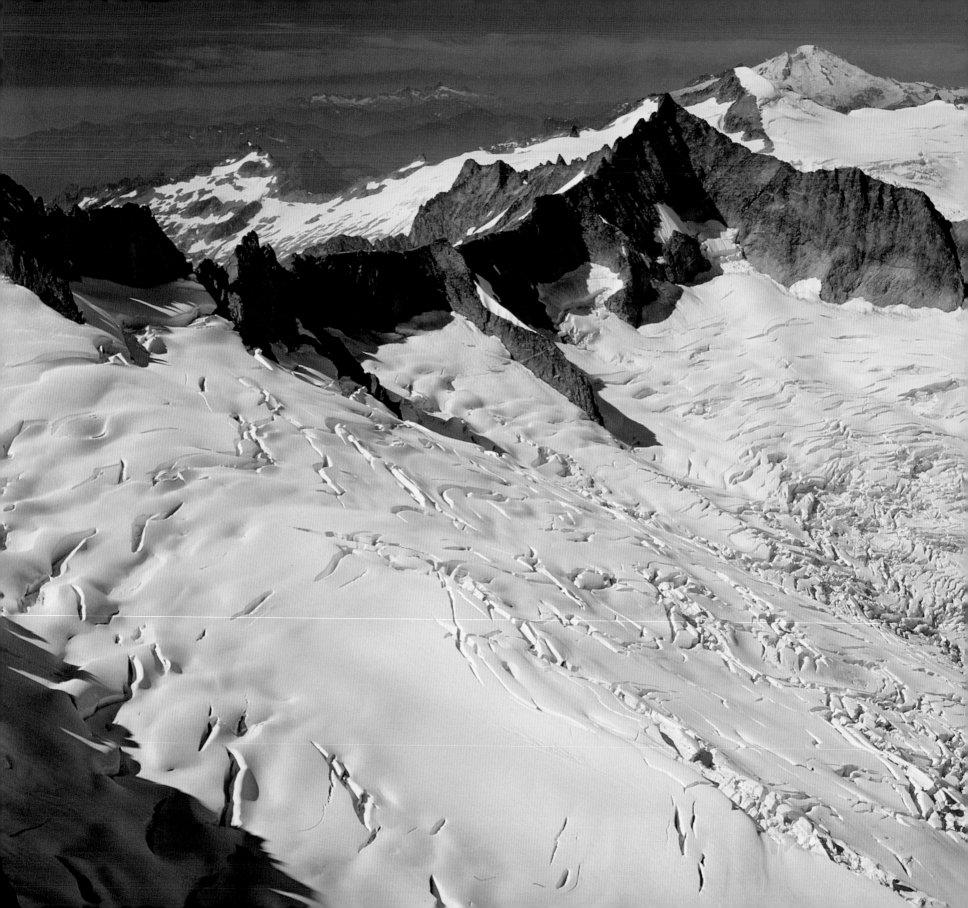

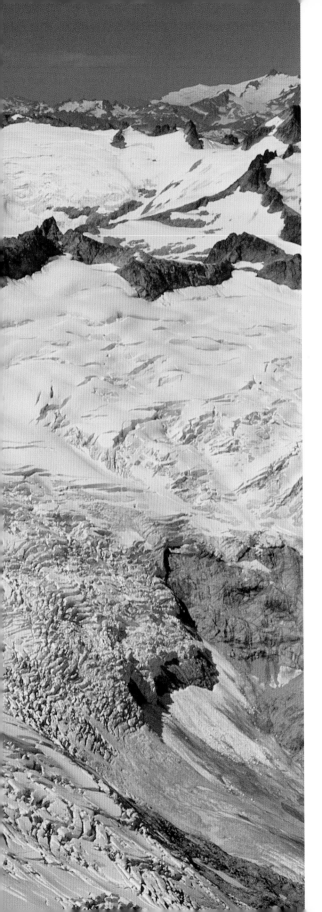

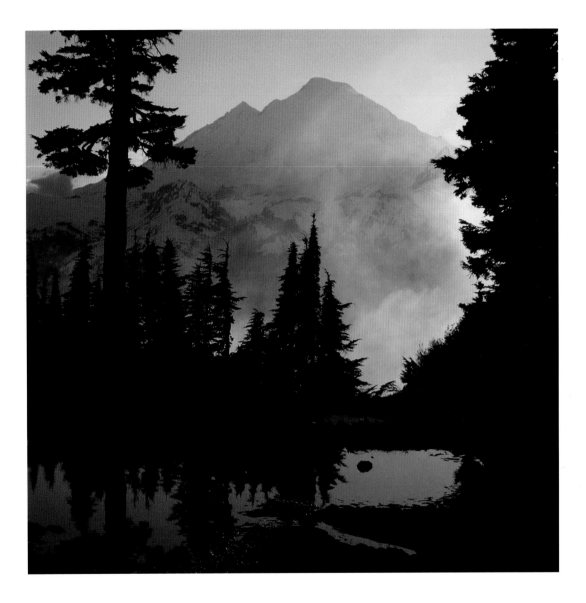

Left: Mount Baker rising beyond the summits of Forbidden and Eldorado peaks, viewed from above Boston Glacier

Above: Mount Baker from Austin Pass

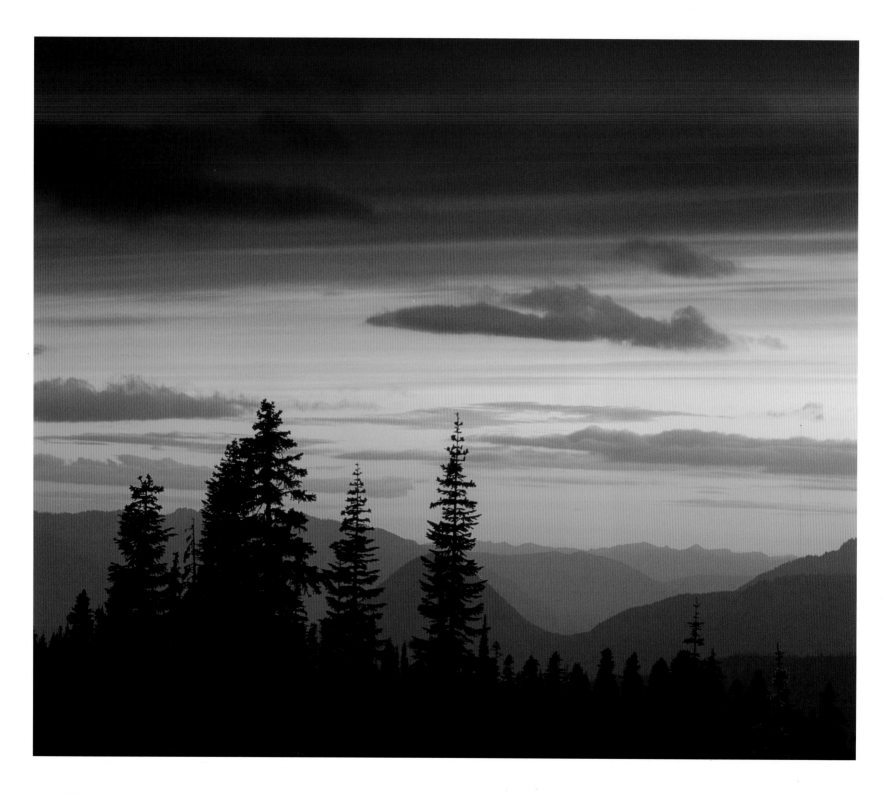

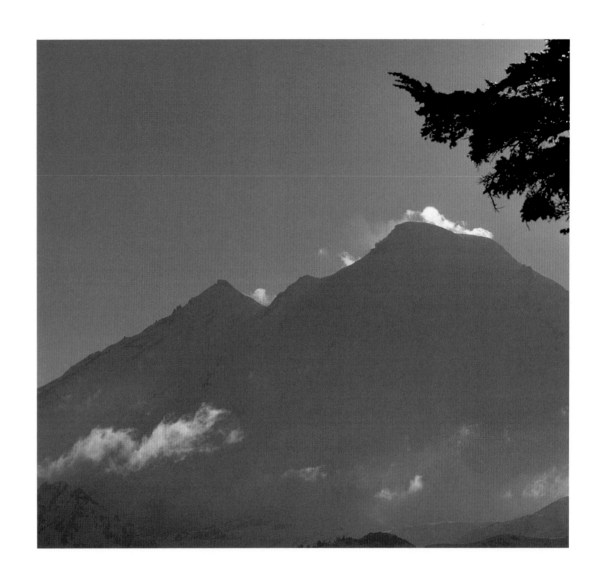

Left: North Cascades sunrise

Right: Sunrise over Mount Baker, near Austin Park

Next page: Mount Baker and Mount Shuksan

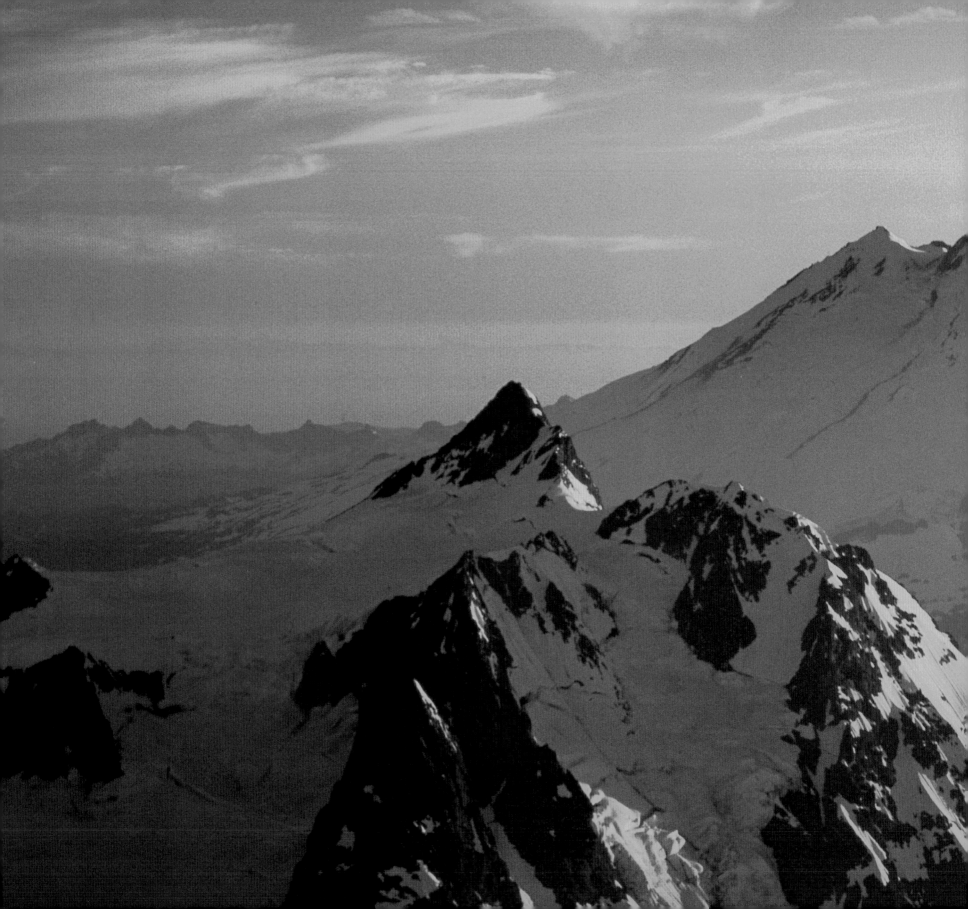

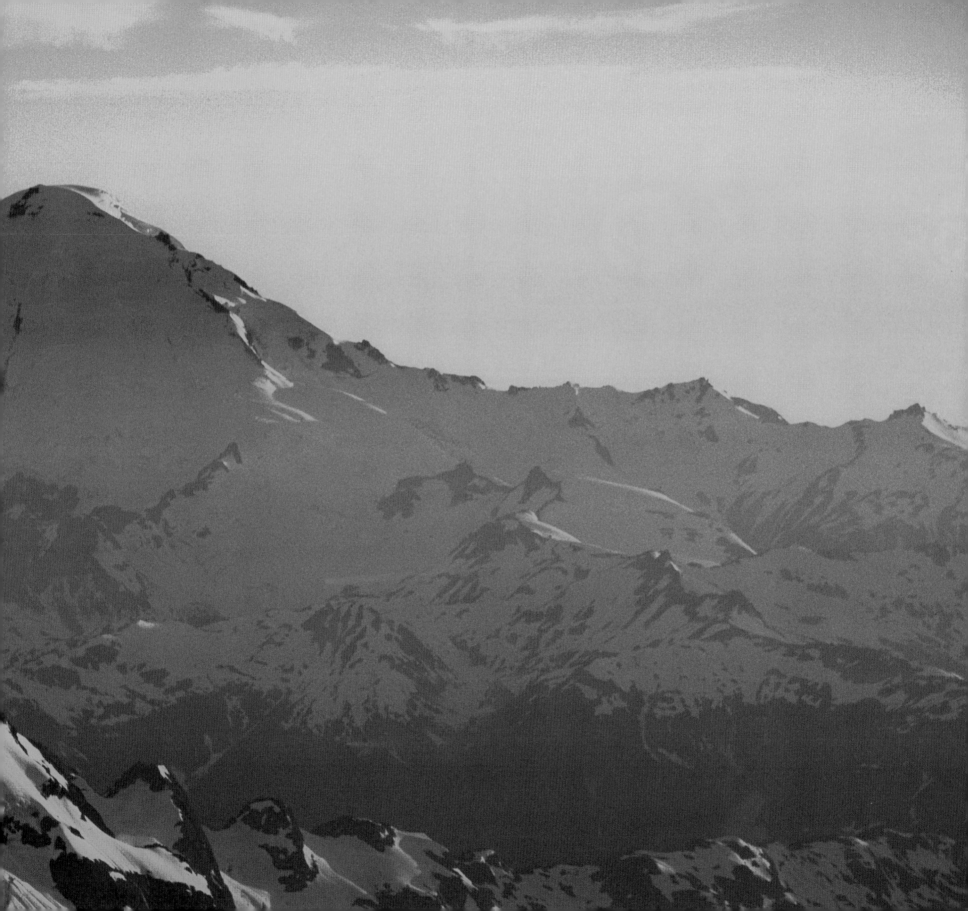

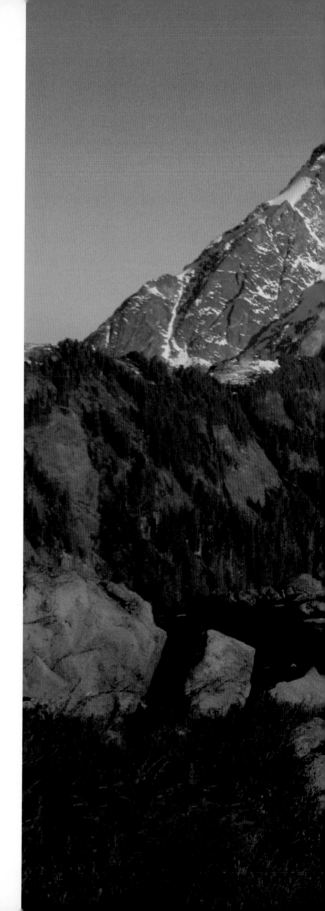

VIEWPOINTS

9,131: Elevation, in feet

48° 50' N; 121° 36' W: Latitude/longitude of summit

40: Approximate distance, in miles, from Bellingham, Washington

7,700: Vertical feet separating the summit from the North Fork Nooksack River, just 3 miles away

9: Number of glaciers

2.34: Combined area, in square miles, of the adjacent Sulphide and Crystal Glaciers, the mountain's largest ice mass

1897: Year that hermit Joe Morovits is believed by some to have reached the summit, though no proof exists

September 7, 1906: First undisputed summit climb, by Asahel Curtis and W. Montelius Price, both of whom now have Shuksan glaciers named for them

1968: Year that North Cascades National Park, which includes Mount Shuksan, was designated by Congress

"Roaring Mountain": Meaning of the peak's name to the Nooksack Indians

Right: Mount Shuksan from Austin Pass

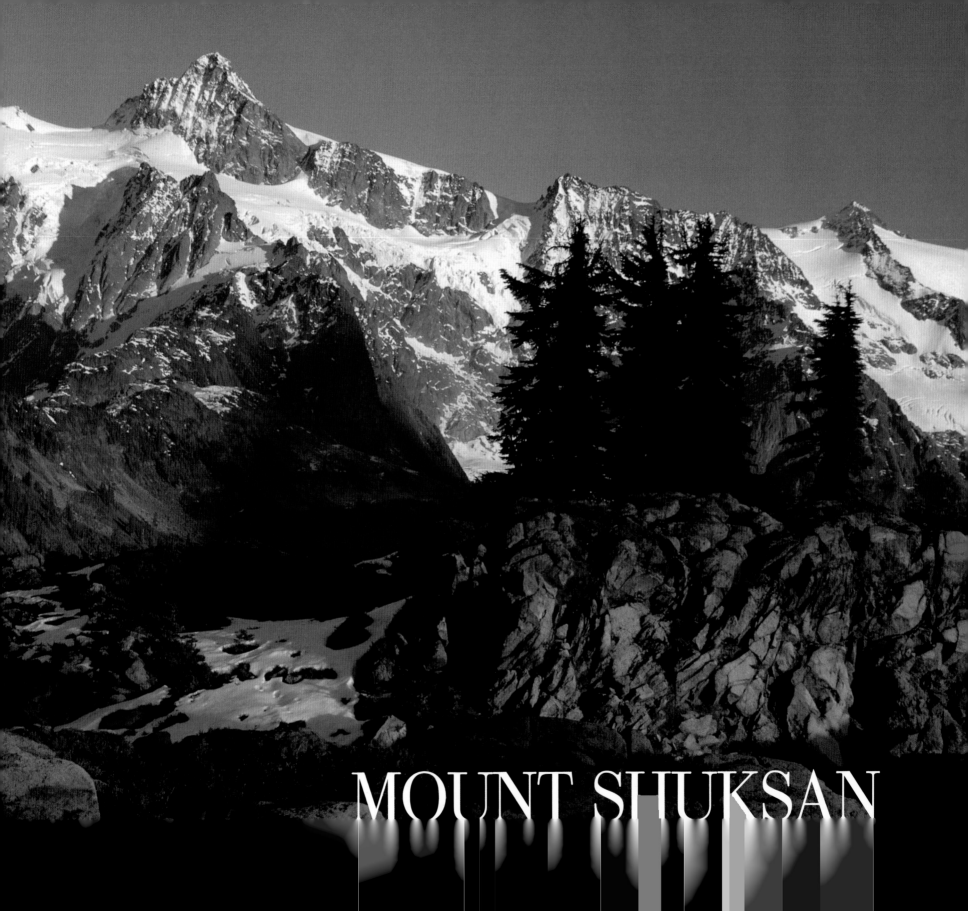

MOUNT SHUKSAN

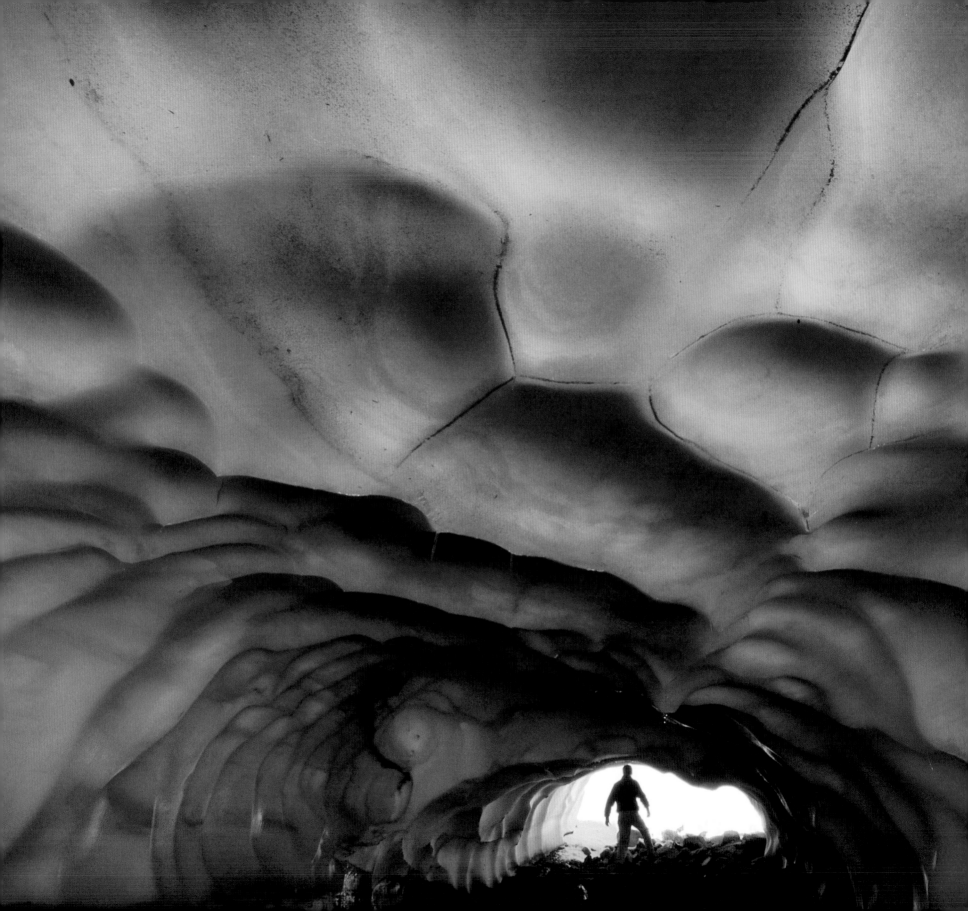

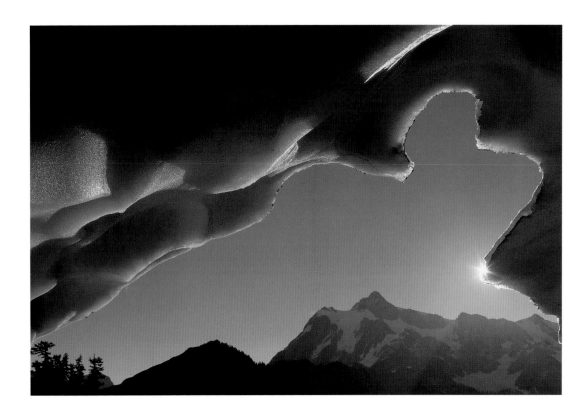

Left: Snow cave near Austin Pass

Above: Mount Shuksan from within a snow patch, Austin Pass region

Page 132: Ethereal Mount Shuksan

page 133: Winter camp on frozen Picture Lake, Mount Baker Wilderness

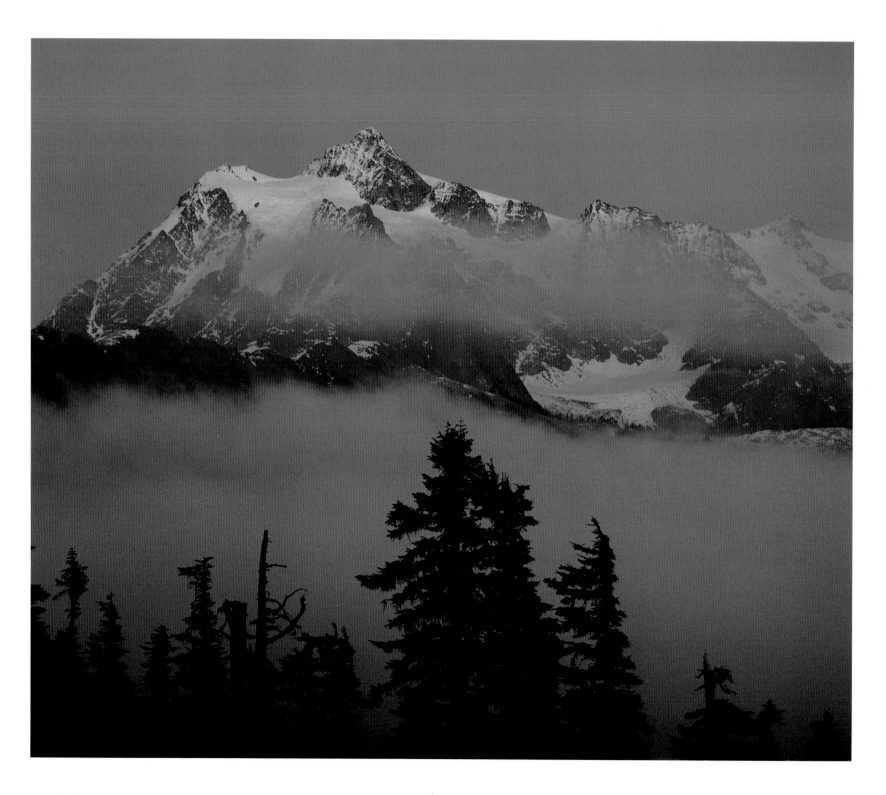

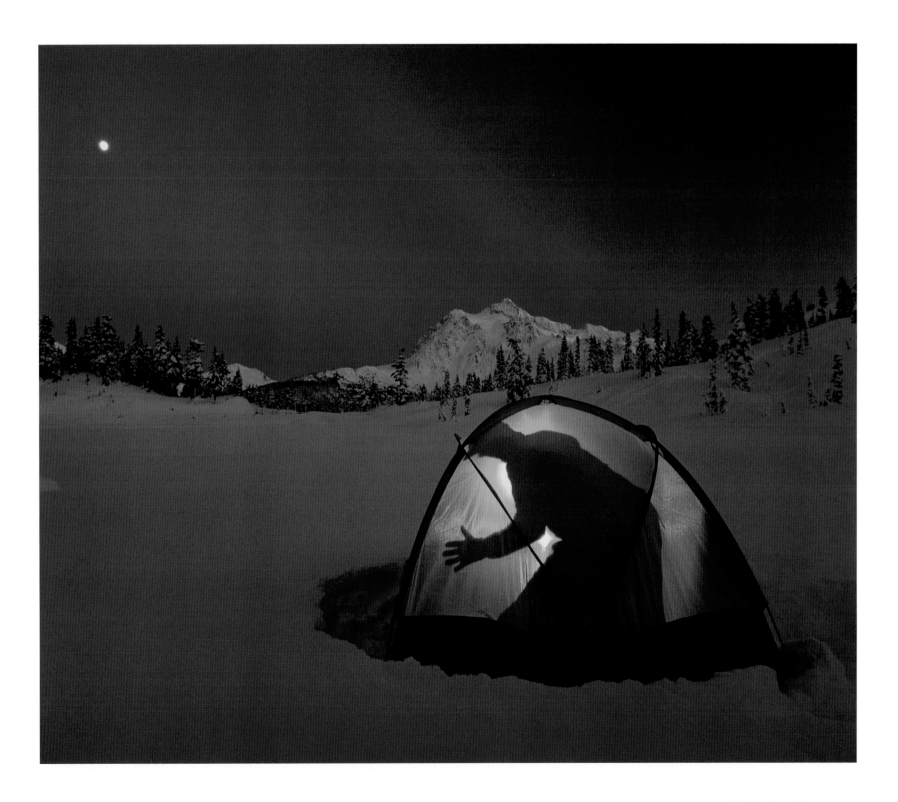

Left and above: Ice cave on Sulphide Glacier, Mount Shuksan

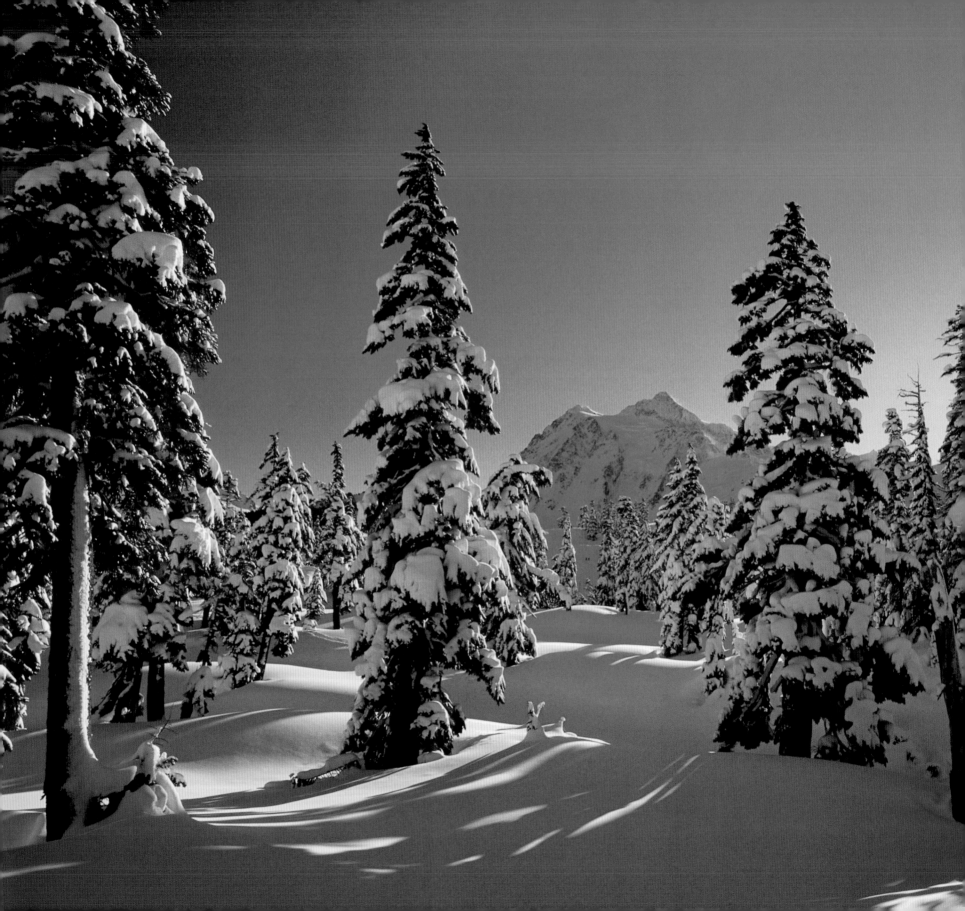

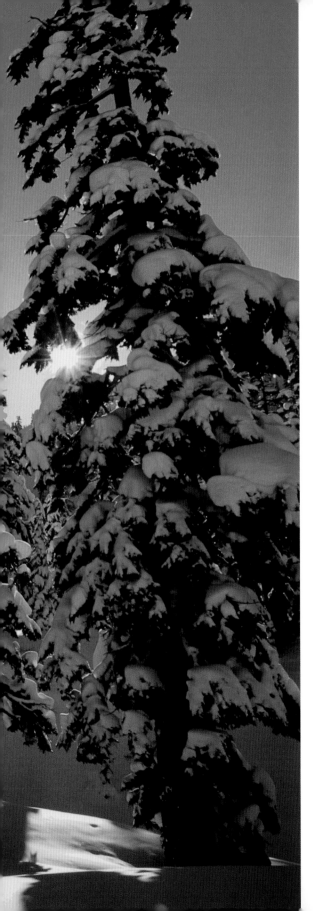

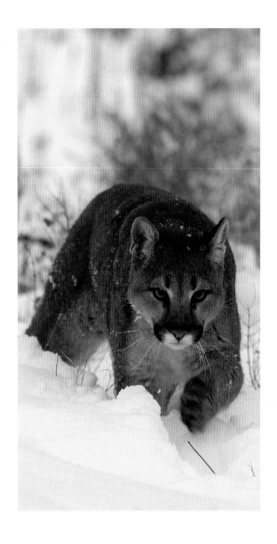

Left: Mount Shuksan through
a snow-clad forest

Right: Mountain lion in the Cascade Range

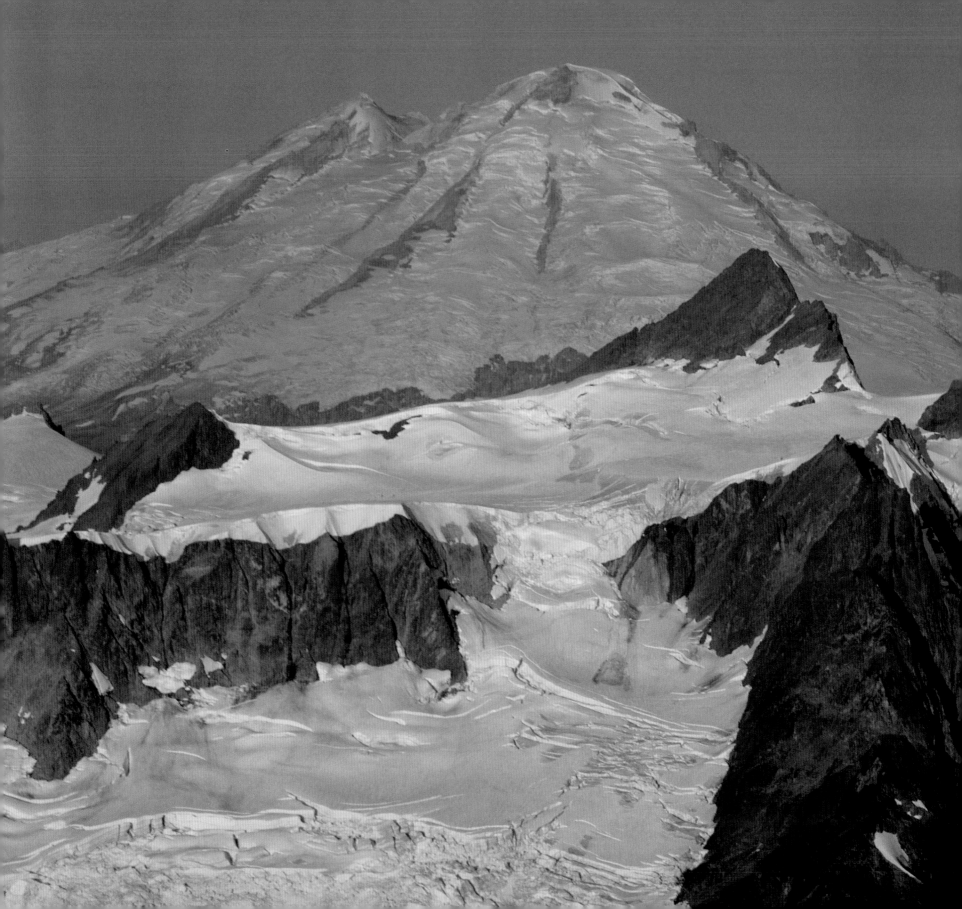

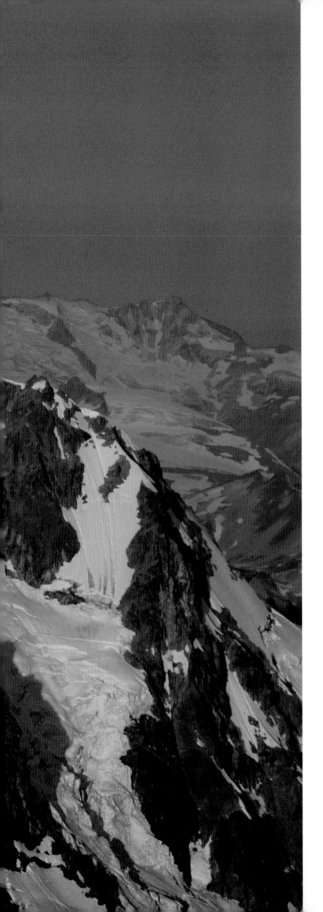

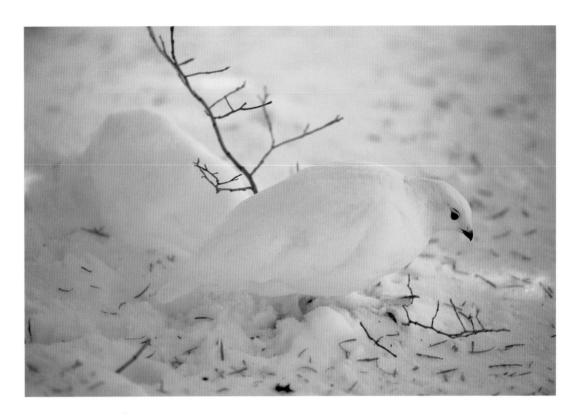

Left: Mount Baker rises above Shuksan's summit pyramid

Above: White-tailed ptarmigan

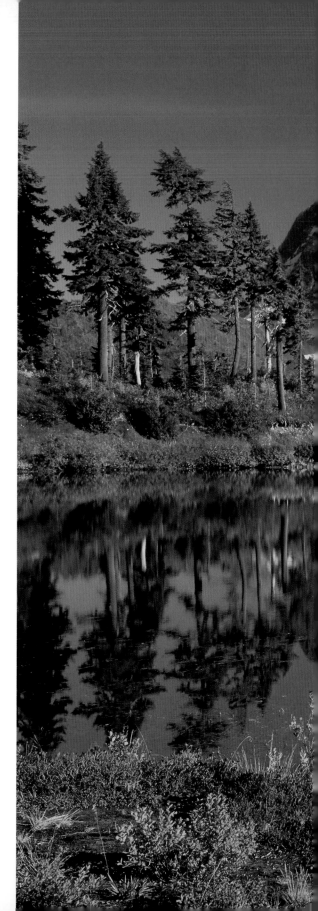

Left: Vine maple

Right: Mount Shuksan reflecting in Picture Lake

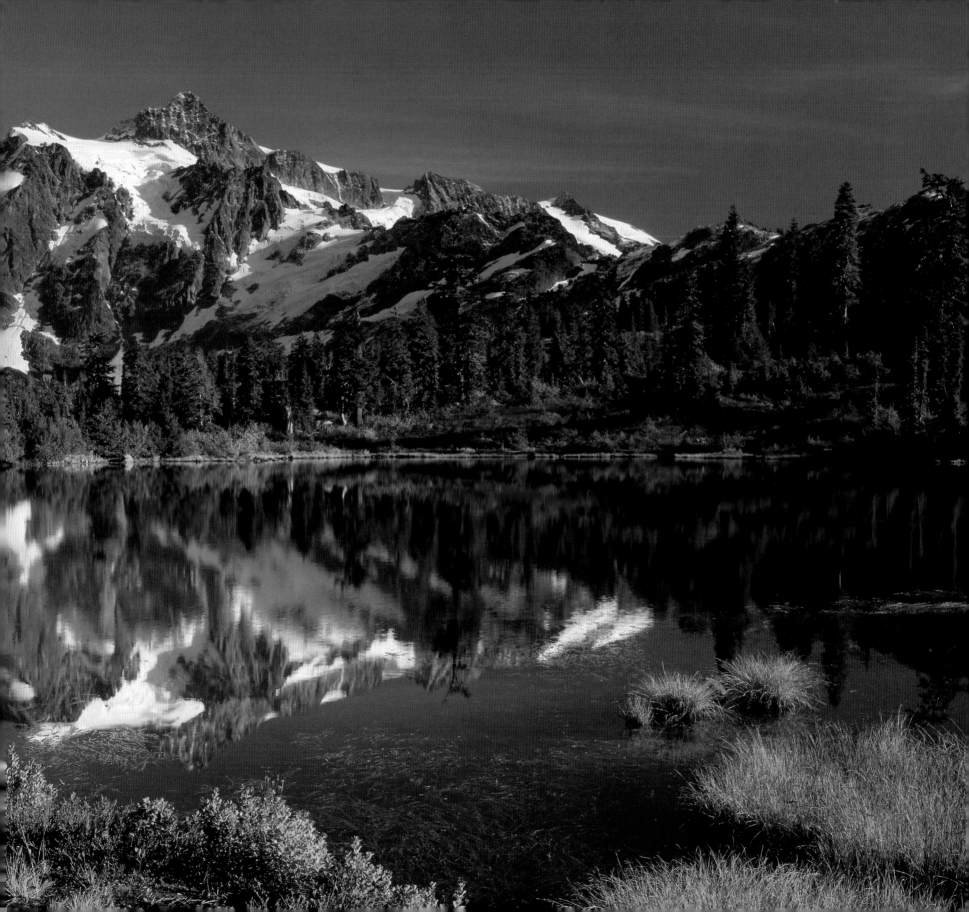

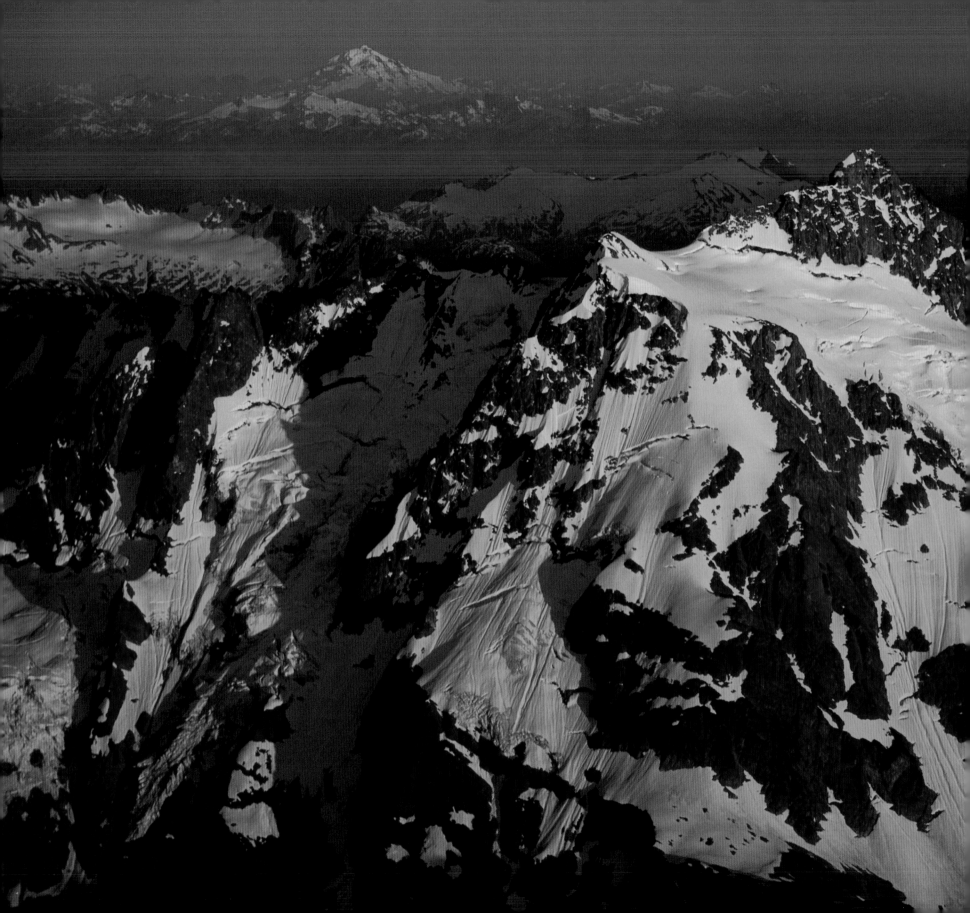

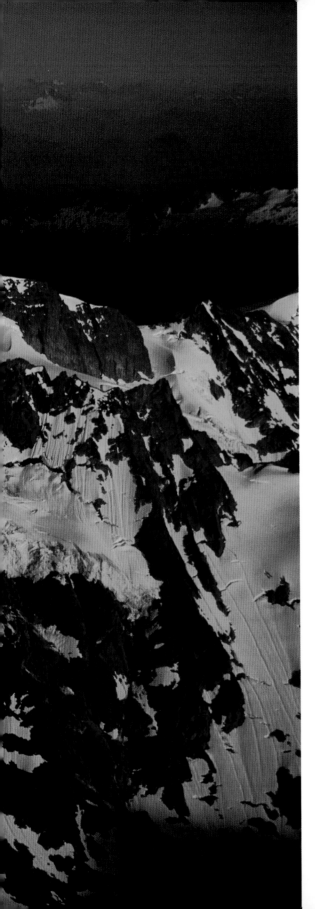

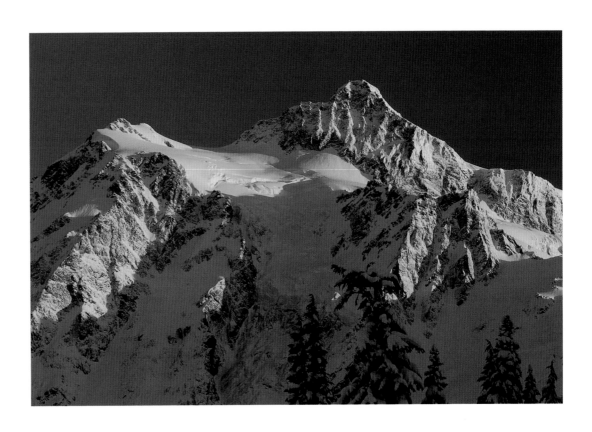

Left: Mount Shuksan's north face with Glacier Peak in the distance

Above: Alpenglow on Shuksan's summit

Contributing photographers—

Philip Kramer: pages 3, 8, 31
Dave Sattler: page 114

Printed in China
Published by Sasquatch Books
Distributed by Publishers Group West
14 13 12 11 10 09 08 07 06 05 6 5 4 3 2 1

Cover photograph: Aerial of Mount Hood with
 Mount St. Helens in the distance
Book design: Kate Basart/Union Pageworks

Library of Congress Cataloging-in-Publication Data is available.
ISBN: 1-57061-475-X (hardcover) / 1-57061-476-8 (paperback)

Sasquatch Books
119 South Main Street, Suite 400
Seattle, WA 98104
206/467-4300
www.sasquatchbooks.com
custserv@sasquatchbooks.com

Art Wolfe would like to dedicate this book

to his friend and pilot, Russ Borgnin.

Art Wolfe

is considered a master of light and composition. With numerous exhibits and more than 60 books to his credit, he has established a reputation as one of the world's leading landscape and nature photographers. His recent publications include the award-winning *Edge of the Earth, Corner of the Sky; The Living Wild;* and *California.* He is based in his native Seattle.

Michael Lanza

is Northwest Editor of *Backpacker* magazine. His articles and photos have appeared in several other publications, and he is the author of four other books. An avid hiker and backpacker, climber, skier, and bicyclist, he has hiked and climbed extensively in the Northwest, including most of the peaks featured in these pages. He lives in Boise, Idaho, with his wife, Penny Beach, and their son, Nate, and daughter, Alex.